W9-CKI-116

FORT WORTH PUBLIC LIBRARY
3 1668 02520 9120

709.2 CHAGALL
Chagall, Marc
Marc Chagall

Central MAR 2 4 1999

CENTRAL LIBRARY

MARC CHAGALL

Origins and Paths

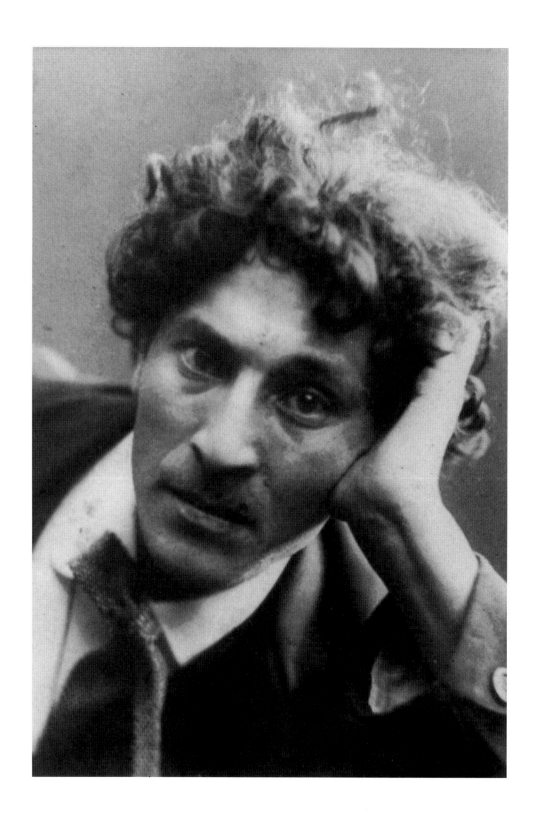

MARC CHAGALL

Origins and Paths

Edited by Roland Doschka

With contributions by
Roland Doschka, Françoise Dumont
and Meret Meyer

Prestel
Munich · New York

This book was published in conjunction with the exhibition of the same name held at the Stadthalle, Balingen, Germany (13 June–13 September, 1998) and in the Salle Saint-Georges, Liège, Belgium (25 September–20 December, 1998).

Front cover: *La Promenade (The Stroll),* 1929
Courtesy Galerie Rosengart, Lucerne, Switzerland (see plate 32)
Frontispiece: Marc Chagall, 1910
Page 5: *Entre chien et loup* (At Dusk), 1938–43 (see plate 36)

© Prestel-Verlag, Munich · New York, 1998
© for illustrated works by Marc Chagall: VG Bild-Kunst, Bonn, 1998

The biography by Meret Meyer was first published by Flammarion, Paris, in 1995

Translated by Joan Clough-Laub, Munich

The Publisher would like to thank the owners, institutions and museums for their kindness is lending pictorial material.

Photographic Credits: see page 232

Prestel-Verlag
Mandlstrasse 26 · D-80802 Munich, Germany
Tel. (89) 381709-0; Fax (89) 381709-35
and 16 West 22nd Street, New York, NY 10010, USA
Tel. (212) 627-8199; Fax (212) 627-9866

Prestel books are available worldwide.
Please contact your nearest bookseller or write to either
of the above addresses for information concerning
your local distributor.

Designed by Cilly Klotz
Lithography by Fotolito Longo, Frangart
Printed by Gerstmayer, Weingarten
Bound by Auer, Donauwörth

Printed in Germany on acid-free paper

ISBN 3-7913-1989-2

Table of Contents

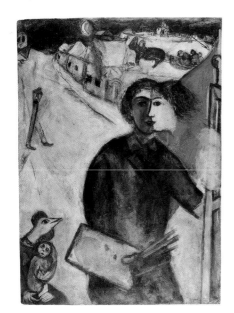

Acknowledgments

I would particularly like to extend my gratitude to the numerous lenders of works and to thank them sincerely for the generosity and trust they have demonstrated. My heartfelt thanks also go to my friends and colleagues, as well as to the staff of Prestel for their meticulous care in the production of this publication.

A special thank-you goes to Meret Meyer-Graber for the exceptionally generous support she showed throughout this project. Once again I have been fortunate to have been able to count on the unfailing support and assistance of Angela Rosengart, whose contribution is reflected in the significant works which enrich and complement this volume. Similarly, I am indebted to Françoise Dumont, the Curator at the Musée d'Art moderne et d'Art contemporain de la Ville de Liège, for her excellent contribution.

Foreword

The twentieth century is drawing to a close; a century which has seen not only fundamental political upheaval but also radical transformations in the art world.

A significant part in the latter is attributable to Marc Chagall whose artistic output spans nearly the whole of our century. Chagall's marvellously rich œuvre has been at the centre of innumerable exhibitions and has received considerable acclaim worldwide. The time is now ripe to reassess his work, to rid it of a multitude of clichés and to attempt a conclusive critical appraisal. Chagall's contribution to 20th-century art soon becomes apparent, as do both the unique qualities of his iconographical paintings, which explore the very essence of his subject, and his use of mythical imagery.

Chagall is indeed to be placed among those great artists who have paved the way for Modernism. The metaphors and symbols deeply embedded in Chagall's Russian homeland and the village life of his childhood, his intense feeling for colour, and the fundamental changes he made to pictorial space all render his painting distinctive in character and substantiate its uniqueness within the art of the twentieth century.

In addition to works of unparalleled significance which have contributed to Chagall's immense popularity, there are other facets to his painting waiting to be discovered. These are to be found in a number of astonishing works from the artist's estate which have not been accessible up until now, and which are published here for the very first time.

It has been my intention to illustrate all significant periods of Chagall's life with exemplary works and, as such, to create a picture of the artist's œuvre in its entirety. Works from the artist's early period through to his more consolidated style in the fifties form the greater part. However, the importance of the lyrical painterly style of his Mediterranean period should also be emphasized, since it is these works that have contributed to Chagall's widespread popularity.

Roland Doschka

Marc Chagall – Origins and Paths

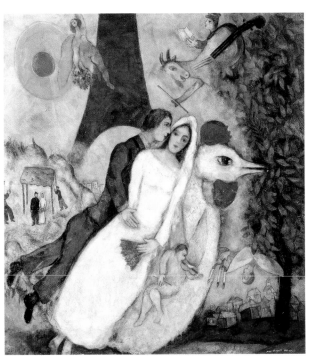

1 *The Bride and Groom with the Eiffel Tower,* 1938/39, Oil on canvas, 150 × 136.5 cm, Musée national d'Art moderne, Centre Georges Pompidou, Paris

No 20th-century painter has challenged poets to such a poetic response to his work as Marc Chagall. No other artist has inspired so many paeons as the Jewish artist from Vitebsk, that remote town in northern Russia, the home of legend, where miracle seems to have merged with reality. What captivated all those Paris intellectuals and bohemians, those wordsmiths? What was so enthralling about the shy Russian boy who set out to capture the teeming world of his imagination in visual imagery, only to return in triumph to the city of his fathers as a great painter?

The history of Chagall's life is a magical tissue woven of remarkable and thought-provoking events – of happy coincidence, as some might say. Others might prefer to speak of divine providence. Threads of destiny, swinging back and forth between the artistic, political and existential extremes of the 20th century: between the artistic diaspora and the centres of modern art; between the feudalism of Tzarist Russia and liberal France – and the return to the revolutionary upheavals marking the birth of the Soviet Union carried by so many great hopes. The lines of Chagall's biography, too, were not always straight ones; they criss-crossed continually. His search for warmth and love in the family was to be overshadowed all his life by fear and menace, persecution, flight from home and exile. His life story began in the cool twilight tingeing the expanses of northern Russia and ended under the hot Mediterranean sun of the Côte d'Azur. This was an artist, or so one would think, looking back on his life, who was always at the right place at the right time.

When the 23-year-old Chagall train at the Gard du Nord in Paris one arrived by morning in 1910 after a journey of four days, things could not have looked more favourable for him. Art had literally come apart at the seams. Pablo Picasso and Georges Braque had shocked the art world, abolishing traditional conventions of perspective by introducing Cubism in 1908. Henri Matisse had released colour from the constraints of realistic representation. Poets were deconstructing sentences and words into their basic constituents until from non-sense new meaning emerged capable of expressing a reality which had become tortuously complex, indeed surreal.

In Paris Chagall encountered ideal conditions for his art. His life may not have been comfortable in the material sense at that time. On the contrary, he was nearly destitute, spoke no French and suffered terribly from homesickness. Nevertheless, what he found in Paris nurtured the growth and maturity of his painting. Painting lay broken up into colour and he sensed that in these fragments something new was his for the taking where there would be space enough for everything that stirred him, something which could never be united in traditional pictures. And this is just what had fascinated the poets. Chagall did not go to Paris to lose himself in playing about with form or even theory, cutting the world up into

Cubes like Picasso or deploying colour like sticks of dynamite like Matisse. What he wanted was to find a way of expressing his imagination in painting. Everything else, he was convinced, would take care of itself. Chagall had brought with him from home a store of visions and motifs which his Western colleagues would have to dig deep for and travel far to find, if they found anything comparable at all: in the Lascaux caves, the museum of mankind, in folk art and in children's drawings, even in the undertaking of adventurous journeys to islands they saw as the lost Paradise of originality.

Chagall, however, needed no 'artificial paradise'. He simply started out telling the wondrous tales he had in him, using a new pictorial idiom. These were tales that shattered even such critical avant-gard thinkers as André Breton 'like an explosion of total lyricism'. And so it was the poets who were the first to recognize Chagall's importance, the poets who soon became his closest friends and were to remain his staunchest admirers: Blaise Cendrars, Guillaume Apollinaire, Salmon André, Paul Eluard, Louis Aragon and André Malraux.

It was not long before an epithet had been coined for this unusual artist; Chagall was 'le poète peintre', the poet-painter. But Marc Chagall was never a painter who merely illustrated poems or tales or retold fairy tales or legends with his brush. To the contrary, he condensed and heightened memories, feelings and yearnings, ancient tales, myths and fairy tales to similes, allegories and parables in paint in which gravity, logic and rational thought renounced their powers to poetry.

In order to grasp how Chagall came to have this unusual gift of prophecy, one must retrace the *paths* he himself took as a wanderer between the worlds – between orient and occident, Jewish mysticism and Mediterranean Humanism – all the way back to his *origins* –Vitebsk, his home which he always carried with him so pervasively in his life and work. As Lionello Venturi put it, Chagall '... remained true to himself, to the way he saw, felt and invented things which had been his very own since his childhood. He only borrowed as much as he needed from the West.'[1]

Chagall never tried to make either a mystery or a myth of his life. Far from it, he was so honest and sincere that unkind critics occasionally regarded him as child-like and naïve. But this, incidentally, did not bother Chagall. His art lives, to a great extent, from these very ideas garnered in childhood, which remained vividly with him until he was very old. Yet many of his pictrues seem to speak a simple idiom which is generally easy to understand only at first glance. When one has looked at them for a while, they become more and more enigmatic and mysterious. What thread do they all hang on, these signs, metaphors, symbols and currents of colour? They actually challenge the viewer to interpret, to seek for rational explanations of the miraculous. Chagall himself, however, always distrusted exegesis, no matter whether it was religious or art historical in nature. He had a low opinion of theories and dogma and refused to let himself be caught up in the isms and circles to which

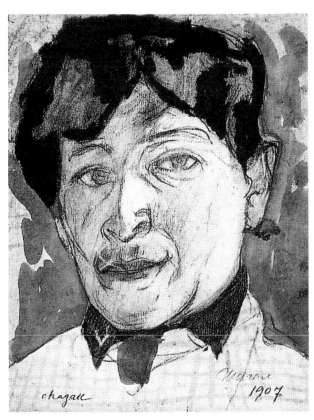

2 *Self-Portrait,* 1907, Pencil and watercolour on paper, 20,5 × 16 cm, Musée national d'Art moderne, Centre Georges Pompidou, Paris

he was always being consigned by their adherents. On the other hand, he had already written the story of his life, *My Life,* by the time he was thirty-five, in which he talks about the world of his childhood, the source of his visual dreaming. He tells of living in the Shtetl at Vitebsk, of legends and festivals, of bearded rabbis and dancing fiddlers, of the warmth of family life and of boundless trust in God. And he goes on to tell of the unusual desire he had of becoming an artist: 'I was familiar with street talk and with all the other simple ways of speaking. But the word "artist", such a fantastic word, perhaps I'd already heard it although no one in my town had yet said itWhat then is an artist, who is an artist, was I too perhaps (to be) an artist?'[2]

Hasidim and Kabbalah – Youth in Vitebsk

Chagall's life began on 7 July 1887 in the Shtetl at Vitebsk. He was the son of a taciturn fishmonger's assistant and an energetic woman who was a grocer. 'Birth is mysticism too', Chagall once told a biographer. Indeed, the primal theme of the origins of human life recurs constantly in his pictures. As if the powers of nature wanted to confirm that his birth was an event, they welcomed him to life with fireworks, a devastating fire, which, according to the Vitebsk newspaper of those days, 'took a toll of 125 shops, 268 wooden houses and 16 other buildings'. The gazette went on to add: 'The city was in flames and so was the quarter where the poor Jews lived. People managed to rescue a bed and mattress, mother and, at her feet, her infant, and get them to a safe place at the other end of town.'[3]

The pictorial motif of birth is very infrequent in 20th-century art, and when encountered, it is usually limited to Christian iconography. Chagall is one of the very few modern artists to have made this subject matter an important part of his pictorial repertoire. *The Birth* (plate 5), painted in 1911 in Paris, is unassumingly descriptive for such a scene, devoid of squeamishness as well as romantically transfiguring sentimentality: mother, child, nurse, a wash tub, a slightly squalid room, all tinged with a strange light. The painter has recorded the event in bold brushstrokes on ungrounded, coarse canvas. The starting beat is a diagonal; vertical stripes and horizontal lines determine the rhythm. Just as in the Nativity scenes of the old masters, the light seems to radiate from an aura about the mother and child.

Birth, marriage, death – the great events of life, the cycle of waxing and waning, form the *basso continuo* to Chagall's work. Deep human emotions like love and happiness as well as mourning and grief strike the basic chords which he takes up again and repeats in colour. There is nothing of hatred, violence, lust for power or vulgar eroticism in Chagall's pictures. Instead, subtle humour and delicate, sometimes almost tragic, irony inform them.

The origin of Chagall's gentle humanity lies in the deeply emotional spiritual life of the 'Hasidim', a community of eastern European Jews. They did not seek their God in a scholarly study of the Torah and the Talmud, in theological sophistry or melancholy humility. Hasidic Jews sought the mysteries of the Kabbalah, in communal prayer, in love and joy, laughter, dancing and singing. The Hasidim, sometimes called the Franciscans among Jews, had brought down mysticism from the exalted heights of the supernatural to the homely level of their daily lives. Their truths and wisdom are couched in colourful legends in which mysterious things happen. The 'Hasidic legend', wrote Martin Buber, 'is the body of its teaching; its herald, its signal on its way through the world.'[4] The sacred fuses with the profane and all things, every stone, every plant, every animal and every person is full of the divine spark. For this reason in Chagall's parents' house, known to us from so many of his pictures, there was always a place at table for the Messiah, whose coming was always imminent. Eternity and wonders were part of everyday living.

Like Joan Miró, the Catalan artist and mystic among the Modernists, Chagall was on close, indeed intimate, terms with myth. What the heavens over Montroig were for Miró, the sky above Vitebsk was for Chagall: 'I say nothing of the sky, the stars of child-hood. Those are my stars, the gentle ones: they accompany me to school and wait for me in the street until I return. You poor things, forgive me for leaving you alone so far above.'[5] The young Miró lost himself in studying nature in the loneliness of a mountain village, observing insects, plants and rocks. Chagall's thoughts, on the other hand, were all for the *condition humaine* – the family, the village community and the religious community. This was the fertile soil on which Chagall's imagination unfolded. This is what shaped the subject matter we know from his paintings: Vitebsk and its environs, the churches, synagogues, houses and shops, 'simple and eternal, like the buildings in Giotto's frescoes.'[6] The Shtetl appears again and again with its wooden houses and exotic inhabitants, cows and goats, cocks and donkeys, aunts and uncles in brightly coloured clothing reflecting both the love of the ornament characteristic of Russian folk art and the splendour of icons. Many a Western spectator is left puzzled before the emotional riches of this fairy-tale world, which seems to withdraw ever further.

'I'm not really all that keen on his cocks and donkeys and flying fiddlers and all the rest of his folklore,' Pablo Picasso once said, yet he had to admit: 'but his pictures are really painted and not just smeared on.'[7] Picasso might be considered the antithesis of Chagall, since his art is rooted in antiquity, in Eros and Thanatos, in the Dionysiac and violently animal. Although the two are so very diffe-rent, Picasso nevertheless thoroughly appreciated Chagall's painterly qualities: 'When Matisse dies, Chagall will be the only painter left alive who still knows what colour is. A few of the recent pictures he has painted in Vence have convinced me that, since Renoir, there has been no one with such a feeling for light as Chagall.'

When he was a young man, no one tried to keep Picasso from striving for a career as an artist. His father, an art teacher, even encouraged him. Chagall's desire to become a painter, on the other hand, was highly unusual considering his family and circumstances, in fact virtually taboo for religious reasons. A great uncle of his in Lyosono is said to have refused to give his hand to the boy when he heard that he drew. 'Thou shalt make thee no graven image, neither any similitude of things that are in heaven above, neither that are in the earth beneath, nor that are in the waters under the earth.'[8] In addition, a Jewish boy was not free to go anywhere he pleased nor might he attend any school he might choose. It was only his mother's cunning and support that enabled Chagall to sidestep prohibitions and restrictions so that, after a short time at school, he could take up a place at Jehuda Pen's drawing school. Pen, the only academically trained painter in Vitebsk, gave Chagall a thorough grounding in his craft for five roubles a month: drawing geometric shapes, ornaments and plaster figures, studies of the old masters and from nature. Here Chagall learned to handle colour. This was where he acquired his precision through industriously copying models, getting a feeling for space and plasticity through practise with light and shade. However, that was not nearly enough for Chagall.

In 1906 he was drawn to the cultural metropolis of St Petersburg. There, once he had the compulsory residence permit for Jews in his pocket, he 'wasted' some time with academic art studies. This experience only made him all the more eager to turn to the modern currents in art which were beginning to shatter petrified tradition even in Russia: 'I, who had no inkling that something like Paris even existed in the world, had hit on a Europe in miniature at Bakst's school.'[9]

The Art World – The St Petersburg Avant-Garde

Chagall, who at first earned enough to live on by painting shop signs and retouching photos, had suddenly encountered 'the Art World' ('Mir Iskusstwa'). Taking this name as their programme, progressive spirits in St Petersburg had banded together as an artists' association in 1899. Their chief adversaries were the exponents of the rigid Salon realism of the officially recognized academic art. The explicit objective of the progressives was to turn art completely around. 'Mir Iskusstwa', which was also the title of the revue they published – had been born of the same revolutionary spirit as the Dresden 'Brücke' in 1905 and, six years later, the Munich 'Blue Rider'. They were for everything which the academicians lacked: rhythmic line and melodic colour, originality of expression and the magic of antique icons as well as the naïveté of folk art. They were seeking a metaphysical plane which the anaemic work of the Salon painters could not reach but which still heightened traditional folklore in the form of fairy tales and myths.

3 Natalia Goncharova, *One of the Three Wise Men* for the ballet 'Liturgy', 1915, Pochoir print, 63.5 × 44.5 cm Lobanov-Rostovsky Collection

Consequently, Chagall admired the dreamy Symbolist work of Mikhail Wrubel in which the ornamental line of Art Nouveau was condensed to almost abstract form. Chagall immersed himself in the Neo-Primitivist, deliberately simple figure compositions of Natalia Goncharova (fig. 3) and Mikhail Larionov, who had rediscovered the forgotten possibilities of expression in folk art, which was so colourful and decorative. The models for their art were toys and Siberian embroidery, shop signs and above all, 'Lubki'. These were wood carvings which had been popular in Russia since the 18th century, distinguished primarily by comical burlesque effects rather than precision of perspective and anatomical accuracy (figs. 4 and 5). Moreover, Chagall could not see enough of the ancient Russian icons whose magical imagery had fascinated him in his boyhood. He was 'shattered' on encountering the icons of Andrei Rublev, 'Our Cimabue'.

The movement for renewal in art launched by the St Petersburg avant-garde extended beyond painting to embrace poetry, music, dance and the theatre. Everything was to fuse into a 'total work of art'. The experiences he had in St Petersburg were to bear

4 Russian
The Celebrated Erusian, Slaying the Serpent, 19th century, Lithograph, 35.3 × 44 cm, Musée national d'Art moderne, Paris, Bequest of Nina Kandinsky

5 Russian
Song, 19th century, Lithograph, 36 × 43.7 cm, Musée national d'Art moderne, Paris, Bequest of Nina Kandinsky

6 Léon Bakst, *Dancers in Jewish Costume*, 1910, Gouache and pencil, heightened with gold paint (bronze powder), 34 × 24 cm, Lobanov-Rostovsky Collection

fruit ten years later in Chagall's work for the Jewish theatre in Moscow, where he produced what well may be his most splendid monumental work. Painters were now also responsible for stage design and costumes, fields in which Chagall's teacher, Leon Bakst, was active (fig. 6). The young Chagall was soon enthralled by Bakst, a sophisticated bohemien who was to become famous as the director of the 'Ballets Russes'. 'Bakst, Europe, Paris', noted Chagall in succinct admiration.

Paris and Colour Unfettered

Chagall was proud to show *Studio at Narva* (plate 1) in 1909, confiding that he had already heard something from Bakst about the work of 'those Modern painters' in France. This early painting attests to the same bold dislocation of interior spaces that distinguishes the work 'of the painter who cut off his ear.' With this early drawing Chagall demonstrated that he had long progressed beyond merely applying basic academic technique. The composition is cheerful and light, built up on only a few touches of colour dotted like decoration about the picture surface. In his 1911 *Self-Portrait* (plate 6), he was already experimenting with varying intensity of contour as well as a bold use of reserve, a far cry from brittle academicism. His line is still reticent, even tentative, compared with the portrait of his mother, executed three years later (plate 14), but by twenty-two Chagall had already attained his full powers of draughtmanship. In the course of his development, he grew increasingly bored with mere precision of line and began to concentrate on colour. He was soon to realize that form grew of itself from colour.

Supported by a small scholarship paid to him by a patron, Chagall finally set out in 1910 for the art metropolis. Paris was for him the ultimate experience: the Louvre, the galleries and 'modern life' meant a freedom he had never known but at the same time utter loneliness: 'I knew no one in Paris. No one knew me. When I got out of the station, I looked at the roofs, the grey sky and thought of the destiny that awaited me in this city.'[10] Chagall was literally intoxicated on seeing masterpieces of art in original – previously he had only known these paintings from bad reproductions. He first saw original Matisses and Gauguins at Bernheim's gallery. And, too timid to go in, he stood for hours before the windows of Durand-Ruel, studying Monet's water-lilies, Cézanne's still lifes and Renoir's nudes.

At first Chagall was caught up in the work of the Fauves. A group of painters in Henri Matisse's circle had so shocked visitors to the autumn Salon that they would henceforth be called 'the Wild Beasts'. 'The public is being hit in the face with a pot of paint,' wrote an indignant critic for the 'Figaro'. Through the use of bold contrasts, the Fauves forced colour to its ultimate intensity. Contrasting blue with orange, red with green and yellow with violet meant

infringing the traditions of Western painting. Showing such pictures at the autumn Salon was bound to cause a scandal.

Handling colour in an unconventional manner was nothing new to Chagall, since he recognized affinities with Russian folk art. Here, however, contrasts had been driven to extremes. Without wanting to imitate Fauvist work, he nonetheless practised playing with contrasts in complementary colours, thus satisfying an urge for powerful expression. This can be seen in his *Lisa with a Mandolin*, 1914 (plate 10), which is a composition of yellow, red and green highlights. Chagall's handling of the blouse reveals his delight in strongly rhythmic contrasts but his bold attack indicates that he had by now abandoned the classical rules of composition for a more modern arrangement of space.

Chagall then proceeded to take up Cubism. The art scene had been taken aback in 1907 by Picasso's *Demoiselles d'Avignon*, which playfully questioned the assumptions of nearly five hundred years of composition. Meeting Picasso and Braque, Albert Gleizes, Jean Metzinger, Robert Delaunay and Fernand Léger thrust Chagall into the eye of the storm that had blown up around the new style. Applauded by his literary friends, he began at once to enhance the new pictorial language with new variations on it. The leading theoretician of the Modernists, Guillaume Apollinaire, coined the label 'peinture surnaturelle' for what Chagall was doing. However, Chagall's interest in the controversial movement that was Cubism was neither fed by mathematics nor the philosophy of perception: 'I personally do not believe that scholarly endeavours serve the interests of art. Impressionism and Cubism are alien to me. Art seems to me to be primarily a condition of the soul.'[11]

Simply breaking up an object and depicting multiple aspects of it as if they were to be viewed simultaneously, the dissecting view of things, or analytically addressing reality was not Chagall's idea of art. Through meeting Robert Delaunay, who filled the fragments of the Cubist picture plane with prismatic colour, thus creating, as Apollinaire put it, 'Orphic pictures', Chagall became familiar with the new form of composition. Delaunay, married to the Russian artist Sonia Terk, painted a series of Eiffel Towers in 1910/11, in which he succeeded in compressing the gigantic iron structure, which could not be taken in at a glance, into a normal picture space. To do this he broke up the tower into a series of fragmented perspectives, which he reconnected in a different way on the canvas, thus creating an arrangement in which rhythm and harmony, the crystalline structure and movement of vibrant colours embracing the entire interplay of pictorial means became the determinant of form. This represented a total departure from representational reproduction. The result was a composition which seemed at once magical and modern. With his simultaneous colour contrasts, Delaunay had created a visual metaphor for the way Modernists viewed the world. What motif could be more appropriate than the Eiffel Tower, the very symbol of technological progress? Chagall was quick to realize that this technique of simply suspending the traditional contrasts

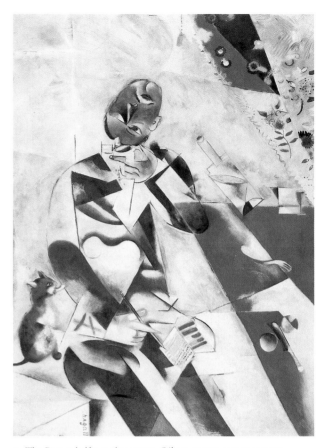

7 *The Poet at half-past three*, 1911, Oil on canvas, 197 × 146 cm, Philadelphia Museum of Art

of big and small, close and distant, above and below, making them meaningless and suspending the laws of gravity and anatomy, was just what he was looking for (see *The Poet at half-past three*, fig. 7). It enabled him to refer metaphorically to his own situation as an artist. *My Village and I* (fig. 8), painted in 1911, constitutes a programme of his years in Paris. In it Chagall turns memories of his childhood in Vitebsk into an 'Orphist' painting. This large canvas (192 × 151 cm) is demanding. The viewer must concentrate on it since it is almost impossible to take in the picture at a glance. Instead one's eye is continually jumping back and forth between close-up and distance, from figurative detail to ornamental decoration, from abstract geometry to the narrative element. The picture planes are constantly changing and interconnecting, and, ingeniously interlaced, emerge from the ground only to drift back gently, leaving harsh contours to implode into the soft flow of colour. This daydream of a painting is based on a clear concept of composition, worked up in numerous preliminary drawings and gouaches (see plate 7). A central circular form, cleft by diagonals, fans out in facettes to the edge of the picture space. Colour alternates between delicate and powerful tones, repeatedly interrupted by contrasts of complementary colours which give the picture a hallucinatory and ecstatic power. Macrocosm and microcosm, human being and animal, plants and constellations confront each other, linked by the rustic scene: the Shtetl at night, a meeting in the village street – eternity and every day, tragic seriousness and comical irony interconnect. André Breton sums up: 'The aesthetic reversal of spatial planes and the refusal to accept the dependence of creation on gravity and the laws of nature, anticipated in Arthur Rimbaud's poetry, take their creative point of departure in Chagall both in the dream picture and in the intensive sensuousness of impression. A compelling magic emanates from his pictures, whose enchantingly prismatic colours dissolve and transmute the tortuous tensions in modern man ...'[12]

During those years Chagall was working like a man obsessed, usually at night. When he ran out of canvas, he kept on painting, using old tablecloths and sheets as a support. His colleagues in the artists' colony 'La Ruche', among them Fernand Léger, Amedeo Modigliani and Chaim Soutine, were amazed at this euphoric, not to say ecstatic, productivity. Chagall was never more prolific, was indeed at the height of his powers during this first Paris period between 1910 and 1914. Then he learned to dissect the world into its constituents in order to put it back together again according to the new laws of aesthetic harmony. Thus he developed such an intuitive yet unerring grasp of colour that the writer Ricciotto Canudo was to write in 1913 in the Paris 'Journal': 'Chagall is presumably the most astonishing colourist of Modern painters. It is his colour above all with which he manages to stir us.'[13]

Among the most sensational masterpieces of Chagall's early Paris years are *To Russia, Donkeys and Others* (1911), *Hommage à Apollinaire* (1911/12), *The Saintly Coachman* (1911/12), *The Poet Mazin*

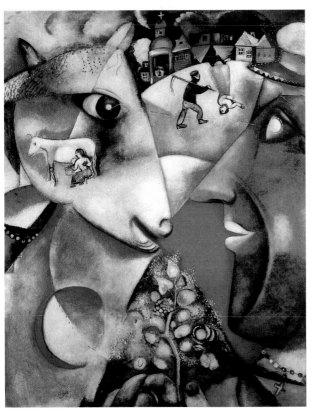

8 *My Village and I*, 1911, Oil on canvas, 192.1 × 151.4 cm, The Museum of Modern Art, New York

(1911/12) as well as *The Fiddler* (fig. 9, see plates 9 and 22) and *Self-Portrait with Seven Fingers* (fig. 10), 1912/13.

In 1914 Apollinaire arranged for Chagall to meet Herwarth Walden. A pioneer of the German avant-garde, Walden was a musician and writer with an unerring instinct for avant-garde developments in art, literature and music. In 1910 he founded a periodical called 'The Storm', which became a forum for the Expressionist movement. In 1912 Walden opened a gallery of the same name, which rapidly developed into a platform for the avant-garde of Italy, France and Russia.

Chagall already had a name in Paris but was still unable to earn enough from his pictures to earn a living. Flattered by Walden's invitation, he immediately agreed to show his best oils, drawings, watercolours and gouaches in Berlin. The thought of going on from there to Vitebsk and finally seeing Bella again had hastened his decision.

Unfortunately, Chagall had very little time to observe how the Berlin public took to his work. No sooner were his pictures hung than World War I broke out. 'My pictures billowed in the breeze in Potsdamer Strasse whilst canon were being loaded nearby.'[14] However, he managed to leave for Russia just in time. What had been planned as a four-week holiday at home was to become eight years during which he could not get away.

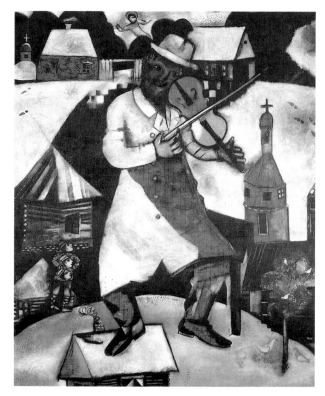

9 *The Fiddler*, 1912/13, Oil on canvas, 188 × 158 cm, Stedelijk Museum, Amsterdam

My Vitebsk ... My Board Fences!

Vitebsk, that in the Paris pictures had been increasingly transfigured to a colourful daydream, abruptly regained the harsh contours of reality. A 'wretched, boring town,' wrote Chagall, 'The stench of the front, the pungent odour of herring, tobacco, fleas.'[15]

He soon began to straighten out his dislocated Cubist perspectives. He cooled down his overheated colour and toned down his contrasts. A striving for harmony emerged in the pictures to come, a return to order. Vitebsk was chaotic enough anyway. Moreover, the 'peinture surnaturelle' once so acclaimed by the poets might easily be taken for a sign of incipient madness there. He did not pick up a brush until months spent in complete quiet and withdrawal had passed: 'I painted everything my eyes lit on. I painted from my window, never going into the street with my paintbox.'[16]

A soft, almost delicate light veiled his new pictures. The ironic fragmentation and ecstatic garrulousness of the Vitebsk pictures he had painted in Paris was transformed into a lyrical hymn to home. With the eye of a cosmopolitan, he now discovered the moods of the landscape (see plates 15 and 23), the picturesque corners of the Shtetl (see plates 24 and 25) and its inhabitants, so like the comical figures of genre painting (see plates 17 and 18). Chagall slowed down the impetuous modernity of his Paris years, showing by means of

10 *Self-Portrait with Seven Fingers*, 1912/13, Oil on canvas, 128.1 × 107 cm, Stedelijk Museum, Amsterdam

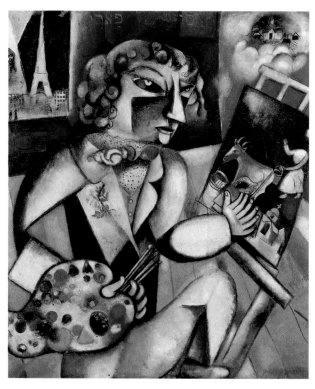

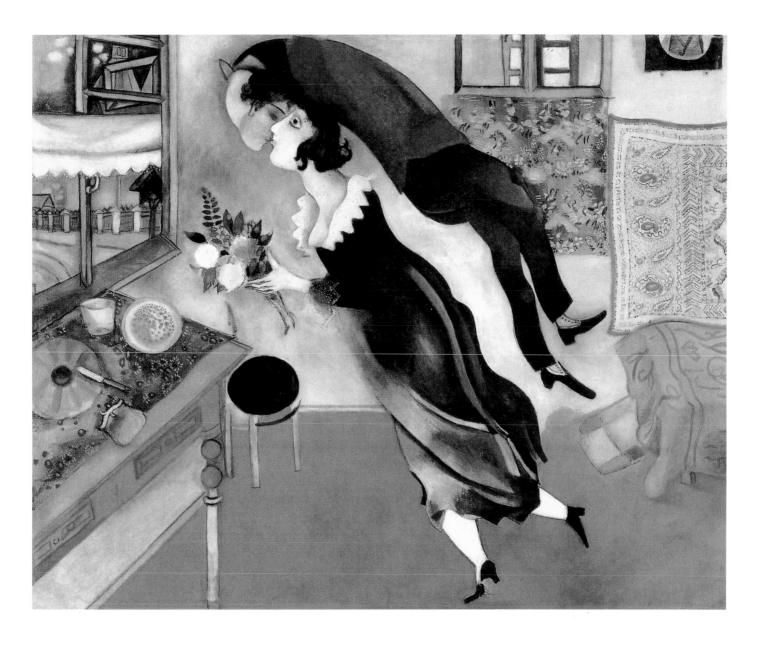

11 *The Birthday*, 1915, Oil on canvas, 80.5 × 94.7 cm,
The Museum of Modern Art, New York

easily understood subject matter what he had learned during those four years. He painted portraits of his family, his sisters (plates 10 and 11), his brother David (plate 13) and, a recurrent theme, his mother (plate 14).

Echoes of Cubism, and modified ones at that, had by now been consigned to certain pictorial elements. They resurface in the multiple facets into which his sky zones are split, in the crystalline folds of clothing or in architectural details. All this is interspersed with a realism which, due to the precision of his line, assumed almost classical qualities and created space in the conventional manner, that is, by the use of perspective. All that remains of the Paris innovations is the dream of flying. Peasants, rabbis and loving couples continue to float above Vitebsk and environs (fig. 11). Their weightlessness is enhanced by the lightness with which Chagall now handled colour. Thus Chagall transmuted the heavy gloom which weighed on Vitebsk during the war years into a melancholy harmony. His brown, blue and gree tones are suffused with light.

Rich hues dissolve into the translucency of watercolour. Everywhere rays of light seem to pierce the picture plane.

With his marriage to Bella Rosenfeld in 1915, a dream that Chagall had cherished for many years finally came true. It had seemed as if social differences would prevent the match. He was, after all, the son of a fishmonger's assistant and she a jeweller's daughter: 'Dressed all in white or in black she had long haunted my pictures as the leitmotif of my work.'[17] Chagall made no effort to repress his joy at the union. His rapture screams out from his pictures, which look 'winged' in the literal sense of the word. A good example of this is *Double Portrait with Glass of Wine* (plate 27) which shows the painter on his wife's shoulders. Their daughter Ida, born in 1916, floats like a violet angel above the couple, who are high above Vitebsk, tiny and far below them. In another variation of this theme, *The Stroll* of 1917 (fig. 12), it is Bella who is drawn up as if by an unknown power. The collage of various stylistic registers is as odd as the composition itself: realistically modelled faces are mounted on stylized planar figures. The almost abstract monochrome ground constrasts sharply with the Cubist-style fragmented landscape. Generous planes of colour abut ornamental details, surfaces are juxtaposed with space, local colour with complementary colours. Thus Chagall has playfully deconstructed pictorial logic by replacing stylistic uniformity with a multiplicity of formal planes.

From now on Bella's portrait and the motif of the loving couple were to become the dominant iconographic elements in Chagall's work, the Song of Songs of his painting: Bella as a bride, a wife, a mother, a woman in love in green, grey and pink.

Chagall's euphoric happiness seems scarcely to have been touched by the war. Only during his term of national service, which he spent at a desk in St Petersburg, did the war briefly infringe on the style of his drawings. He now had no time to paint. He produced a soldier cycle in which he symbolized pointless suffering in the harshness of his line, recalling woodcuts, and the spectral coldness of positive-negative contrasts.

Between Hope and Disappointment – The Russian Revolution

Although, as Chagall himself said, he was 'never a political person', he was nevertheless swept up in the events surrounding the Russian Revolution of October 1917. The new order, in which he thought he glimpsed the glorious Paris *lumière libertée,* seemed to herald the new age which oppressed Jews had so long yearned for: freedom instead of the ghetto and restrictions. Moreover, Chagall suddenly became aware that he himself was the son of a working man.

Along with social change, the October Revolution brought with it radical changes in the status of the artist. The rigid academic structures and the power of the Salons were banished to oblivion.

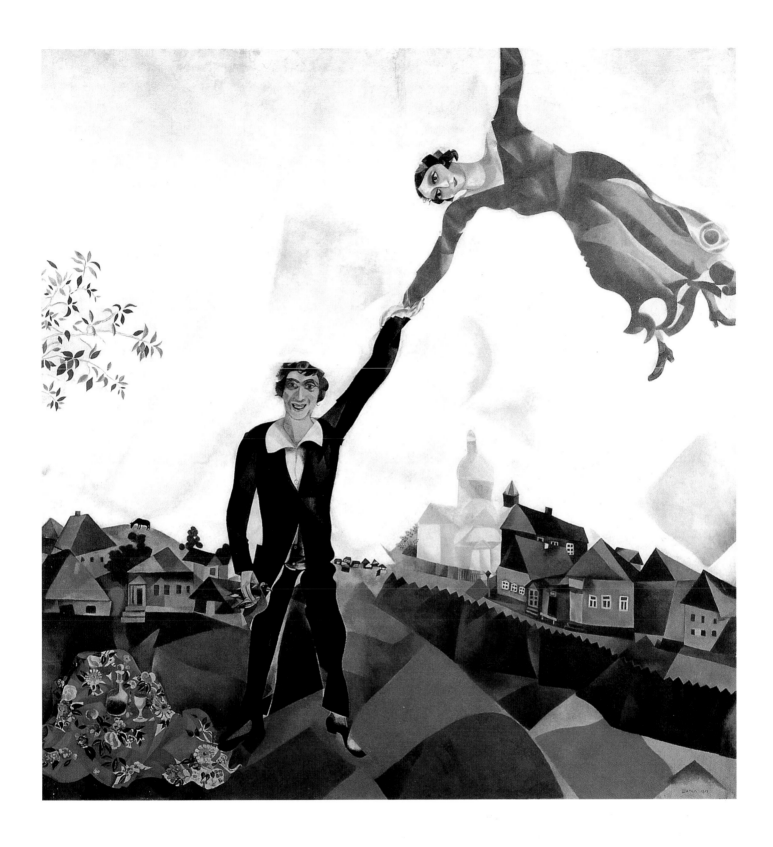

12 *The Stroll*, 1917, Oil on canvas, 170 × 163.5 cm,
Russian Museum, St Petersburg

Art was now to intervene actively in educating the new person, schooling awareness of the ideals of the new society.

'The extraordinary spectacle of the dynamic elan of this Revolution left a deep impression on me. The revolutionary elan is utterly pervasive, it transcends one's wildest imagination, breaks in a tidal surge against one's inner world, where the inner world of the artist seems like a revolution in any case.'[18]

In 1918 Chagall was appointed Fine Arts Commissar in Vitebsk. Old ties of friendship forged in Paris turned out to be useful. Anatol Lunacharsky, for instance, had returned to Russia after the Revolution and was now Chief Commissar for education and the new order for the arts. Chagall was mainly responsible for organizing art schools, museums, exhibitions, lectures and talks. In addition, he personally became director of an art school. He summoned leading Russian avant-garde artists to teach there, among them Kasimir Malevich, El Lissitzky and Ivan Paul. However, he soon realized that the old conflict between tradition and avant-garde had now shifted to the various currents within the Modern movement, where it raged just as acrimoniously as ever. Chagall was quick to notice that his notion of art would inevitably clash with that entertained by Malevich, whose ideal was 'the naked unframed icon', the black square which reflected the new reality of a technical world. Everything that was representational and emotional was to be replaced by the austere appreciation of cosmic harmonies, by a non-representational world characterized by the purely non-purposive play of squares, rectangles, circles and elliptical shapes.

By contrast, Chagall's flying figures simply could not pass the test of such dogmatic Suprematism; they looked romantic and at best pseudo-revolutionary, at worst expressive of bourgeois decadence. Chagall even had to take harsh criticism from his own side. Orthodox revolutionaries were at a loss when confronted with his lavish decorations – Vitebsk was awash with flags and banners – for the anniversary of the Revolution: 'And on 25 October my colourful animals, billowing with the Revolution, swung and swayed throughout the town The Communists seem to be less satisfied with them. Why is the cow green and why is the horse flying heavenwards? Why? And what has all that got to do with Marx and Lenin?'[19] In retrospect Chagall had to admit that he was not really interested in the details of political ideology at the time: 'My knowledge of Marxism was limited to an awareness that Marx was a Jew, sported a large beard and that my painting was utterly irreconcilable with Marxism.'[20]

Malevich staged an open revolt against Chagall in 1920 and El Lissitzky had proclaimed that 'the sensibility of the soul is to be replaced by the sensitivity of the photographic plate.' Deeply hurt, Chagall resigned as head of the school, where his authority had been weakened by intrigues, to withdraw with his family to Moscow.

Almost as if he wanted to put his critics in their place, he produced a monumental work, an *opus magnum* indeed, within the space of only a few months. Into this work, the murals for the Jewish theatre, he distilled all the experience and achievements of what he had done up to then. Chagall furnished the auditorium with a complete 'environment' by covering the walls, the ceiling and even the curtain with paintings, thus enveloping the audience in his poetic cosmos. Blending the Jewish theatre tradition with modern currents in stage design, he created a stylistic amalgam of Cubist and

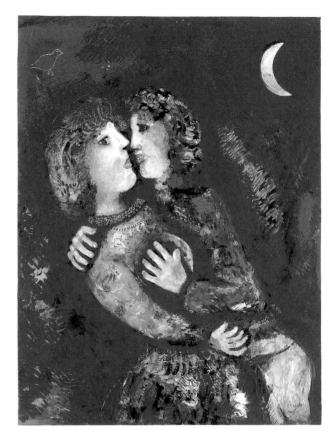

13 *Lovers with Half Moon*, ca. 1926/27, Gouache, 64 × 40 cm, Stedelijk Museum, Amsterdam

Constructivist, even Suprematist elements, interspersed with figurative motifs, cosmic geometry and Jewish calligraphy, enhanced by brilliant Fauvist colour and the translucency of watercolour. Chagall was later to explain that he was in a state of great inner turmoil, marked by ecstasy and even religious fervour, whilst he was working on the theatre. In 1989, this work, which had been gathering dust in the archives for over fifty years – which is why it has survived – was restored and presented for the first time to a Western audience in the Schirn gallery at Frankfurt, Germany. The art critics were bowled over.

After Stalin had stifled the new freedom and the short heyday of modern art, Chagall and Wassily Kandinsky managed to leave the Soviet Union just in time. Not very long afterwards it became almost impossible to travel abroad. A picture on the theme of 'Revolution' with Lenin doing a handstand before harlequins (see fig. 16) might, at the very least, have landed Chagall in the Gulag for a few years in 1937 when Stalinist repression was at its height.

14 *Village Festival*, 1929, Gouache, 50 × 65 cm, Marcus Diener Collection, Basle

From Pictorial Sign to the 'Chemistry' of Colour – Back in Paris

Chagall probably knew that he would never return to Russia. Nor was he ever to see Vitebsk again. When the Soviet Union was undergoing a process of cultural liberalisation during the 1970s and the legacy of modern art was recalled, Chagall was honoured by an exhibition at the Tretyakov Gallery. On that occasion the 86-year-old artist was offered the chance of visiting his native town but Chagall refused: 'What I would see there I wouldn't understand. What's more, it might turn out that the very thing that is one of the deepest elements of my painting exists no longer. That would hurt, it would make me ill.'[21]

With Chagall's move back to France a shift in emphasis gradually became noticeable. The metaphoric meaning of the pictorial elements became less important whereas colour as the basis of expression grew increasingly significant. Enthusiastic about Monet's

late work, Chagall spoke of the 'chemistry' of colour, by which he meant alchemy of sorts rather than a rationally grounded theory of colour. He turned almost obsessively to colour. This ruling passion is at its strongest in the designs he did for the stained glass windows of the cathedrals, churches and synagogues in Reims, Metz, Mainz and Jerusalem. They represented a reversion to the metaphysics of light in the medieval sense but, on the other hand, the pre-occupation with light led to a neglect of form for which Chagall was occasionally criticized. Yet the almost visionary glow of luminous colour is a phenomenon encountered in the late work of many of the great colourists from Titian to Renoir and Manet.

Chagall intended to break his journey back to Paris in Berlin for a while since he had left almost the entire production of his first Paris period there eight years earlier. However, all he found at Herwarth Walden's was the pitiful remains of the collection he had entrusted to the art dealer and the millions Walden wanted to give him for the sale of his work had been rendered virtually worthless by galloping inflation. A prolonged lawsuit folllowed. Chagall had little hope of getting his pictures back. Whilst the lawsuit was dragging on, the artist, by now thirty-five and eminently conscious of the break that had taken place in his life, worked on his auto-biography. He was not to find the serenity and assurance he was longing for until he had settled in Paris. There it became obvious that the Revolutionary elan of the pre-war years had ebbed. Forced to take stock of the situation, Paris artists were once again mindful of the great French tradition.

A new realism and classicism were beginning to replace the pre-war Cubist and Fauvist delight in experimenting. Through his friend, the poet Blaise Cendrars, Chagall had made contact with the renowned art dealer Ambroise Vollard, who commissioned him to do a series of etchings, his first, in 107 parts illustrating Gogol's *Dead Souls*. Vollard raved about the refreshing originality with which Chagall translated the text into subtle tonal values of black and white. He received more commissions as an illustrator: La Fontaine's *Fables*, Goethe's *Reynard the Fox*, the Bible, Homer's *Odyssey* and the Hellenistic pastoral novel *Daphnis and Chloe*.

The feeling of financial security is reflected in Chagall's canvases as well. He discovered the atmospheric properties of colour, the Mediterranean light and the beauty of the landscape. His fantastic visions yielded to a romantically wistful contemplation of nature. The harsh contours that had occasionally marred the work he did during his years in Russia dissolved into sinuous, flickering lines. The meticulous delimitation of colour fields thawed into a lyrical tide of colour (see fig. 13). His choice of motifs, too, began to change. The Vitebsk scenes faded into the background without, however, disappearing entirely to be replaced by bouquets of flowers, views from windows (fig. 14) and mother and child repre-sentations. The countryside of rural France, Provence, Brittany, and the Côte d'Azur became intertwined with the lost paradise of his native Russia. Through his intense preoccupation with La Fontaine's

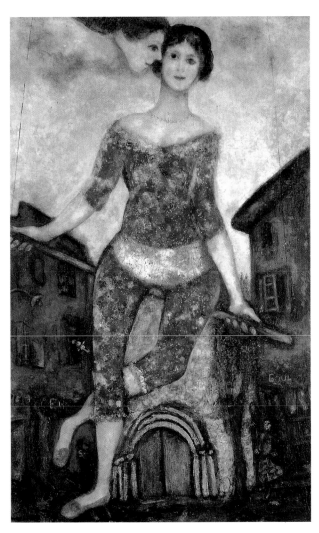

15 *The Acrobat*, 1930, Oil on canvas, 65 × 52 cm,
Musée national d'Art moderne, Centre Georges Pompidou, Paris

Fables, Chagall not only assimilated the French zest for life but was able to convey it with contemplative empathy. Even the floating and flying quality of his figures, the reversals and dissonances of scale in his compositions seemed to have taken on new meaning. In his early work they had derived from a Cubist deconstruction of reality based on constrast and built up on collage. Now, in his new work, they seemed more like a reflection on the Baroque 'world stood on its head'. In *The Stroll*, 1929 (plate 32), the couple are not depicted side by side. Bella stands on her head and her feet are grasped by Chagall's arms, a scene which does not seem to surprise the spectator behind the window of the farmhouse. The tonal value fundamental to this picture anticipates what was to become widely known as the Chagall blue: a deep, brilliant blue which literally seems to draw the eye of the beholder into the picture space. Colour has taken on substance, appearing at the same time to be a space enveloping the observer. This effect achieved by colour was to culminate in the vast 1970s canvases with their biblical subject matter.

Chagall's circus trick riders, trapeze artists, acrobats, clowns and harlequins of the 1930s are a deliberate link with the great French tradition ranging from Watteau to Degas and Picasso: the circus symbolizing the life and work of the artist, and the harlequin as the symbol of the artist who lives on the applause and donations grudgingly accorded him by a society which basically treats him as an outsider. With these circus scenes and loving couples, Chagall may also have wanted to emphasize the festive aspect his life had by then assumed. Indeed, as he later never tired of pointing out, the years between 1923 and 1933 represented the happiest period of his life. What more could he have wished? A clever businessman, the art dealer Vollard recognized Chagall's talent as a graphic artist and was promoting it liberally by heaping him with new ideas for book illustrations. The art dealer's hunger for pictures seemed truly insatiable and this was reflected in Chagall's enhanced self-assurance and his feeling of finally being financially secure. In addition, other important collectors and colleagues were increasingly appreciating Chagall's work. The exhilaration he felt at the time can best be seen in the ambiguous answer he gave when asked to spell his name: 'Chagall, with two Ls' which, in French, also means with two wings.

The tragic undertone still characteristic of so much of the work he did during his years in Russia began to disappear from the picture surface. Although Bella was certainly not very convincing in the pose of an acrobat – she seems firmly rooted to the ground (fig. 15) – the good spirit hovering above her does seem to have freed her of worries about where the next meal was to come from, as the scene at her feet shows. Chagall was so prolific in those years that art dealers could hardly exhibit his work fast enough. Late in 1924 the Barbazanges-Hodebert Gallery in Paris exhibited 122 works. In 1925 the Cologne Kunstverein and, not long afterwards, the avant-garde Arnold Gallery in Dresden, showed a great many Chagalls. Early in 1926 the Reinhardt Gallery in New York exhibited nearly one hundred pictures. The flurry of exhibitions during

those years culminated in a contract with Bernheim-Jeune, the top Paris art dealer.

Bella, too, who came from a rich family of jewellers, enjoyed the social status which came with Chagall's rise in fame. Even the global economic crisis of 1929, which forced Bernheim-Jeune to terminate the contract with Chagall, does not seen to have affected Chagall and his family. However, in the mid-1930s political events in Germany began to cast a long shadow over Chagall's work. He was deeply disturbed on hearing that some of his greatest works had been publicly burnt in Mannheim by the Nazis.

His palette again changed during the 1940s. The contrasts in his pictures became more marked although they were unlike those in his early work. The brilliance of his colour faded, yielding to sonorous tonality, a creamy, even dirty, white, earthy browns and reds and cobalt blues. In *At Dusk,* the colourless translation of *Entre chien et loup* (plate 36), this change is most apparent. The painter is depicted in the midst of a snowy landscape, palette in hand, turned frontally to the observer. The austerity of the colour reflects the inner state of the figure. Wrapped in an earthy brown coat, his face tinged a cool blue, the painter is idly holding a palette without colours, staring apathetically out of the picture plane without seeming to desire any contact with the observer. On his round face the profile of a white-faced woman is delineated. Her red, winged robe is the only touch of warm colour in the picture. Blue, white and red, the colours of the French flag, envelop the couple protectively yet the world about them seems to have grown menacing and unsafe.

Chagall's private worries were growing. His application for the French citizenship he had been trying to get for so long was finally refused in 1933. The reason advanced was that he had served the Soviet regime as an Arts Commissar.

Nevertheless, Chagall's love of travel did not yet seem to have been affected by the disquieting events taking place in Europe. Or perhaps he simply kept on travelling as a reaction to his own growing feelings of unrest. In 1931 he and his family went to Egypt and then to the Holy Land, Palestine, where he hoped to find inspiration for the *Messages Bibliques* (Biblical Messages) series of etchings he was planning. Then in 1932 he went to Holland, where he was deeply moved by the Rembrandts he saw there. In Toledo in Spain he was confronted with El Greco, who left as lasting an impression on him as the Titians he had studied in Venice in 1937. Indeed, Chagall's own existential insecurity seems to have deepened his humanity, vastly enlarging the scope of his sensitivity to encompass the visionary power of colour that was to inform his late masterpieces.

At the invitiation of the Jewish Cultural Institute at Vilna, Chagall even went to Poland in 1935 but there he was confronted with the menacing shape anti-Semitism had assumed. Finally, in 1937, three of his paintings were mocked in the notorious Munich exhibition of 'Degenerate Art'.

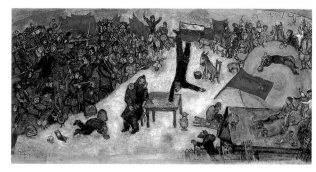

16 *Study for Revolution,* 1937, Oil on canvas, 50 × 100 cm, Musée national d'Art moderne, Centre Georges Pompidou, Paris

The themes of suffering, menace and violence dominated Chagall's iconography during the 1940s. Jewish religious motifs and 'Revolution' (fig. 16) overwhelmed his imagination. The Christian motif of the Crucifixion came to the fore in his thinking and his work albeit on a different premise. For Chagall Christ became a simile for man, who unconditionally obeys God's will. 'I can't imagine Christ from the standpoint of a particular religious affiliation or dogma. My image of Christ is to be humane, full of love and grief.'[22]

His triptych *Resistance* (plate 41), *Resurrection* (plate 42) and *Liberation* (plate 43) is a work in which Chagall's pictorial language expresses his anxiety and concern about the growing threat to the Jews.

Each of the three panels is based on the same composition: agitated groups of figures and iconic signs swirl about a centre of quiet, condensing to a pictorial expression of indescribable suffering, reawakened hope and, ultimately, redemption. Like Picasso's *Guernica*, painted in 1937, Chagall's triptych cries out against inhumane injustice and hate-inspired terror. Yet, unlike Picasso's work, Chagall's version of the underlying theme conceals moments of hope.

Chagall did not begin to understand the scope of the catastrophe until the spring of 1940. He moved with his family to Gordes in southern France. Then, a year later, and literally at the last moment, the Chagalls managed to escape imminent arrest and flee to the United States via Marseille and Lisbon.

Exile – the New York Years

On 23 June 1941 Chagall, Bella, their daughter Ida and 600 kilos of luggage, most of it his work, arrived in New York after a voyage which had taken several weeks. Seven lean years awaited him, years during which his creative drive was to be blocked by cares and brooding. Financially speaking, he was bettter off than many of his fellow artists, since his reputation had long been bolstered in New York by exhibitions of his work. Nevertheless, freedom from financial worries could not shield him from the horror of hearing about the scope and brutality of the atrocities being committed against the Jews. His family, the town of his childhood and source of his inspiration were threatened with extinction. In 1942 he was commissioned by the New York Ballet Theater to design the sets and costumes for the Tchaikovsky ballet *Aleko,* choreographed by Leonid Massine. This commission was followed by another, to design the production of the Stravinsky *Firebird* at the Metropolitan Opera. Pierre Matisse, the painter's son, was an art dealer upon whom Chagall could depend. He saw his old friends Fernand Léger, Max Ernst and André Breton again and made new ones, Piet Mondrian and Alexander Calder. However, Chagall, who did not understand English and made no attempt to learn it, was unable to

develop any feelings for the city. New York never appears in his work, even as a cityscape or pictorial cipher. The Chagalls stayed there as little as possible, spending much more of their time in the country in upstate New York, at Cranberry Lake in the Adirondacks.

His pictures were overlaid with melancholy and apocalyptic gloom. Colour could scarcely pierce the veil of greyness and Chagall's cheerful menagerie of animals occasionally began to take on the appearance of a Bruegel bestiary. *The Sledge* (fig. 17) is typical of this phase.

The basic tonality of this gouache is a dirty greenish brown, relieved by two solitary touches of blue and violet. Fine contours suggest rather than delineate a cow, a cock, a village and the Vitebsk church tower. At the centre of the picture is a strange team: a man who seems to be driving on the team with his whip is seated on a huge sledge with runners ending in a blue woman's head with white horns. This is an enigmatic picture, seemingly evocative of ambivalent associations: is the sledge stuck in the mire or is the odd sphinx-like figure pulling it out?

Only a few weeks after Chagall had painted this picture, on the day he heard of the liberation of France, Bella fell ill. She died not long afterwards on 2 September 1944. Chagall's grief was so profound that for nine months he refused to paint. All the pctures in his studio were turned to the wall.

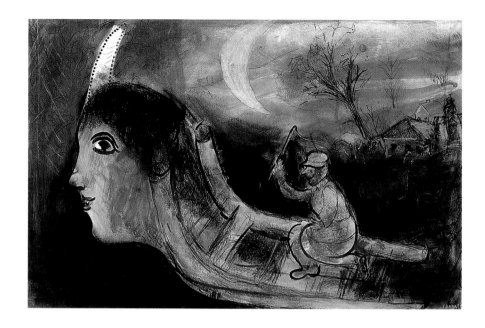

17 *The Sledge*, 1943, Gouache, 51 × 78 cm, Private Collection

Et in Arcadia Ego – Last Years on the Côte d'Azur

Chagall was now sixty years old. Not until some time after he had returned to Paris, where he was given a triumphal retrospective in the Musée d'Art moderne to welcome him back, did he begin to regain his pre-war productivity. For a last time, he shifted ground, now emphasizing the monumental gesture and the primacy of colour, which became the dominant medium of expression in his work and was to remain so for the rest of his life.

Colour emancipated itself from form to spread across entire picture surfaces, weightlessly, as a monochrome background, or dotted about the picture plane to achieve a carpet-like decorative effect. Like Monet, Renoir or later Miró, the late Chagall utterly disregarded the traditional conventions and constraints of his craft in a last burst of pure creativity. Using palette and painting knives or even his fingers, he laid on paint like primal matter, thus creating a relief-like plasticity. It was only natural that this technique led him to explore other materials, from mosaics and designs for tapestries,

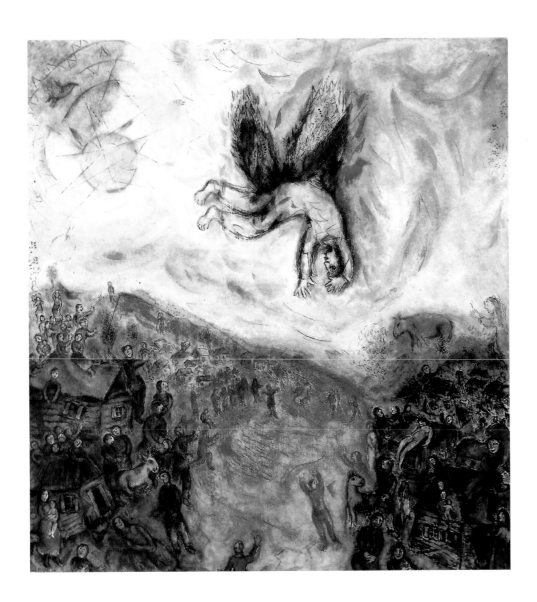

18 *The Fall of Icarus*, 1974–77, Oil on canvas, 213 × 198 cm,
Musée national d'Art moderne, Centre Georges Pompidou, Paris

and into the third dimension. From 1952 he painted vases and plates in the Madoura Studio in Vallauris. Later he made sculptures in terracotta, which he then had cast in bronze.

Gradually his mourning was yielding to new happiness. In about 1950 Chagal settled in Saint-Paul-de-Vence on the Côte d'Azur, which had become a pastoral paradise for modern painters. In 1952 he married Valentine 'Vava' Brodsky, with whom he was to share years of peace and happiness. She gave him back his serenity. For the rest of his life, he would be inundated with awards, prizes and commissions for monumental projects. The creative powers of these last prolific years have something of the supernatural about them.

Under the intense Mediterranean light of the Côte d'Azur, ancient myth entered into Chagall's work. He visited the sites of classical antiquity, spending months on remote Greek islands. Pagan Arcadia now supplanted the biblical Paradise (fig. 18). In addition, he was taking advantage of the possibilities offered by stained glass to realize his ideal of transcendental, spiritual coloured light. In 1958 he designed the windows for Metz Cathedral, in 1962 for the synagogue of the Jerusalem University Clinic, in 1970 for the Zurich Frauenmünster. Later he was commissioned to execute windows for the cathedrals at Reims and Mainz. Then there were the mosaics he did for the Frankfurt Schauspielhaus Theatre (1959), interiors for theatres in Tokyo and Tel Aviv, the Metropolitan Opera in New York (1965) and the Knesset in Jerusalem (1966) as well as the University (1968) and the Musée national Message Biblique (1971) in Nice. This last museum is entirely devoted to Chagall's works which were donated by the artist.

Chagall was obviously deeply moved by André Malraux' request in 1963 to paint the ceiling of the old Paris Opera House: 'I was confused, touched and moved. Confused, for I'm afraid of commissions although I dream of monumental ones; touched by the trust and the vision shown by André Malraux …. I worked wholeheartedly and gave this work in gratitude and appreciation to France and the Ecole de Paris, without which there would be no colour and no liberty.'[23]

The gold-ribbed Neo-Baroque dome of the Paris Opera represents the apotheosis of Chagall's grandiose vision of colour: the birth of painting from the spirit of music. This masterpiece is not only rich in mythological allusion but is also Chagall's metaphor for his life's work. It is the sum of all that was formative for his painting: the power of colour and the clarity of light, profound empathy with man and nature, myth both living and lived and boundless trust in a higher power guiding man's destiny.

His pictures are a revelation of the artist's cosmos. In painting the mundane, he touched the eternal. His origins are his family, his native town, his faith. Unswervingly the artist threaded his way through the labyrinth that is modern painting, guided by a providence that brought him to wherever modern art was in the making, yet it always let him slip past Scylla and Charybdis.
High above the Côte d'Azur at Saint-Paul-de-Vence, Chagall died in 1985. On the Mt Olympus of painters, or the Mout Sinai of his imagination, he is guarded by one of those winged beings who watched over his charmed life. As Picasso put it: 'When Chagall paints, you don't know whether he's asleep or awake. Somewhere in his head he must have a guardian angel.'[24]

Roland Doschka

1 Lionello Venturi, *Chagall,* Paris 1966, p. 99
2 Marc Chagall, *Mein Leben (My Life),* Stuttgart 1959, p. 52
3 loc. cit., p. 5
4 Martin Buber, *Die Chassidische Botschaft,* Frankfurt a. Main 1922, p. 38
5 Marc Chagall, *Mein Leben,* Stuttgart 1959, p. 6
6 loc. cit., p. 6
7 loc. cit., p. 89
8 Exodus, 20.4
9 Marc Chagall, *Mein Leben,* Stuttgart 1959, p. 88
10 Marc Chagall, ›Memories of J. Tugendhold‹, in: *L'Art,*
 Fine Arts Edition, Moscow 1928, 3/4, p. 239
11 Marc Chagall, *Mein Leben,* Stuttgart 1959, p. 113
12 André Breton, *Die Dichter verdanken ihm viel (What Poetry Owes Him),*
 quoted in *Homage à Marc Chagall,* Paris 1969 (German ed.:
 Hasso Ebenling Verlag: Luxemburg 1976, p. 12)
13 Riciotto Canudo, in: ›Paris Journal‹, 1913; quoted in: Waldemar George,
 Marc Chagall et son oeuvre, Paris 1928
14 Marc Chagall, *Mein Leben,* Stuttgart 1959, p. 114
15 loc. cit., p. 123
16 loc. cit., p. 117
17 loc. cit., p. 34
18 *Marc Chagall,* exhibition catalogue, Kunstverein Hamburg,
 Hamburg/Munich/Paris 1959, p. 13
19 Marc Chagall, *Mein Leben,* Stuttgart 1959, p. 137
20 loc. cit., p. 136
21 Alexander Kamenski, *Chagall. Die russischen Jahre 1907–1922
 (The Russian Years),* Stuttgart 1989, p. 15
22 Günter Rombold/Horst Schwebel, *Christus in der Kunst des 20. Jahrhunderts
 (Christ in 20th-Century Art),* Freiburg/Basle/Vienna 1983, p. 46
23 Walter Schmalenbach/Charles Sorlier, *Marc Chagall,* Paris and
 Frankfurt a. M. 1979, p. 165
24 Quoted in: Ingo F. Walther/Rainer Metzger, Marc Chagall 1897–1985.
 Malerei als Poesie (Painting as Poetry), Cologne 1993, p. 73

Vitebsk – St Petersburg (1906–1909) and Paris (1910–1914)

"More than anything else he is 'the product of his childhood' (Saint-Exupéry), of his very own little town of Vitebsk, which was to be not only his birthplace but also the place where, from earliest childhood to old age, his soul unfolded." [1]

In the early 20th century, Vitebsk, a small provincial town in White Russia with beautiful churches and synagogues, still boasted a large number of wooden houses, some of them painted. They opened on to courtyards, gardens or the surrounding countryside in close proximity to an entire world of animals: donkeys, cocks, cows, horses and goats....

Segregated from the rest of Russian society, the Jewish community lived in its own quarter, 'the Shtetl,' remaining deeply rooted in its own traditions, rituals and customs. Chagall's family – parents, eight brothers and sisters – and the people around him – craftsmen and shopkeepers – were the main characters figuring in the young artist's life.

These three important elements of his childhood are the source of Chagall's iconography: the image of an external reality which would nurture his imagination so that it became the expression of his inner vision of the world.

Although his first encounter with art took place at Vitebsk under the tutelage of the painter Jehuda Pen, it was not until he was living in St Petersburg that Chagall was able to embark on more intensive training as an artist.

In the cultural capital of Russia, on the other hand, Chagall attended a number of academies before finding the kind of instruction he was looking for at the Zvantseva School under Léon Bakst.

Moi et le Village, 1912
(*The Village and I*), detail

"Limit your colours so that you can get them more under control," was the main piece of advice proffered by the latter. Bakst's attentive pupil put this into practice in *The Wedding Ring* (plate 2), where the predominating grey tonality makes the green and pink of the flowers more emphatic. In this allegory of fidelity (the young woman is holding a wedding ring), Chagall was already concerned with the theme of the couple, which, like the bouquet of flowers motif, was to run through his entire œuvre.

Chagall discovered the new Russian avant-garde which was regrouping around non-academicians. He rose to the challenge. Like these artists, he was receptive to the influences prevailing in international art, which were

essentially French: Paul Cézanne, Vincent van Gogh, Paul Gauguin, Henri Matisse and the Fauves.

Chagall only stayed once or twice at Narva in the home of his patron, Goldberg, on the shores of the Gulf of Finland. *The Studio at Narva* (plate 1) is the room Chagall lived in and one of numerous motifs for sketches and paintings he executed at Narva.

But only Paris could provide him with a means of reacting to what he had learned in St Petersburg about new art movements.

Those years proved to be the formative ones for his painting. Moreover, they had an equally profound impact on his emotional life. In fact, in 1909 Chagall met Bella Rosenfeld, a young student in Moscow who was also from Vitebsk.

"It's as if she had known me forever, as if she knew my whole childhood, my present, my future, as if she were watching over me, reading me like a book although I've only just met her. I knew that she would be my wife."[2]

"I transported my work from Russia and Paris gave it light."

Following the example of other young Russian artists searching for new horizons, 'light as liberty,' Chagall arrived in Paris late in the summer of 1910.

The French capital was seething with artistic activity. Chagall's initial feeling of being out of place soon gave way to enthusiasm when he first encountered the work of the great masters like Rembrandt van Ryn, Jean Chardin and so many others in the Louvre. But it was the art of his contemporaries in the salons and art galleries that carried the day.

He was really seeing the French art that he had heard of from Bakst in St Petersburg: acclaimed artists like Cézanne, van Gogh and Gauguin, the colours of late Fauvism, the Cubist revolution in form, the various Futurist movements and nascent Orphism.

His palette became lighter although some of the dark tonality of his Russian days has been kept in *Still Life with a Lamp* (plate 3).

A second-generation Cubist, and in this respect close to his friend Robert Delaunay, he borrowed some conventions like the geometric ordering of elements in space as an additional support device and not as an end in itself: *La Joie de vivre* (*Joy of Living*) (plate 8).

Although Marc Chagall was so innovative in dealing with volume, his subject matter remained essentially Russian. The painter adhered faithful to his memories of childhood, as he did in *Woman Selling Bread* (plate 4), a gouache remarkable for the spontaneity of its handling.

He made new versions of works executed while he was still in his native country. *The Birth* (plate 5) reveals the influence of new stylistic devices both in the organisation of space and choice of colour. Chagall also executed numerous gouaches on which he based large compositions like *Self-Portrait with Seven Fingers* (see page 18).

The last and best work in this series, *The Village and I* (plate 7), is a very consciously and stringently ordered one on both the formal and the

symbolic planes. The symbolic ordering of human figures in harmony or in conflict with animal and flower motifs corresponds to the geometric ordering of circle motifs in space.

The human figure does play a major role in the series of nudes and portraits which Chagall was then painting. Nevertheless, Chagall did not paint 'real' portraits except for self-portraits or portraits of people close to him. Otherwise he tended not to be particularly interested in painting his models as individuals.

During the winter of 1911–1912, he left his studio in Rue du Maine and moved into 'La Ruche,' a group of studios which had been fitted out in a building left over from the Paris 1900 Exhibition. Quite a few artists were then living in it: Fernand Léger, Henri Laurens, Alexander Archipenko, Amedeo Modigliani, and Chaime Soutine.

Thus began a period of intensive encounters which had a formative impact on him; in addition to the painters he met, he formed ties of friendship with Blaise Cendrars, Buillaume Apollinaire, Max Jacob and the Berlin writer Herwarth Walden.

Despite, or perhaps because of the detachment he gained to it simply by being in Paris, Chagall continued to draw heavily on his native Russia and its Jewish culture. This was the subject matter of paintings like *The Fiddler* (plate 9), painted between 1911 and 1914. They are notable for a freedom of handling which has a liberating effect on values that are, strictly speaking, purely pictorial. This motif, so cherished by the painter appears here as a musician walking on a village path, accompanied by a young boy holding his peaked cap in his hand. The curve of the path is taken up again in the arc formed by the fiddler's arm, rhythmically defining space. The artist's deployment of intense colour dynamically reinforces this effect.

Only towards the end of this first French period had the painter come to terms with the reality of life in Paris so that he was able to utilize "his other village besides Vitebsk" as pictorial subject matter.

By 1914, Chagall was becoming noticed in informed circles. He was selling his work and exhibiting more and more of it in Paris, especially at the 1913 and 1914 'Salons des Indépendants.' He also showed his work in Amsterdam and Berlin during the summer of 1914.

1 Michael Guerman, *Marc Chagall. Le Pays qui se trouve en mon Éme: La Russie*, Bournemouth, 1995, p. 46
2 Marc Chagall, *My Life*, Paris 1995, p. 108

I
—

L'Atelier à Narva, 1909
(*Studio at Narva*)
Pencil, watercolour on paper, 30 × 24 cm
Private collection

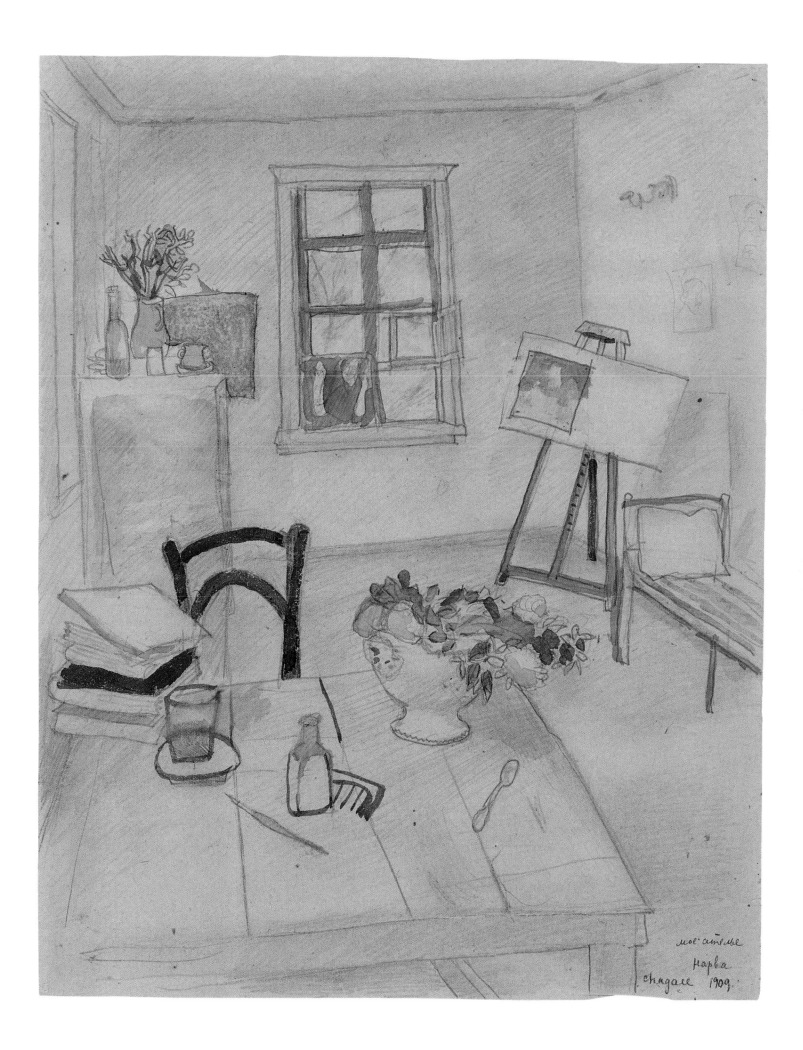

мое ателье
нарва
chagall 1909.

L'Anneau ou Le couple à table, 1909
(*The Wedding Ring or The Couple at Table*)
Oil on canvas, 62 × 81 cm
Private collection

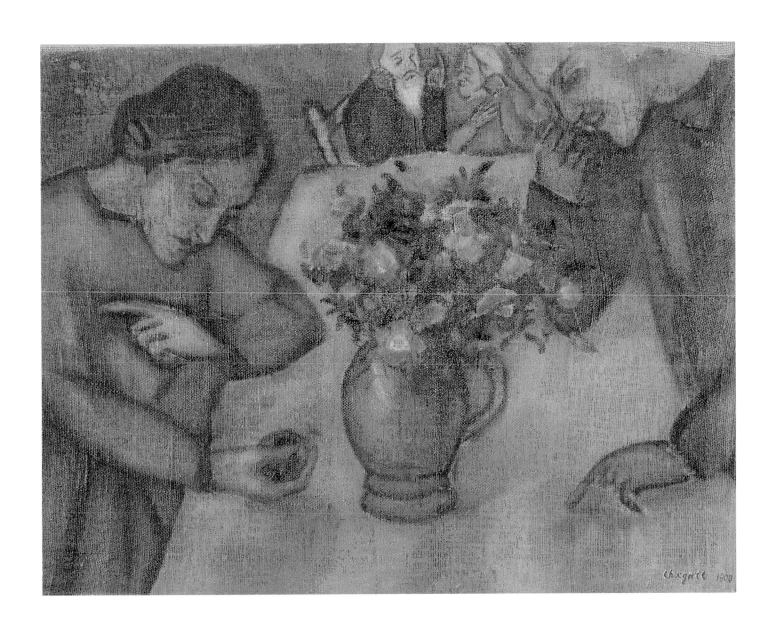

Nature morte à la lampe, 1910
(*Still Life with Lamp*)
Oil on canvas, 81 × 45 cm
National Museum of Art, Osaka, Japan

La Marchande de pain, 1910
(*Woman Selling Bread*)
Oil on canvas, 60 × 73 cm
Pola Art Foundation, Japan

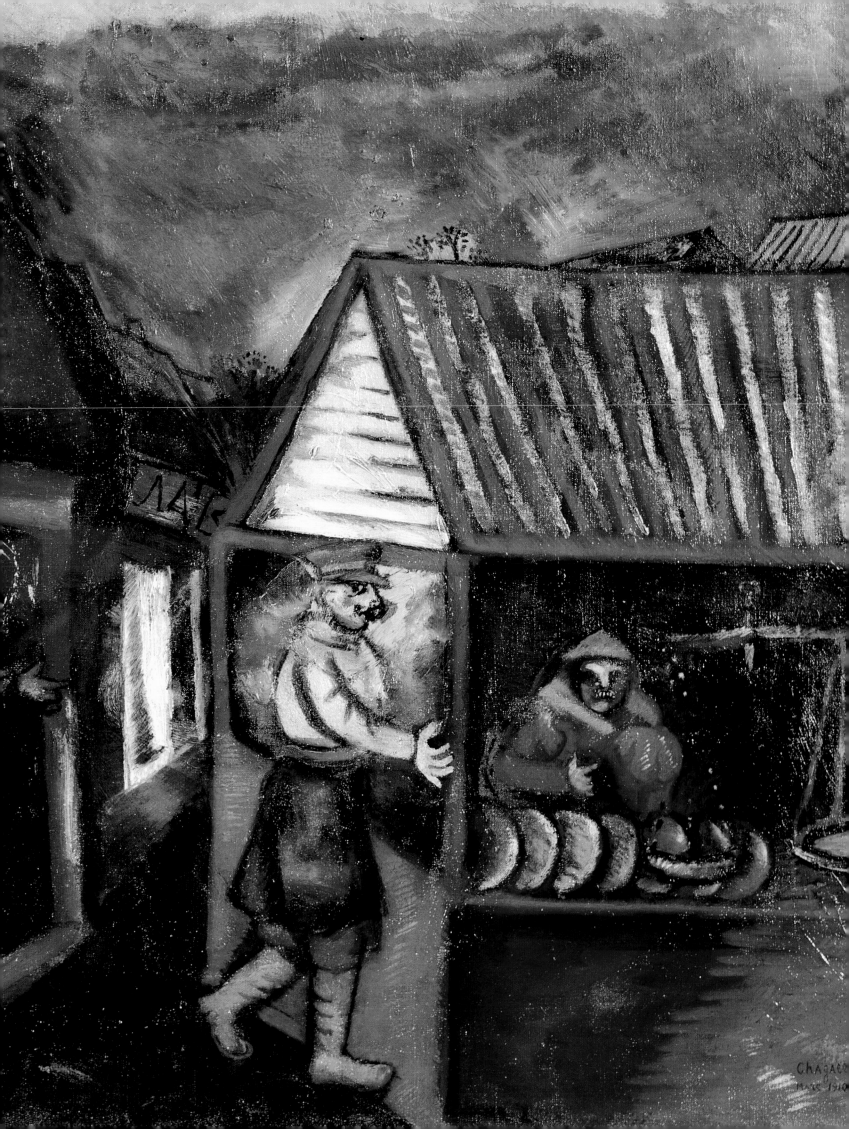

La Naissance, 1911
(*The Birth*)
Oil on canvas, 46 × 36 cm
Private collection

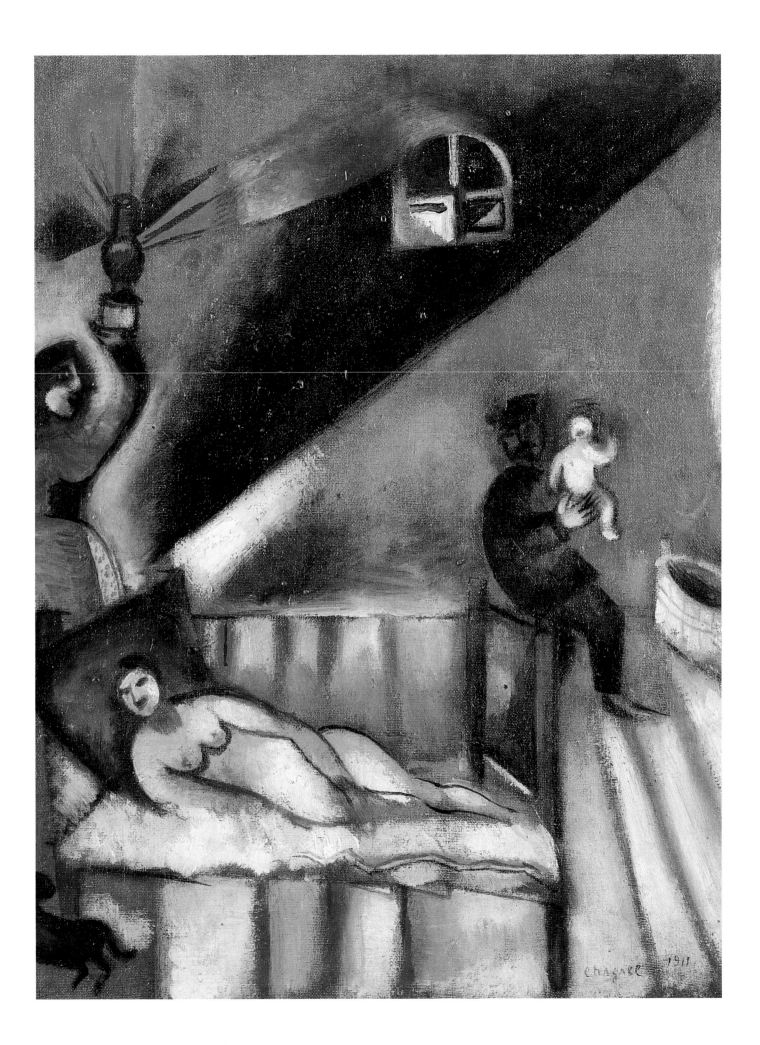

Autoportrait, 1911
(*Self-Portrait*)
Blue ink on paper
26 × 20 cm
Private collection

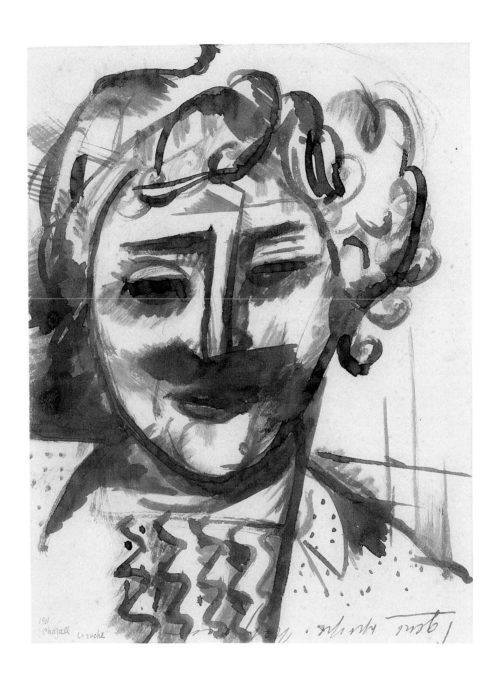

Moi et le Village, 1912
(*The Village and I*)
Gouache, pencil, watercolour on paper,
61.8 × 48.9 cm
Musées Royaux des Beaux-Arts de Belgique, Brussels

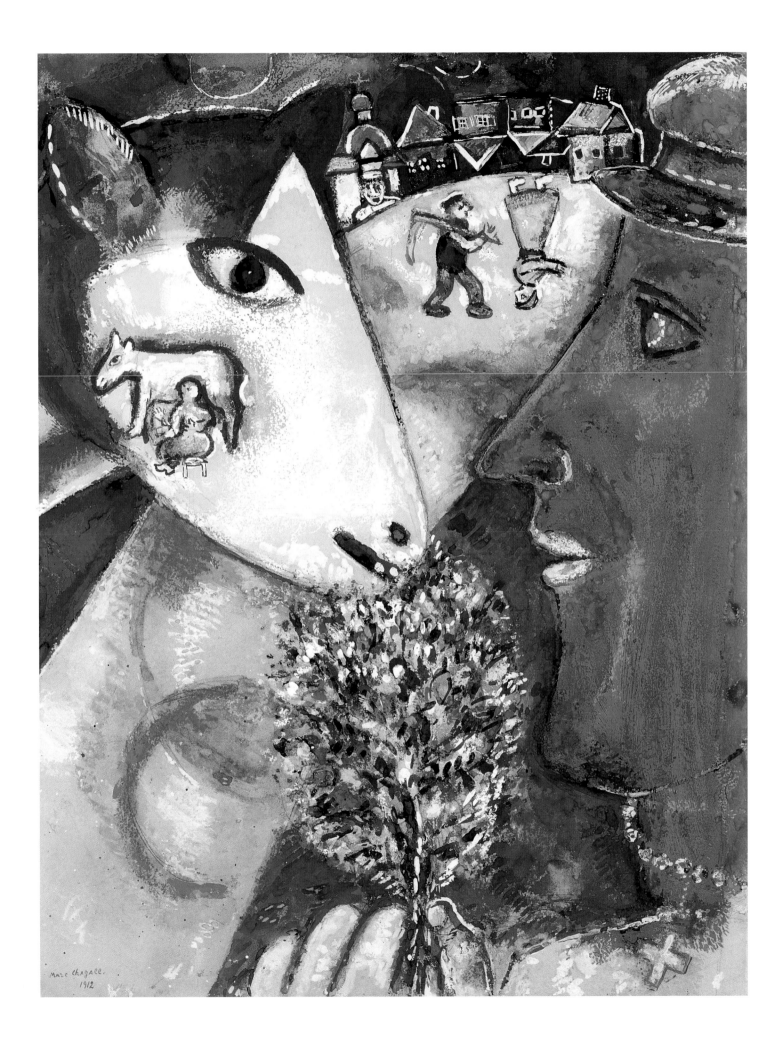

La Joie de vivre, 1914
(*Joy of Living*)
Watercolour over pencil, ink and
chalk drawing on vellum,
22.2 × 32.4 cm
Galerie Berndt, Cologne

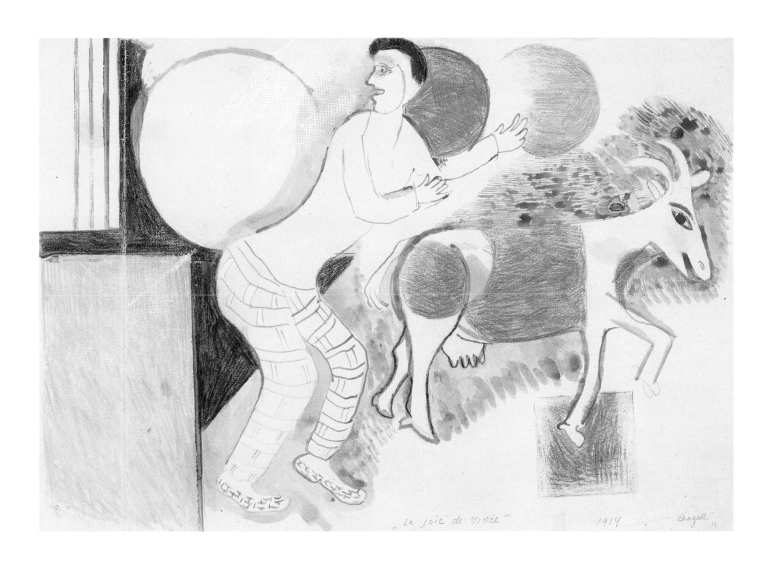

„La joie de vivre" 1914 Chagall

Le Violoniste, 1911–14
(*The Fiddler*)
Oil on canvas, 94.5 × 69.5 cm
Kunstsammlung Nordrhein-Westfalen, Düsseldorf

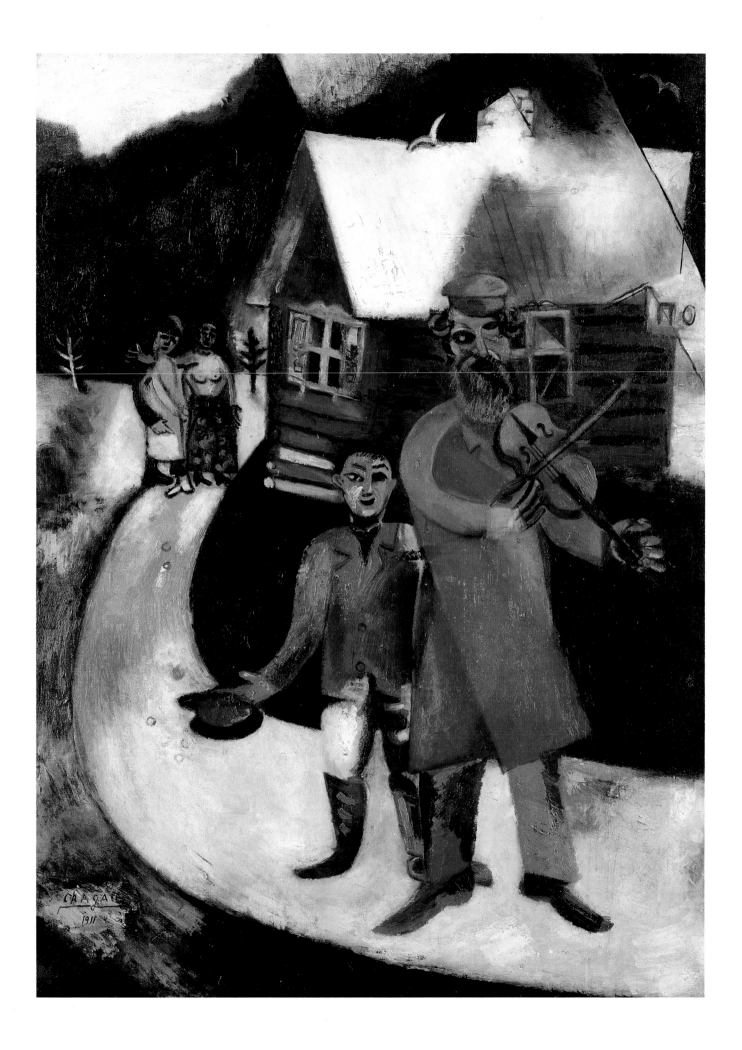

Return to Russia (1914–1922)

The war closed the borders on him, making a quick return to Paris impossible. He was to remain in Russia until 1922.

The painter rediscovered his native town as it was in reality. Paris had somewhat blurred its image. In 1914 and 1915, he executed an impressive series of what he himself termed his 'documents,' evocative of his family, the people around him, the town and the surrounding countryside. Being so far away from the world of his childhood had only made him more deeply aware of his attachment to it. The realisation left him profoundly moved.

He dedicated more works to the theme of the family: *Mother on the sofa* (plate 14), his brother *David* (plate 13) playing the mandolin.

In some of these paintings he has returned to a realism which makes the stylistic impact Paris had on him look like abstraction.

Lisa at the Window (plate 11) is yet another example. It is interesting to compare it with a picture in which Chagall has depicted *Lisa with a Mandolin* (plate 10). There the arrangement of forms in space, the geometric character of some elements and the vivid colour attest to an idiom which has interpreted and assimilated the lessons of Fauvism and Cubism.

La Maison bleue, 1920
(*Blue House*), detail

From this period there are also quite a number of portraits of elderly Jewish men: rabbis and other representatives of the Jewish community at Vitebsk, *Study for the Green Fiddler* (plate 22) and an entire series of views of the town, some from the window in his parents' room, others of the cathedral square with the *Bank of Moscow* (plate 12).

The reunion with Bella was an even more crucial event for Chagall; it set the seal on their deep love for one another.

Inspired by happiness, Chagall produced a series on the theme of loving couples. The earliest of these, dated 1914–1915, radiate passion in a dreamy glow. The couple in *Above the Town* (plate 15) is represented as so carried away that they float above Vitebsk. The picturesque detail and vivid tonality with which the town is depicted are in sharp contrast to the cooler colour and astringent angularity of the couple in the sky.

The second series, painted after their marriage in 1916, radiates fulfilment and consummation.

In the *Double Portrait with a Glass of Wine* (plate 27), Chagall perches on Bella's shoulders, lifting his glass to toast their love. The young woman is walking assertively above the town whilst a strange little purple person is

rubbing his companion's head. The gouache was painted much later, in 1922.

The same spirit informs the paintings executed after their daughter Ida was born in 1916.

In *Bella and Ida at the Window* (plate 16) mother and daughter are depicted in the country *dacha* which the Chagall family had taken for the summer. They spent the rest of that year in St Petersburg, where the painter gradually returned to the Russian art scene.

For the first time Chagall adopted an illustrative style in the little preliminary sketches for a mural he was planning to decorate a Jewish school in St Petersburg. In addition to depicting scenes of family life, such as *The Pram* (plate 18), he devoted himself to illustrating the various everyday events and feast days in Jewish life: *The Feast of Tabernacles* (plate 17) and *Purim* (plate 19).

Several large compositions, like *The Cemetery* (plate 23) and even more importantly, *Grey House* (plate 24), date from 1917. These turbulent canvases reveal the emotional tensions which stirred the painter during the autumn of the Russian Revolution.

What is more, Chagal took an active part in the great adventure that was the Revolution. In 1918 he became Fine Arts Commissar in the Vitebsk provincial administration.

By 1920 the only option he had left was to leave Vitebsk. In *Blue House* (plate 25) Chagall immortalized the town which he was not to see again for so many years. This is a far cry from the anguish of *Grey House* (plate 24). Here the painter offers us a more harmonious vision. The subtlety of tone distinguishing the handling of white walls and roses and the red roofs of the churches and monasteries is reflected in the dark waters of the Dvina. There once again a little bouquet of flowers delicately painted at the bottom of the picture makes the extraordinary blue of the *isba* sparkle. This house, with its rather chaotic arrangement of the round ends of the logs, is counterbalanced by the low brick wall in the foreground, "a distant guest at the daily banquet of sun and light...."[3]

Chagall's great disappointment "in the Revolution," as well as the fact that he was being increasingly obviously 'blackballed' by avant-garde artists like Malevich and Kandinsky, drove the painter to consider exile in the West.

During the summer of 1922, Chagall managed to leave his country and return to Paris after a stay in Berlin and a trip which was to take his family all the way to the Black Forest: *Bella in the Black Forest* (left).

Bella en forêt noir
(Bella in the Black Forest), 1922

3 Guerman, p. 155

53

Lisa à la Mandoline, 1914
(*Lisa with Mandolin*)
Oil on cardboard on canvas, 38 × 49 cm
Private collection

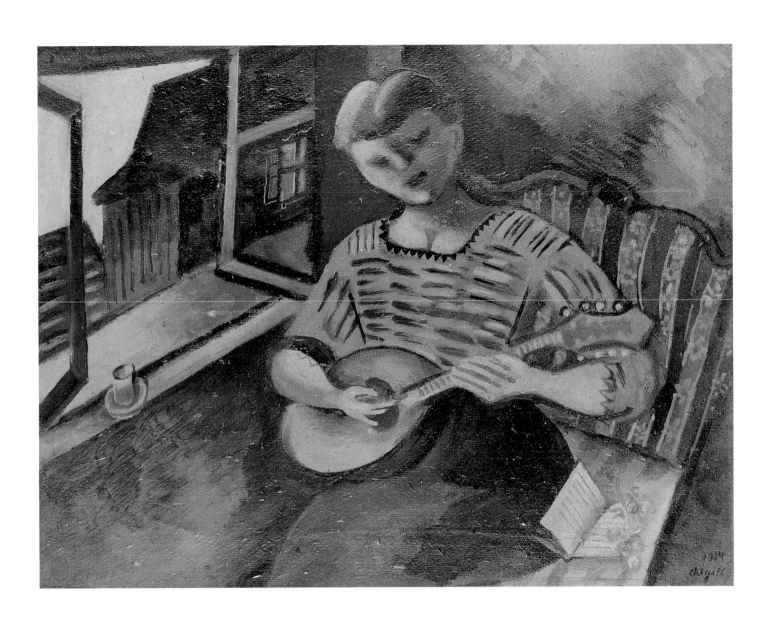

Lisa à la fenêtre, 1914
(*Lisa at the Window*)
Oil on canvas, 79 × 46.5 cm
Private collection

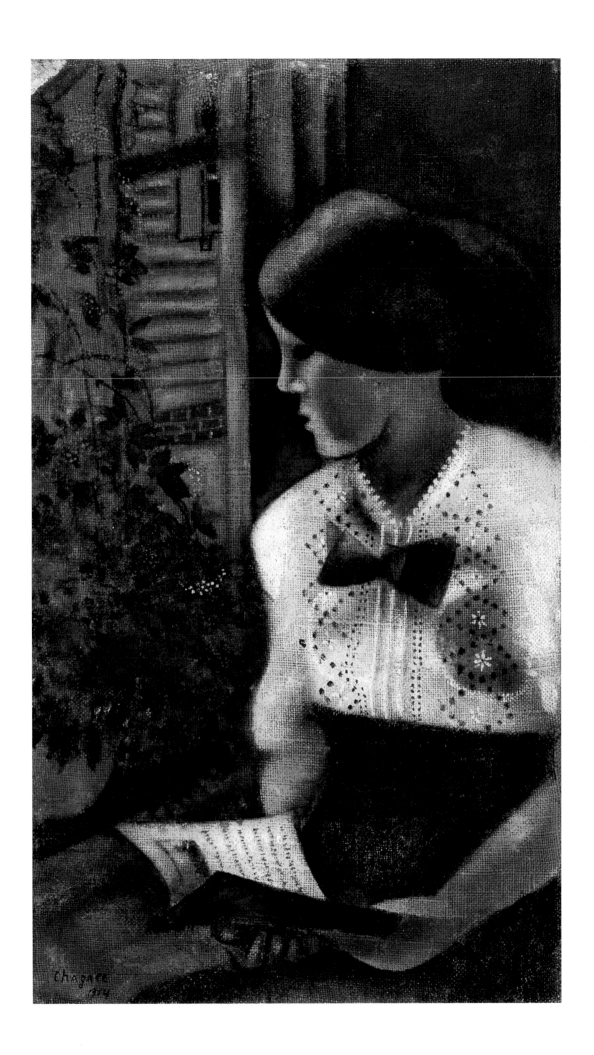

La Banque de Moscou à Vitebsk, 1914
(*The Bank of Moscow at Vitebsk*)
Oil on paper on canvas, 47.5 × 37.5 cm
Private collection

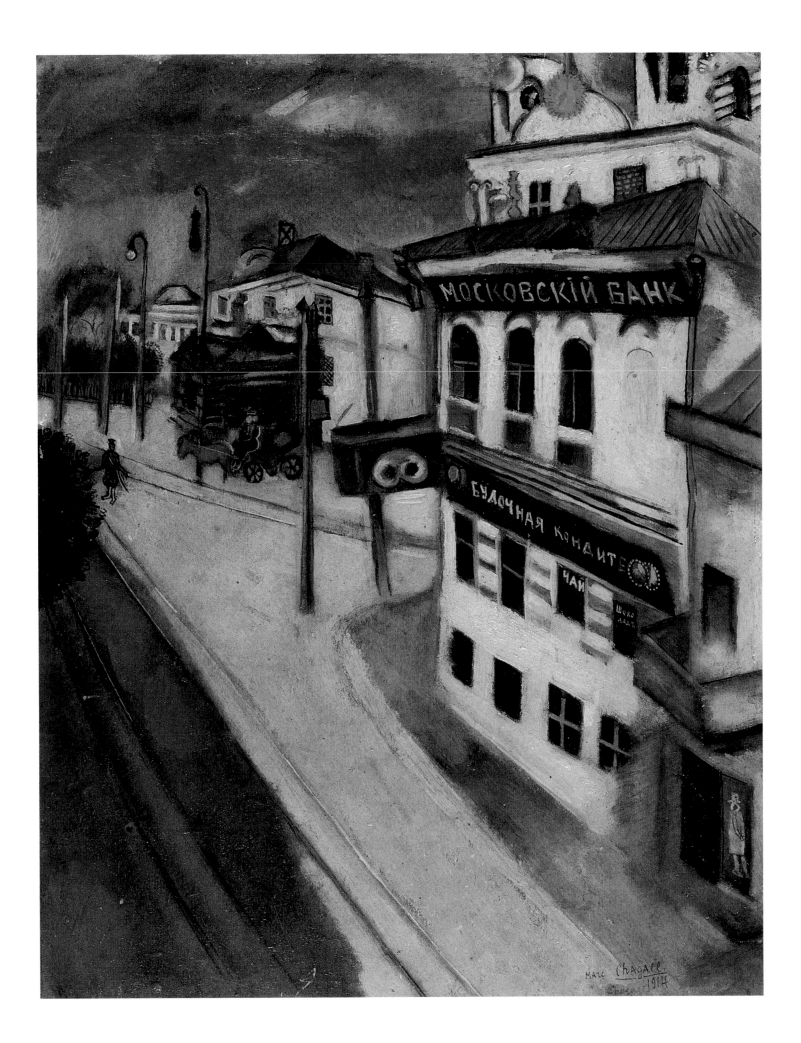

David, 1914
(*David*)
Oil on canvas, 50 × 37.5 cm
Private collection

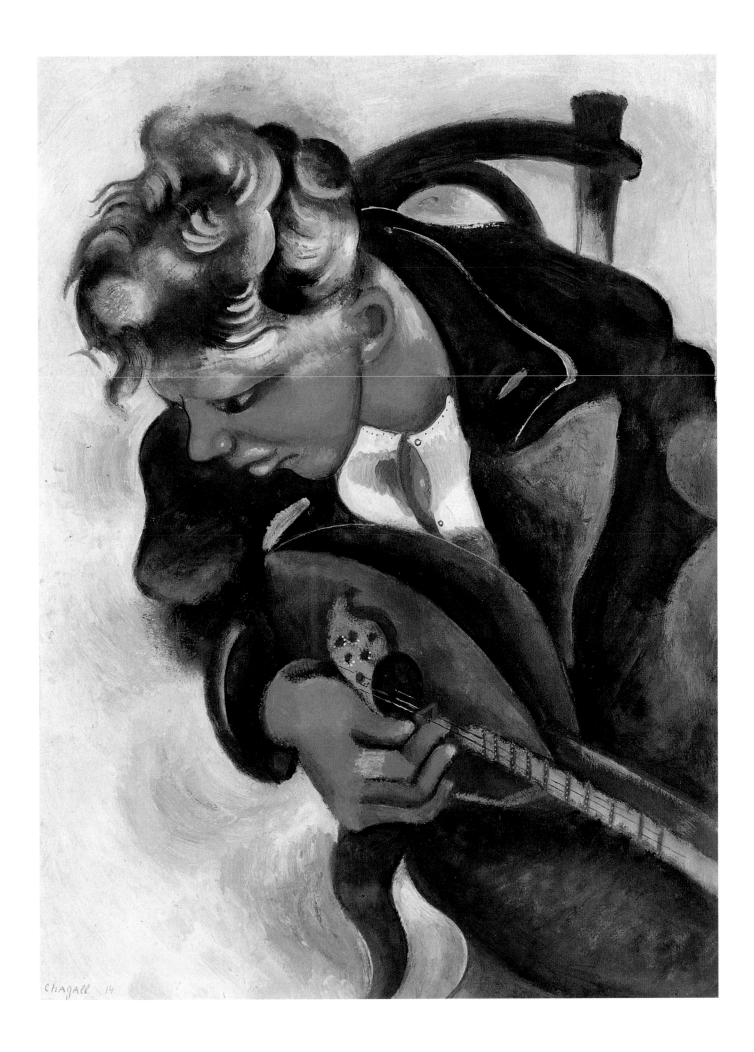

La Mère sur le divan, 1914
(*Mother on the Sofa*)
Oil on canvas, 37.5 × 50 cm
Private collection

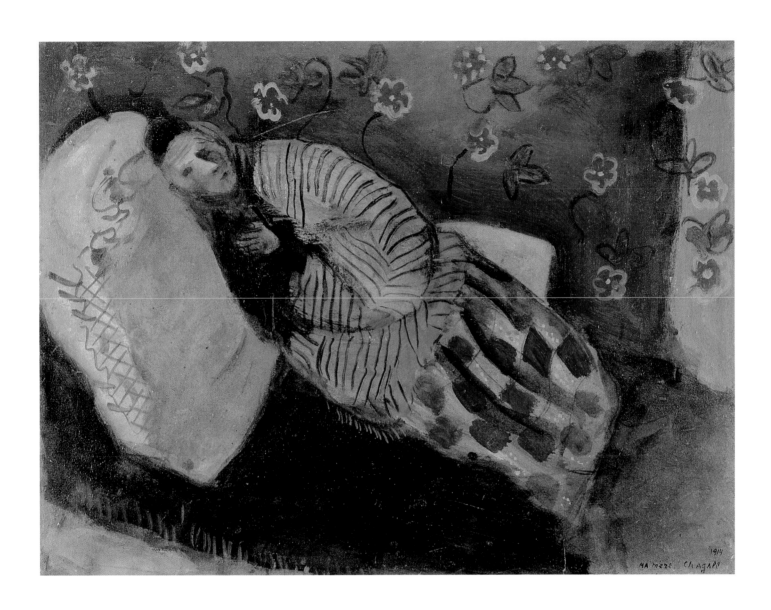

Au-dessus de la ville, 1915
(*Above the Town*)
Oil on canvas, 48.5 × 70.5 cm
Private collection, Japan

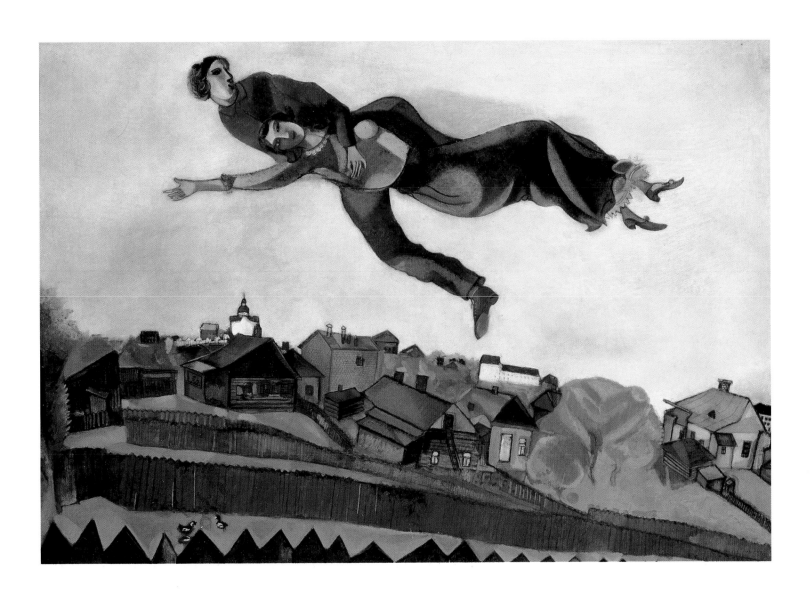

Bella et Ida à la fenêtre, 1916
(*Bella and Ida at the Window*)
Oil on paper on canvas, 56.5 × 45 cm
Private collection

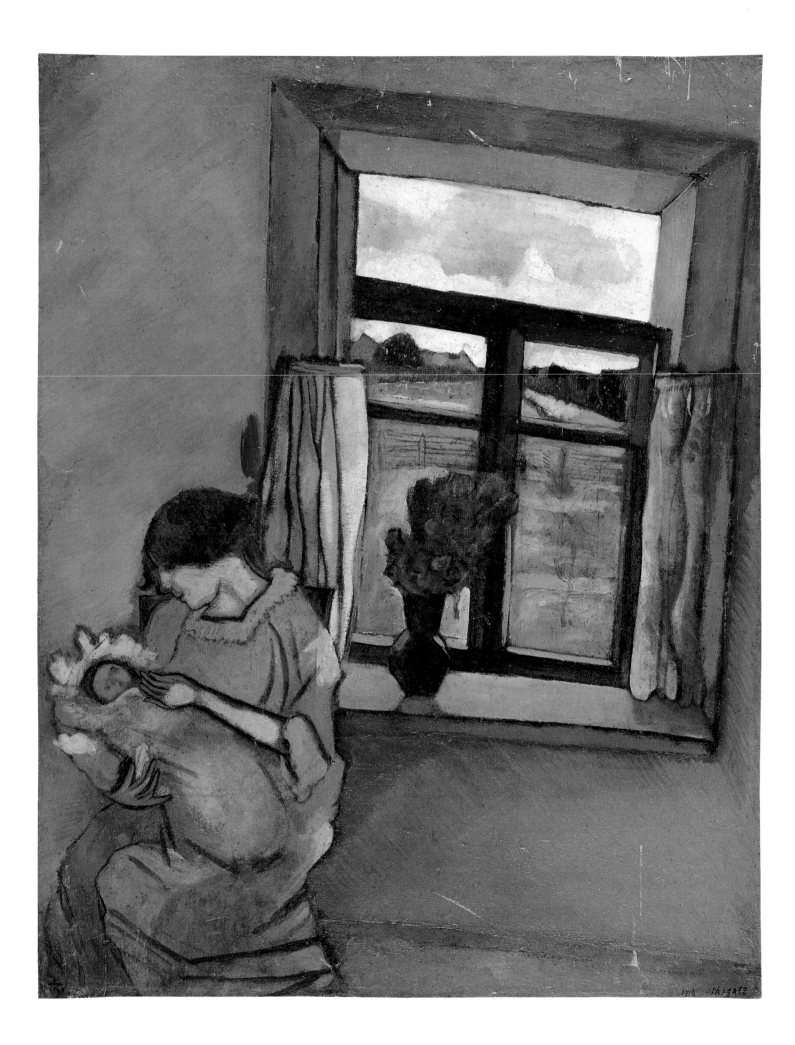

La Fête des Tabernacles, 1916
(*The Feast of Tabernacles*)
Gouache on paper, 32 × 40 cm
F. Weiss Collection, Los Angeles

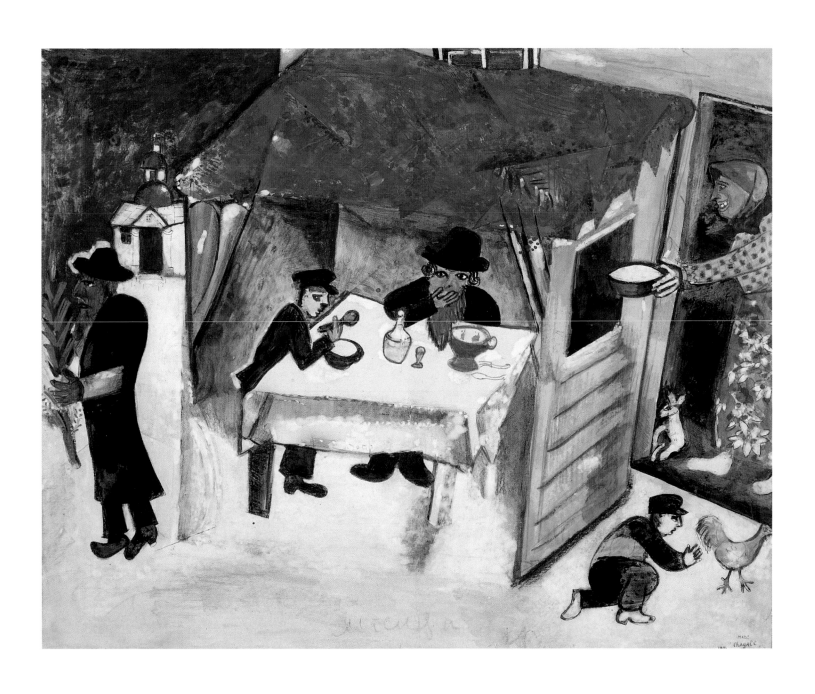

La Voiture d'enfant, 1916–17
(*The Pram*)
Pencil and watercolour on paper, 46.5 × 63 cm
Private collection

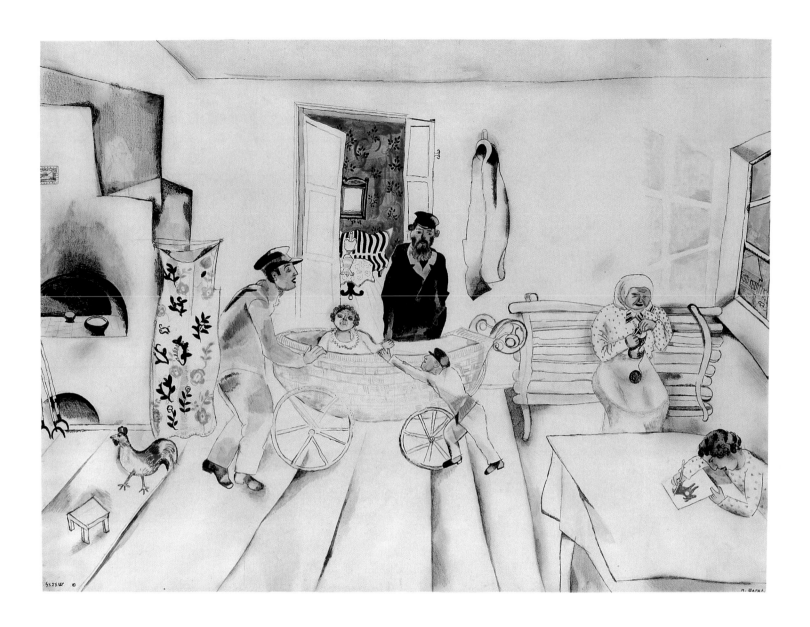

19

Pourim, 1916–17
(*Purim*)
Wash drawing with ink on paper,
47.5 × 64.5 cm
Private collection

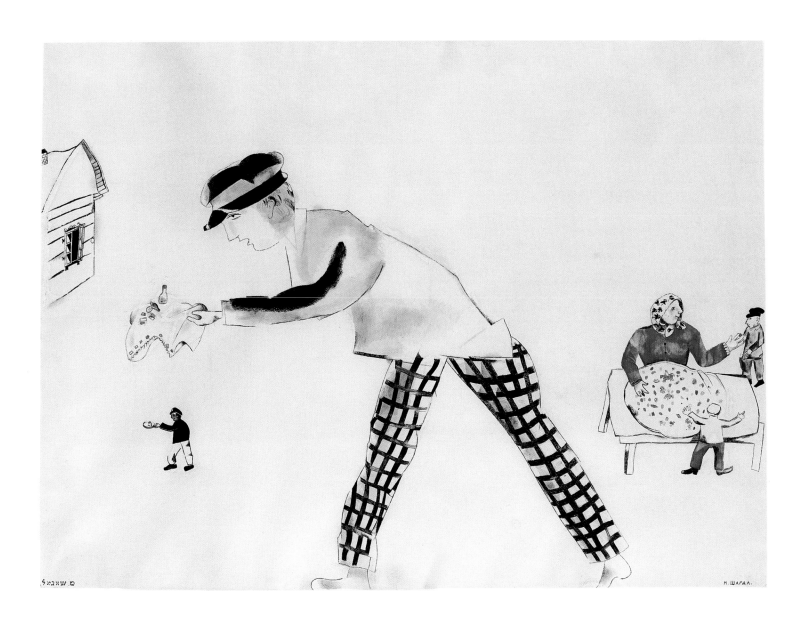

Autoportrait, 1917
(*Self-Portrait*)
Pen-and-wash drawing, 18.5 × 14.5 cm
Private collection

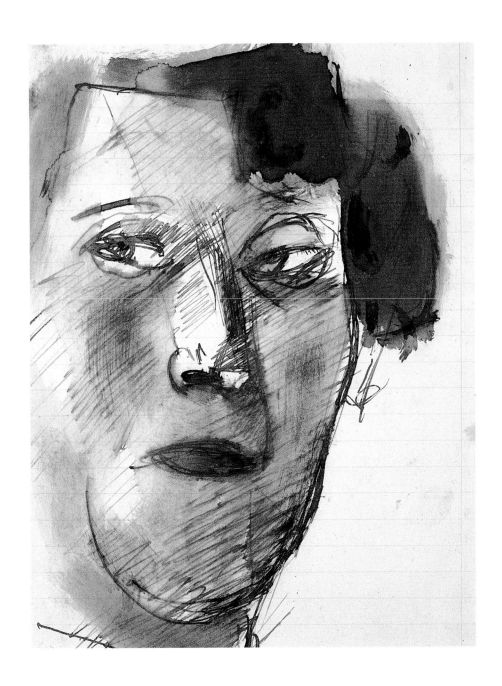

Autoportrait, 1918
(*Self-Portrait*)
Gouache on paper, 12.4 × 10.8 cm
Private collection

Etude pour le violoniste vert, 1917
(*Study for Green Fiddler*)
Pencil and watercolour on paper, 32 × 22 cm
Private collection

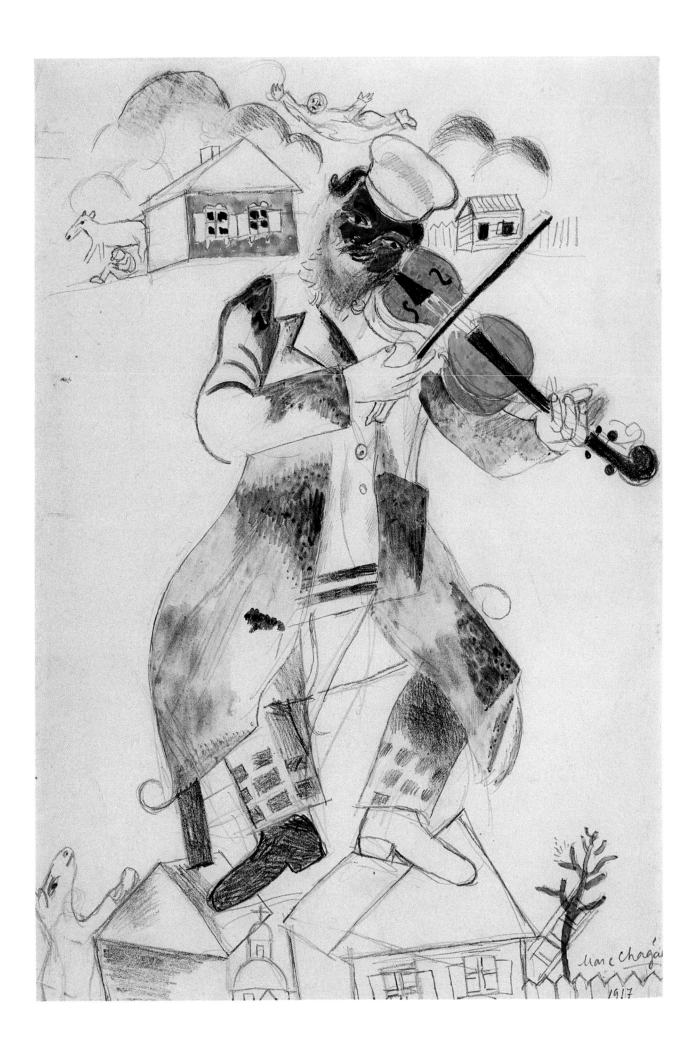

23

Cimetière, 1917
(*Cemetery*)
Oil on canvas, 69.3 × 100 cm
Musée national d'Art moderne,
Centre Georges Pompidou, Paris

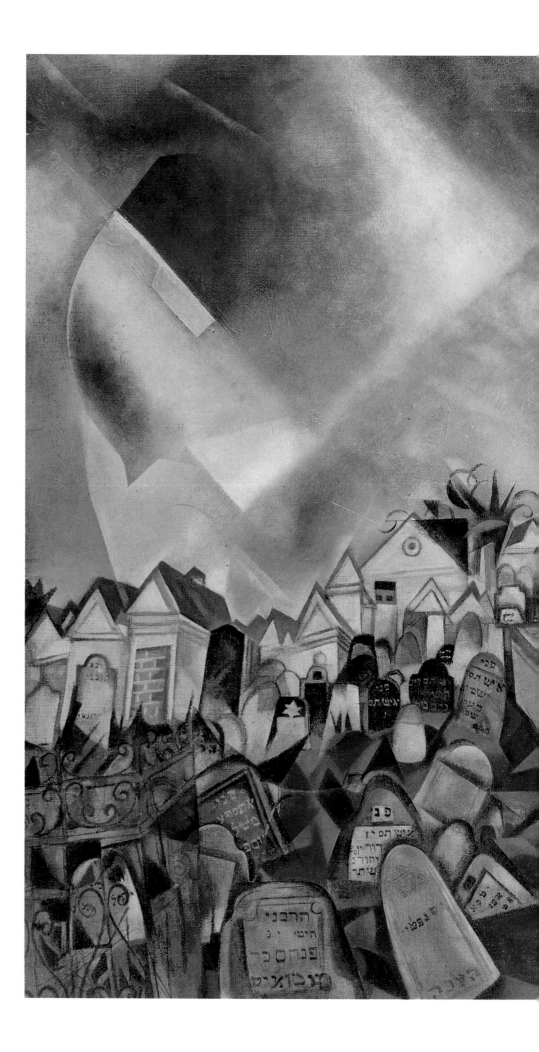

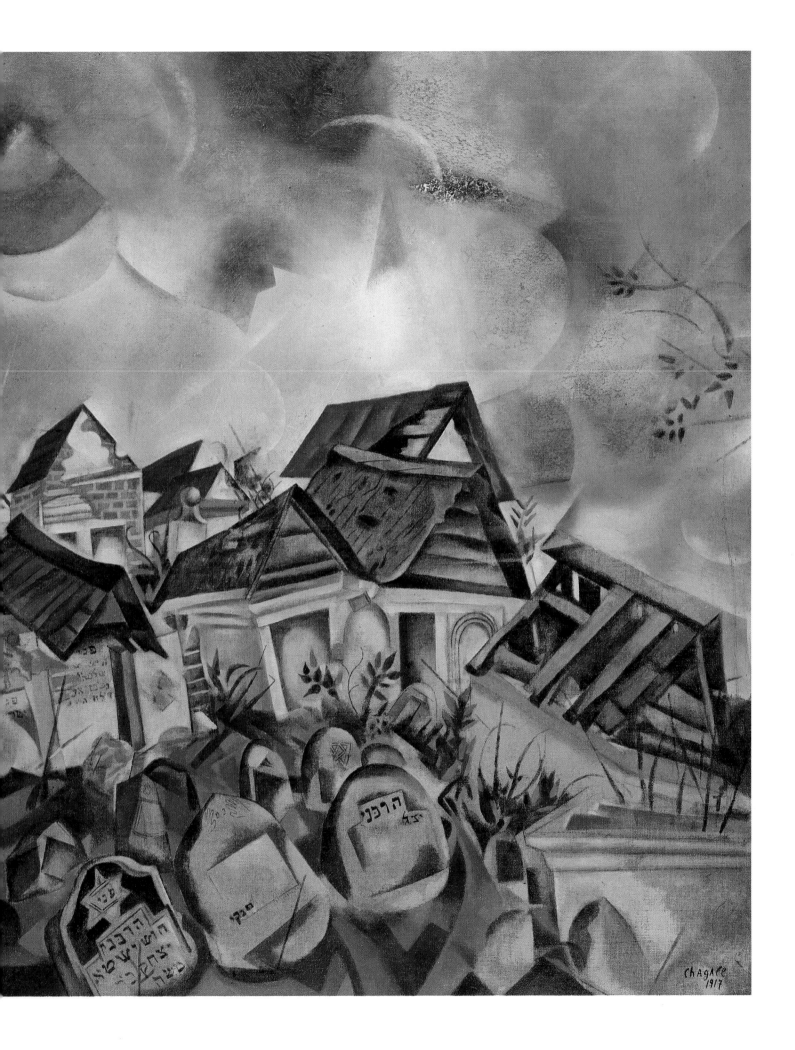

La Maison grise, 1917
(*Grey House*)
Oil on canvas, 68 × 74 cm
Stiftung Thyssen-Bornemisza Collection, Madrid

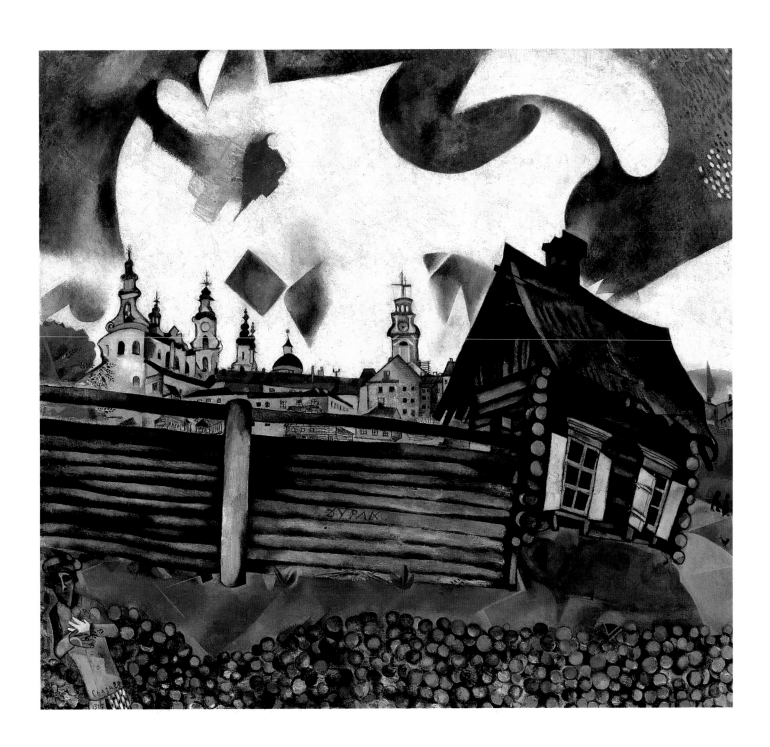

La Maison bleue, 1920
(*Blue House*)
Oil on canvas, 66 × 97 cm
Musée d'Art moderne et d'Art
contemporain de la Ville, Liège

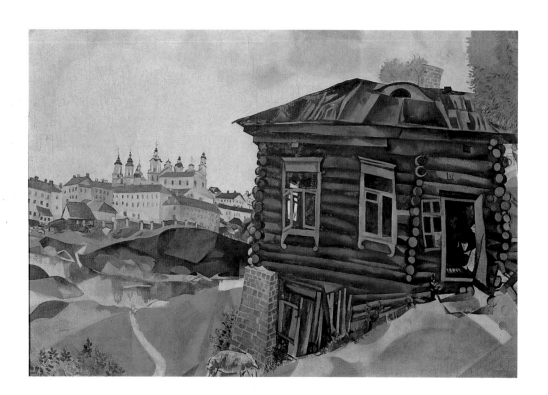

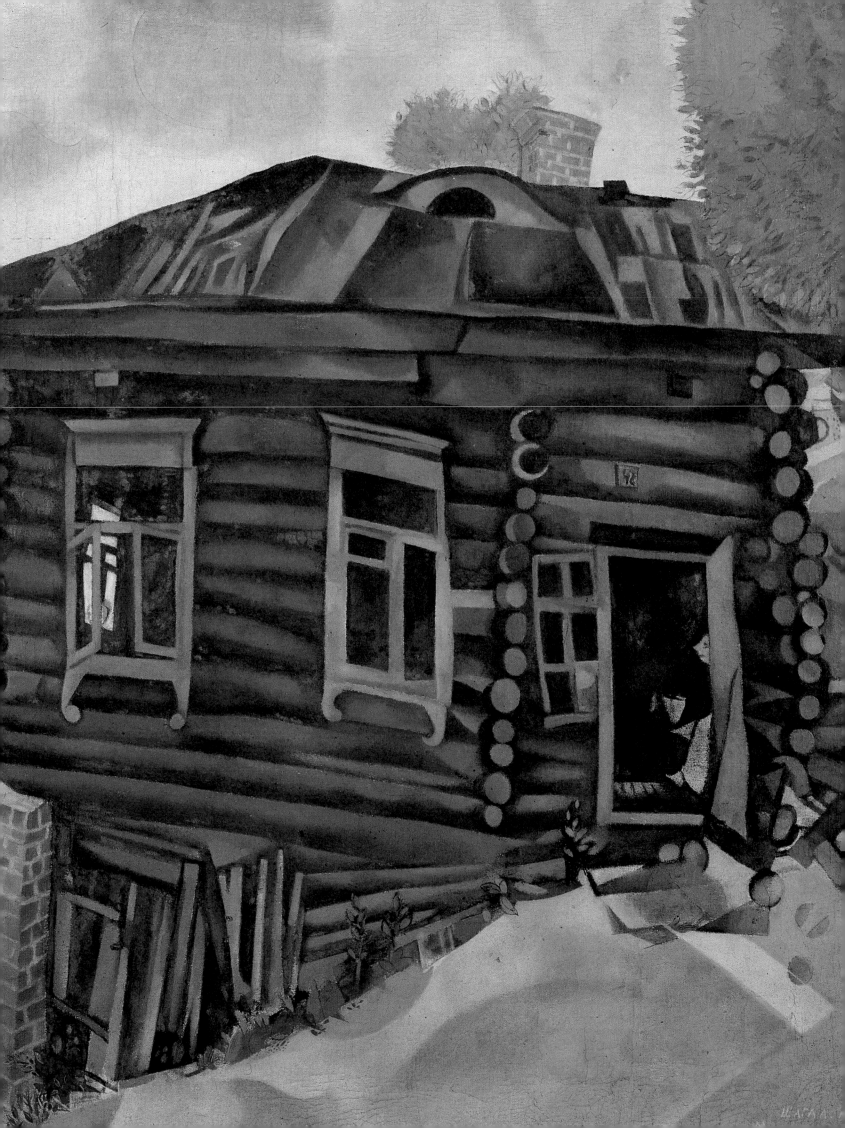

Nu, 1920–1930
(*Nude*)
Gouache and ink on paper,
29 × 44.5 cm
Private collection

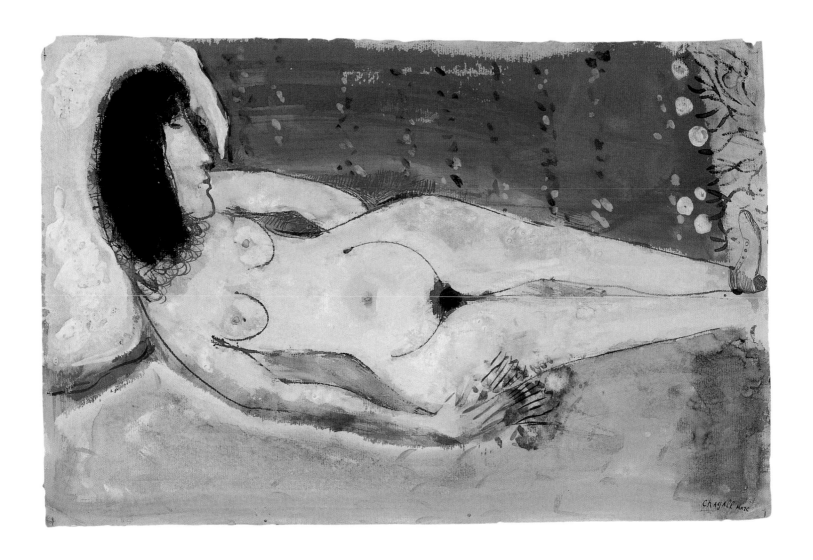

Le Double portrait au verre de vin, 1922
(*Double Portrait with Glass of Wine*)
Gouache on paper, 42.8 × 24.4 cm
Private collection, Vienna

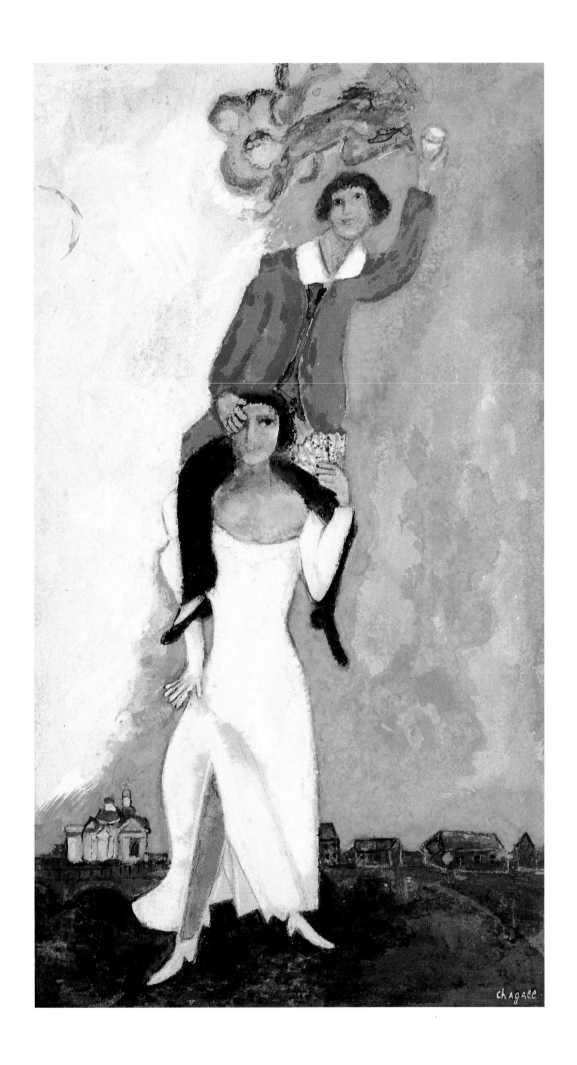

Exile and Creative Freedom in Paris (1923–1941)

August 1922 represents a radical new departure in Chagall's life and work, all the more so for the fact that the painter found almost none of the paintings he had left behind there in 1914.

Since his work and the studies he had done during the four years of his first stay in Paris had vanished, Chagall thought it absolutely essential to reconstitute his past, the well-spring of his art, so he painted his old canvases a second time either from memory or from reproductions. Thus he made reproductions, replicas or variants, all of them faithful to his Russian subject matter.

In Paris Chagall once again encountered 'that spirit of liberty' so conducive to creativity. Now he was working in a real studio and his living conditions improved steadily. He exhibited his work, echoing his early success, and built up a vast network of connections. Paris was good for him.

As for his vision of life, his work of the period radiates a feeling of fulfilment. In the 1924 *Double Portrait* (plate 28), the couple is shown hieratically in profile. Chagall remains in the shade which has intruded into the background of the picture space. Glowing at his side, Bella in an immaculate white dress illuminates the scene. His palette echoes the splendid bouquet of red roses Bella is holding. The painter at his easel is celebrating his beloved and his muse.

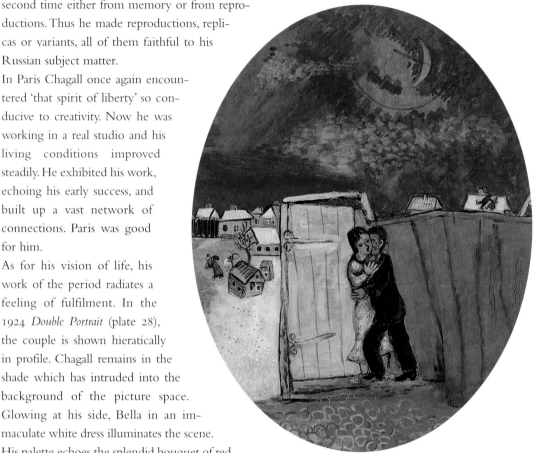

Clair de lune, 1926
(*Moonlight*), detail

In this period he took lovers as his motif, suffused with a glow of tenderness, as they are in a gouache dated 1926, *Moonlight* (plate 29), and in a picture drawing on an early theme. The painter's interpretation of this couple is unfettered by the constraints of logic. In *The Stroll* (plate 32), Chagall is holding Bella by the feet.

The joy of living is also rampant in works like *Ida Clown* (plate 30) or *Bride with Two Faces* (plate 31), belonging to the series called 'Vollard Circus', another series with a circus theme painted for Vollard from 1927 or again, *On the Cock* (plate 33), with its fantastic symbolism. Here the lover has been replaced by a cock.

To the juxtaposition of unreal motifs with confusion reigning from top to bottom, differences in scale have been added, as in *Nude above Vitebsk* (plate 34), where a large nude figure viewed from the back is floating above the town in the cold light of a grey sky. This was a period of supreme happiness for Chagall and Bella. Those were rewarding years,

notable for encounters with other artists – Georges Rouault, Pierre Bonnard, Maurice de Vlaminck, Aristide Maillol, Pablo Picasso – as well as art critics and poets – Eluard, Supervielle, Schwob. Ties with Russia remained close and numerous Russian intellectuals came to visit them.

Chagall also became totally involved in large compositions. Begun in 1933, they were not finished until a dozen years later. One of them was *Dedicated to My Wife*. The painting was ultimately cut in two in 1943 and separately finished under two different titles, of which *To My Wife* (1933–1944) (plate 37) is one.

These years of carefree happiness and increasing professional success were rudely interrupted around 1932. The way Chagall viewed this era began to change. It was indeed a bleak time of economic crisis, which would see the development of fascism and anti-Semitism in Germany and in Europe at large and soon the outbreak of civil war in Spain.

His work grew more serious in tone. New subject matter came into play, as in *Revolution*, a large composition dated 1937. Chagall worked on it for a long time after completing a number of preliminary studies for it: *Study for the right panel of Revolution* (see page 26). Chagall divided the painting into two halves, one of which he entitled *Resistance* (plate 41) and the other *Liberation* (plate 43). A third picture, *Resurrection* (plate 42) is added later and it is only some years after the end of the war that all three paintings we are completed.

Double portrait, 1924
(*Double Portrait*)
Oil on canvas, 130 × 100 cm
Nagoya City Art Museum, Nagoya, Japan

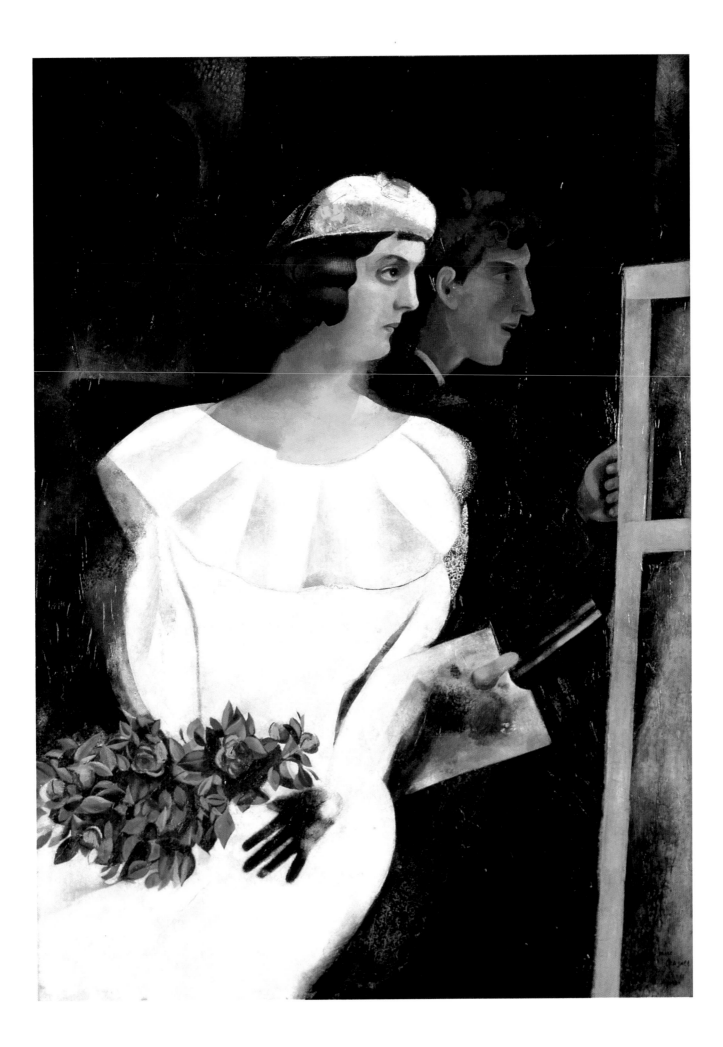

29

Clair de lune, 1926
(*Moonlight*)
Watercolour and gouache on paper,
66.5 × 51.2 cm
Musées royaux des Beaux-Arts de Belgique,
Brussels

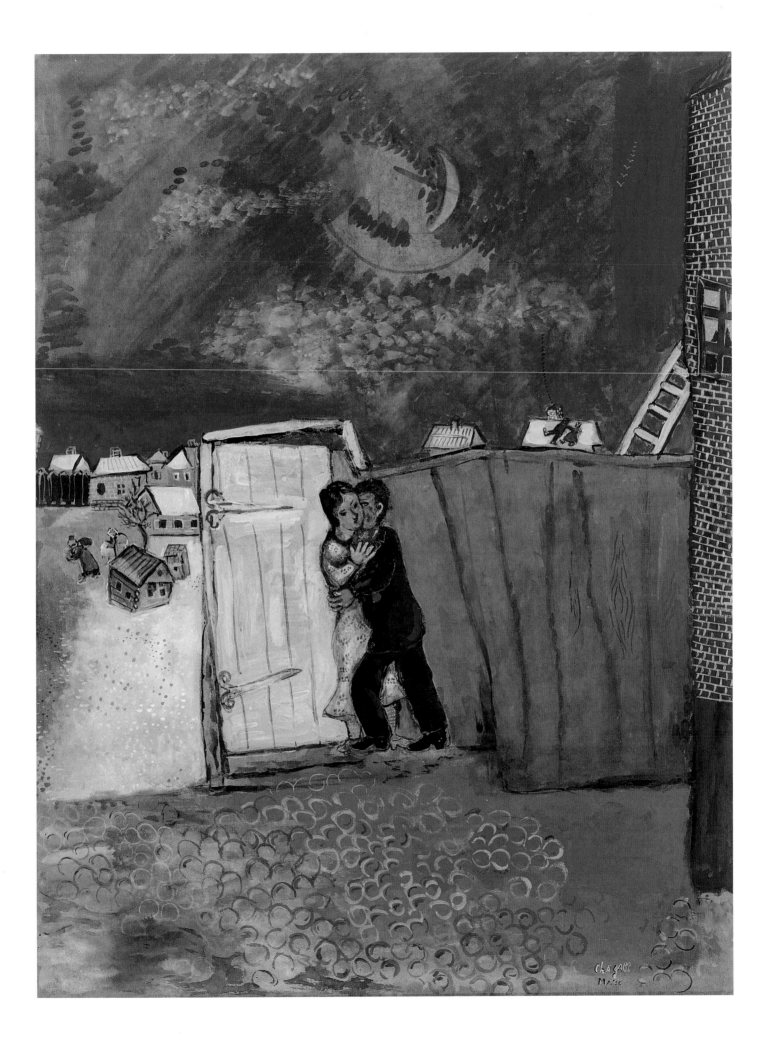

Ida clown, 1927
(*Ida Clown*)
Watercolour and ink on paper, 27 × 21 cm
Private collection

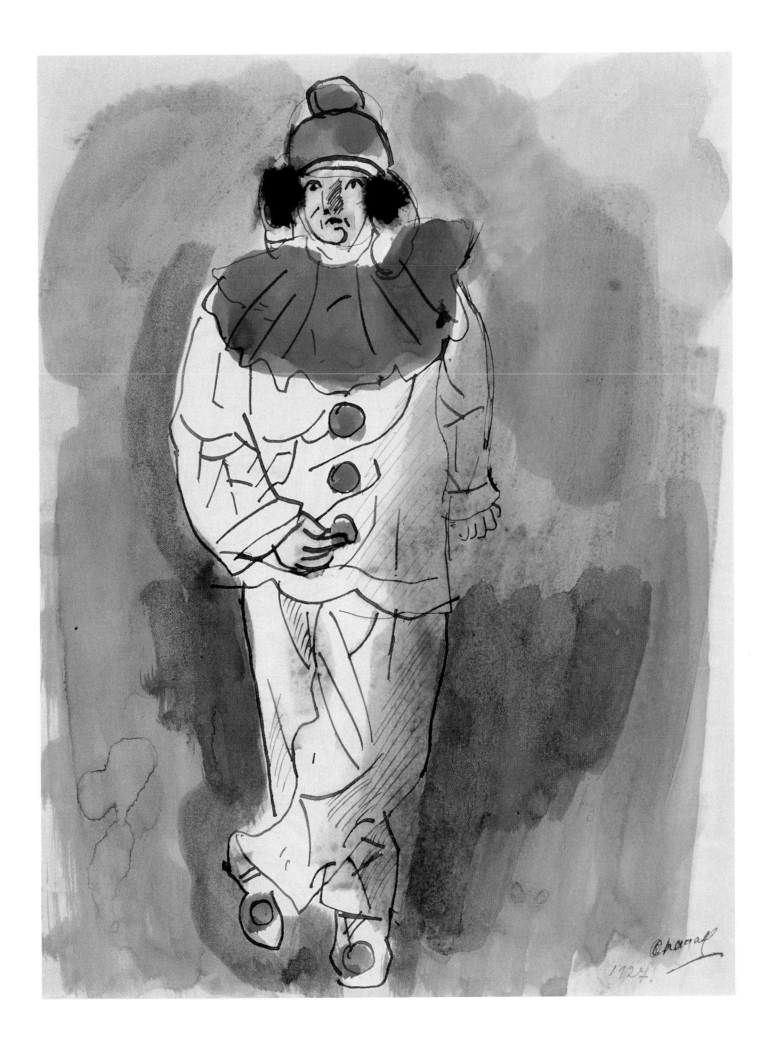

La Mariée à double face, 1927
(*Bride with Two Faces*)
Oil on canvas, 99 × 72 cm
Private collection

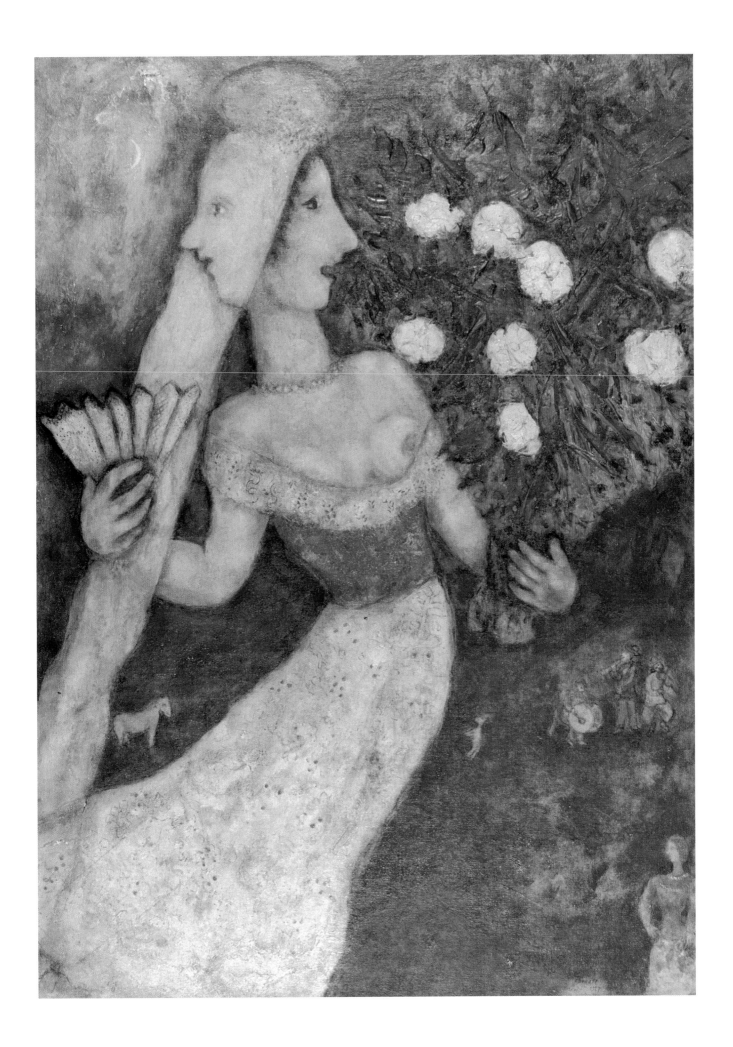

La Promenade, 1929
(*The Stroll*)
Oil on canvas, 55.5 × 39 cm
Courtesy Galerie Rosengart, Lucerne

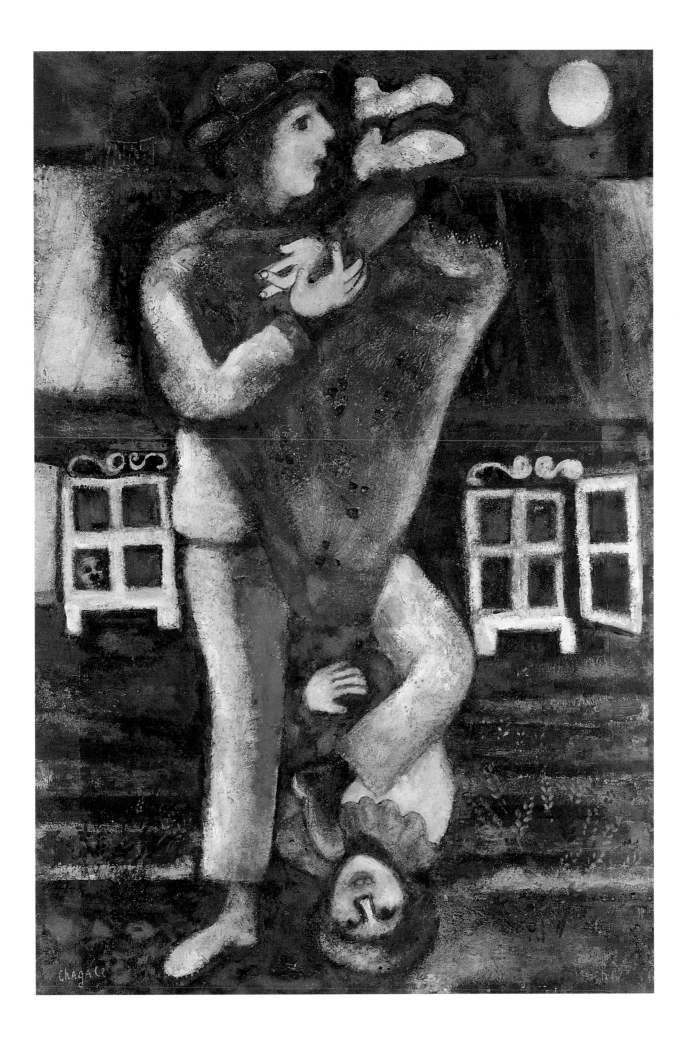

Sur le coq, 1929
(*On the Cock*)
Oil on canvas, 81 × 65 cm
Stiftung Thyssen-Bornemisza Collection, Madrid

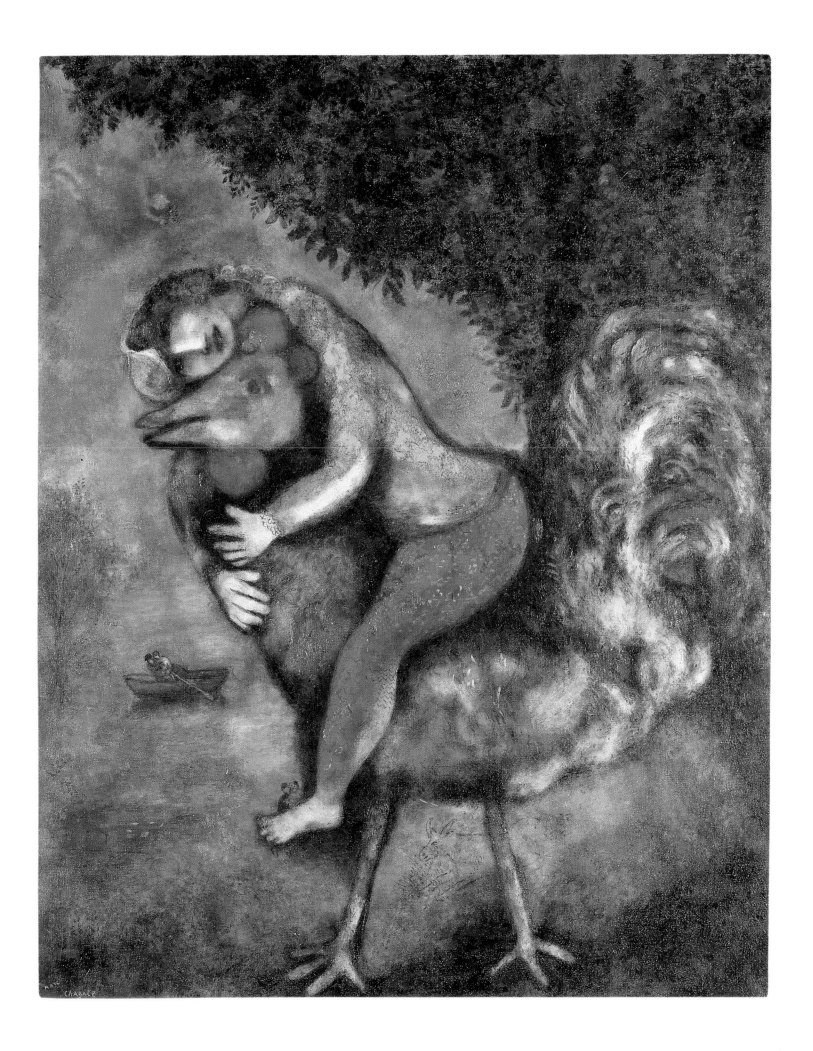

Nu au-dessus de Vitebsk, 1933
(*Nude above Vitebsk*)
Oil on canvas, 87 × 113 cm
Private collection

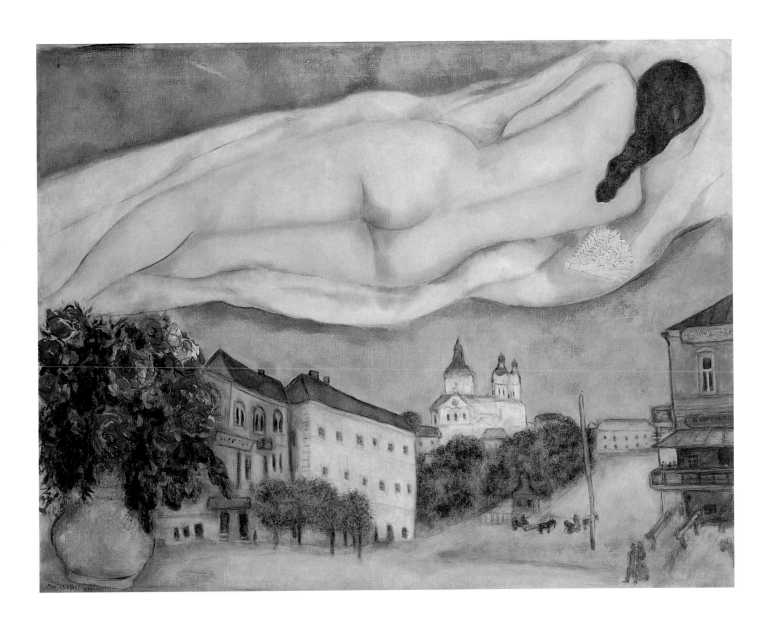

Bonjour Paris, 1941
Oil and pastel on cardboard,
62 × 46 cm
Private collection

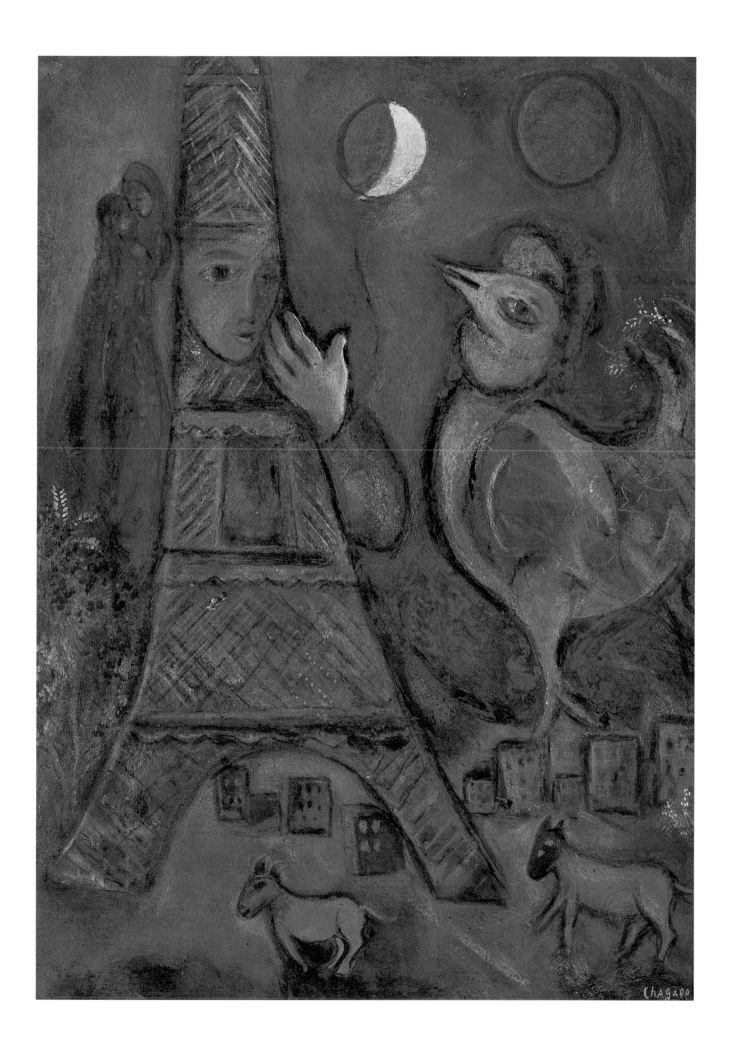

Exile in America (1941-1947)

When he went into exile, Chagall took his entire œuvre with him to New York. Many of the paintings begun at Gordes were finished in America but there is no noticeable break with the past in the stylistic development and iconography of his American work. *Bonjour Paris* (plate 35), 1941, is proof of this. Inwardly, Chagall's attachment to the country of his childhood was intensified following commissions for stage backdrops such as for Tchaikovsky's 'Aleko.' But this was a difficult time for the artist since his exile in America coincided with the outbreak of the Russian campaign which cast an ominous shadow over his country and his paintings.

At Dusk (plate 36), a painting begun in France in 1938 and finished in 1943, reveals the inner state of the artist confronted with the tragedy of the times. The work started as a self-portrait but was transformed in the course of extensive reworking. Before a winter landscape bathed in the cold light of the moon is the painter, holding a palette without colour on it. His face, a blue mask, has lost all trace of personality. His beloved, disembodied, rises from a band of blood red, her wan face joined to that of the man, forehead to forehead, nose to nose, mouth to mouth. Even the bizarre lost street lamp fails to relieve the terrible feeling of existential angst emanating from this work.

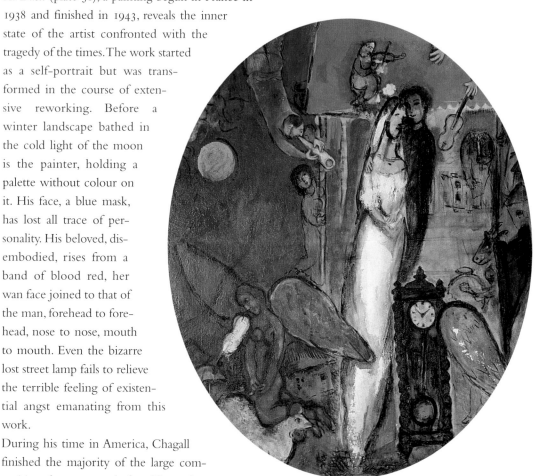

A ma femme, 1933-44
To My Wife (detail)

During his time in America, Chagall finished the majority of the large compositions begun years before. There they assumed definitive form. Some of them did so only after the artist returned to France in 1948. Uniting early elements and new features, these works acquired great density.

Thus Chagall set about painting the canvas *To My Wife* (plate 37), which he finished in 1944. The only real person in it, a young woman, is stretched on a vividly red sofa, gazing out at the viewer. Around her, by way of tribute, a number of motifs cherished by Chagall have been reduced to essentials: the huge bouquet of flowers before the Russian village which a donkey and a candelabra are flying over, a married couple, very slender, with an angel enfolding them, musicians, acrobats, a cock, a fish, not forgetting a winged clock.

The vastness and diversity of the American scenery inspired the artist to paint some landscapes remarkable for their serenity: *Rural Scene* (plate 39)

and *Green Eye* (plate 38). The latter canvas was simply another version of the left part of a bigger composition interpreting the motifs of *The Village and I* (plate 7) although it has been radically modified.

Early in September 1944, the violent death of Bella broke into this harmony with nature and the peace which the couple had found as refugees in America. She died just a few days after the liberation of Paris was announced at the end of August in 1944, assurance that the Chagalls that they would soon be returning to France, the country they regarded as their second home.

That year, 1948, Chagall finished some important canvases which he had been working on for a long time. *The Black Glove* (plate 40), which goes all the way back to the beginning of his second Paris period in 1923, is indeed symptomatic of this new approach. Bella's black glove lies abandoned on a white ground. A pair entwined, the painter and his muse, dominate a village street where the snow serves as a shroud for a diaphanous bride. The painter's easel is easy to spot; it has been transformed into a clock and above it, resting its head on Chagall's, rises a red cock. The complex ordering of this picture suggests waiting and nostalgia.

The painter also finished two of the panels of his *Revolution* triptych, *Resistance* and *Resurrection*, summing up his memories of Russia, the suppressed Revolution, and the war which had just battered all of Europe.

Entre chien et loup, 1938–1943
(*At Dusk*)
Oil on canvas, 100 × 73 cm
Private collection

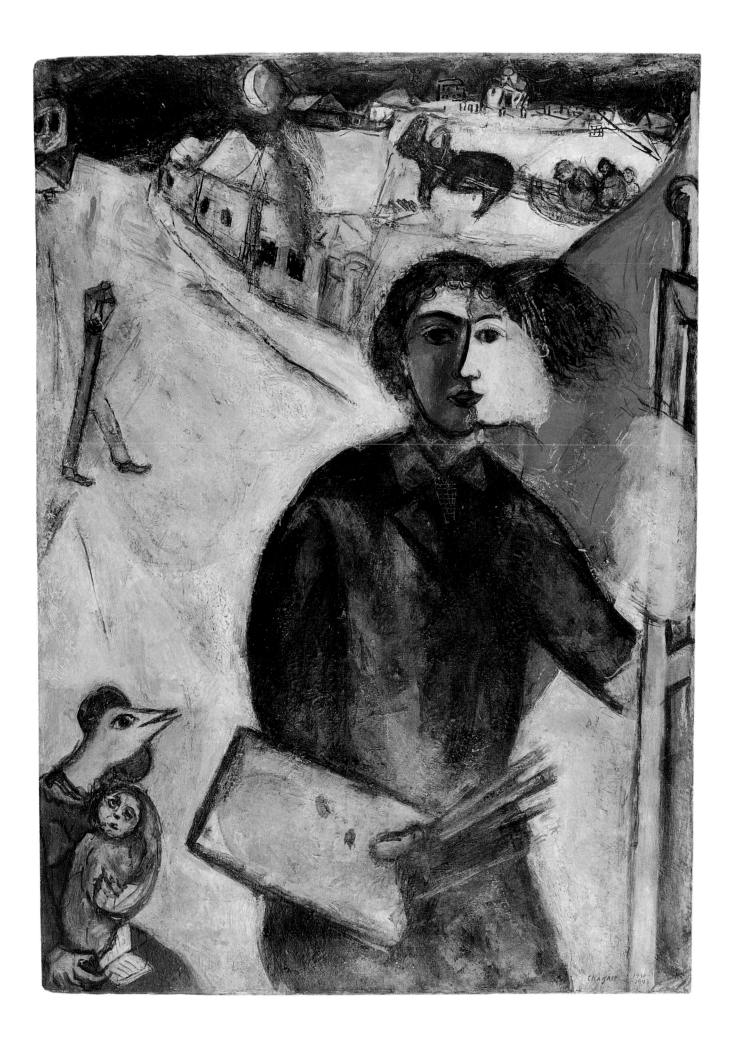

37

A ma femme, 1933–1944
(*To My Wife*)
Oil on canvas, 131 × 194 cm
Musée national d'Art moderne,
Centre Georges Pompidou,
Paris

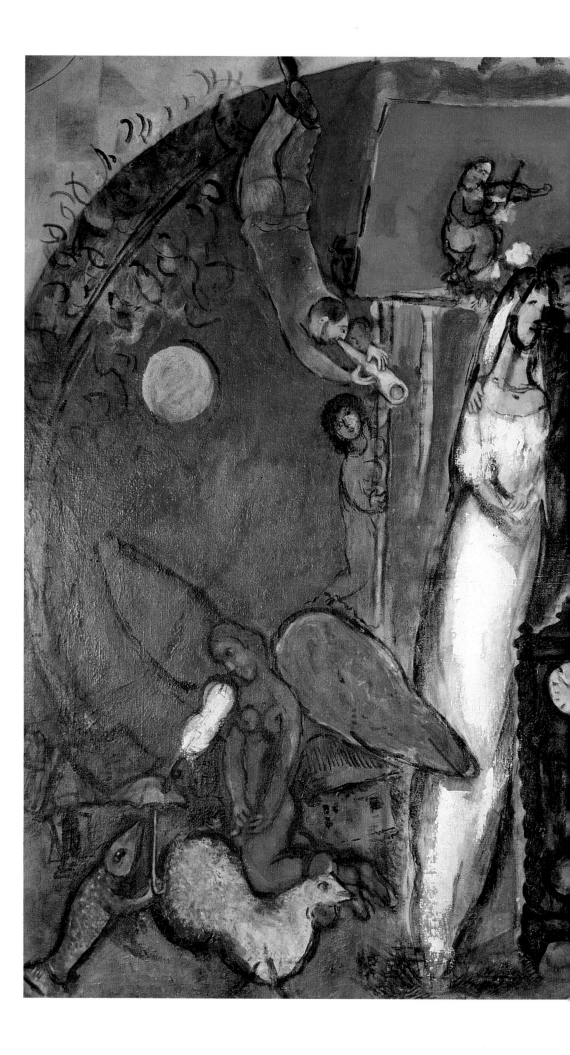

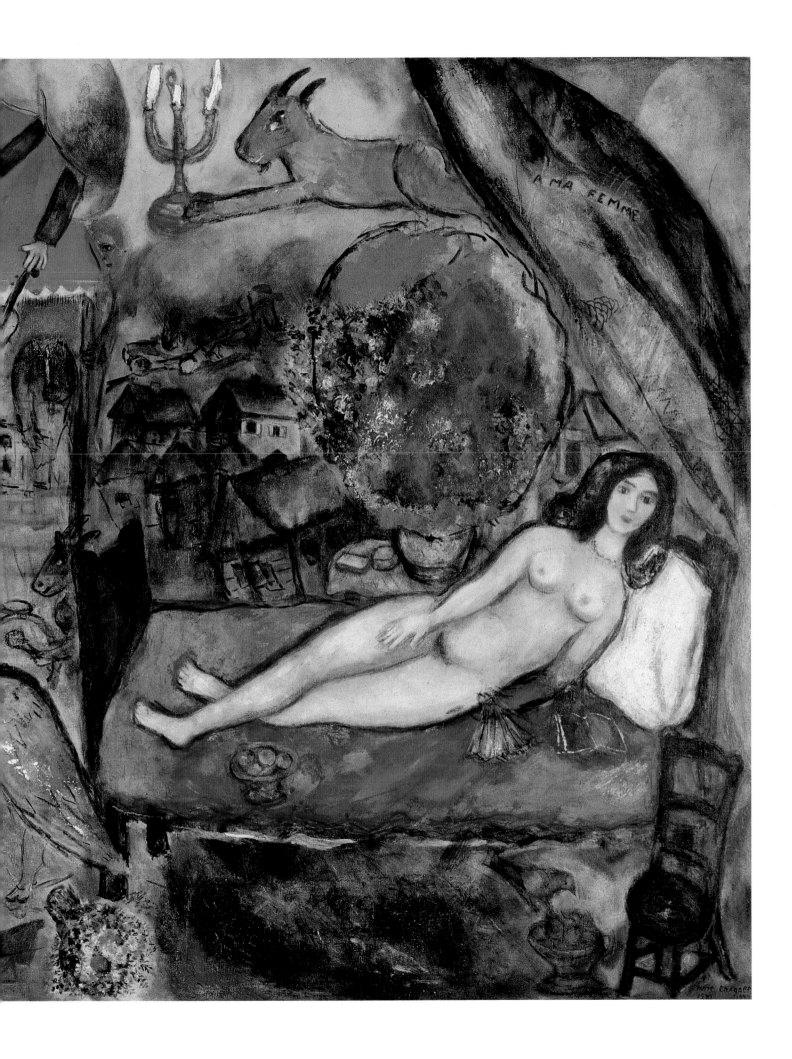

L'Œil vert, 1944
(*Green Eye*)
Oil on canvas, 58 × 51 cm
Private collection

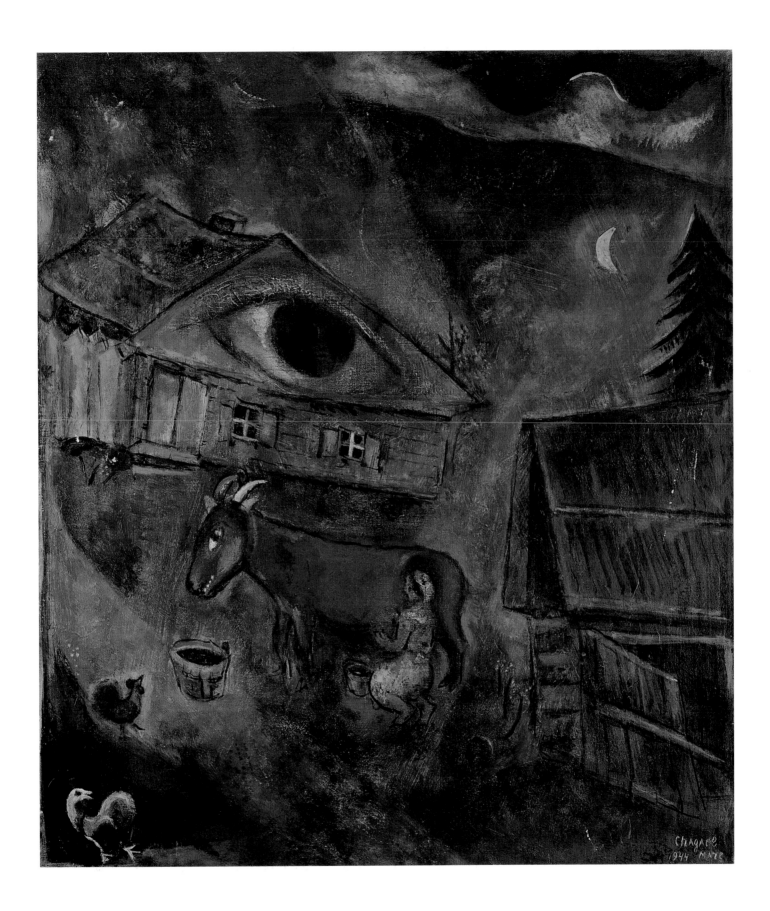

Scène champêtre, 1944
(*Rural Scene*)
Gouache on paper, 45 × 48.5 cm
Private collection

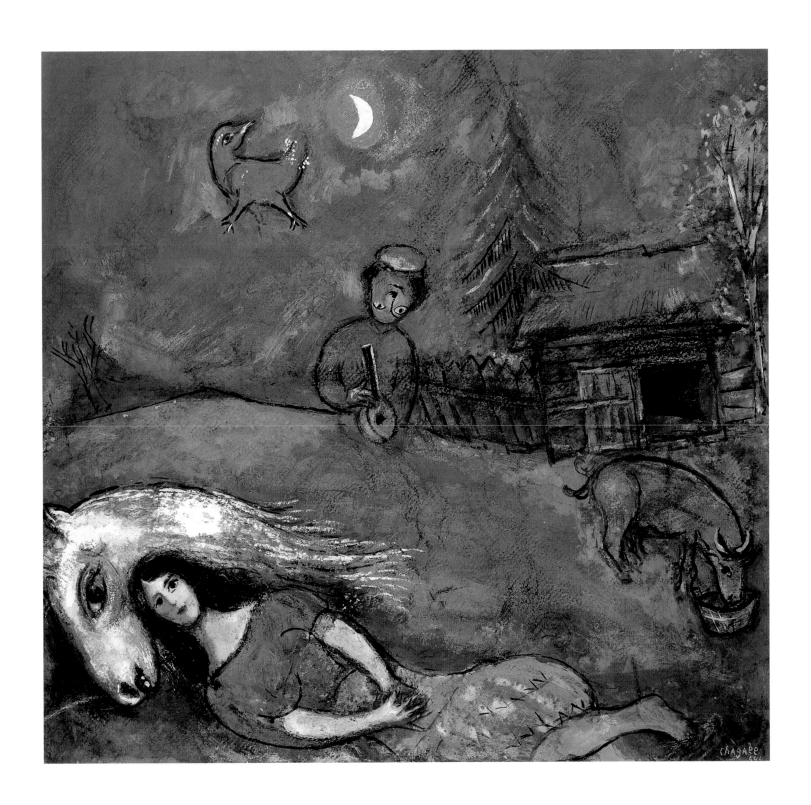

40

Le Gant noir, 1923–1948
(*Black Glove*)
Oil on canvas, 111 × 81.5 cm
Private collection

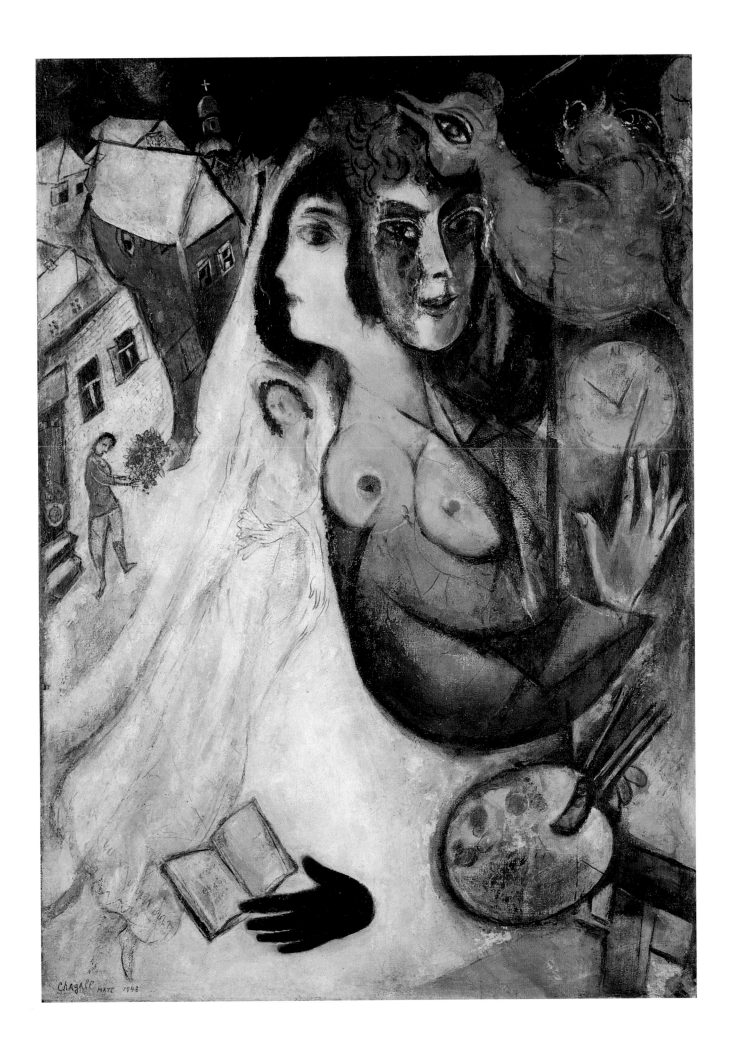

41

Résistance, 1937–1948
(*Resistance*)
Right wing of triptych
Oil on canvas, 168 × 103 cm
Musée national Message Biblique Marc Chagall, Nice

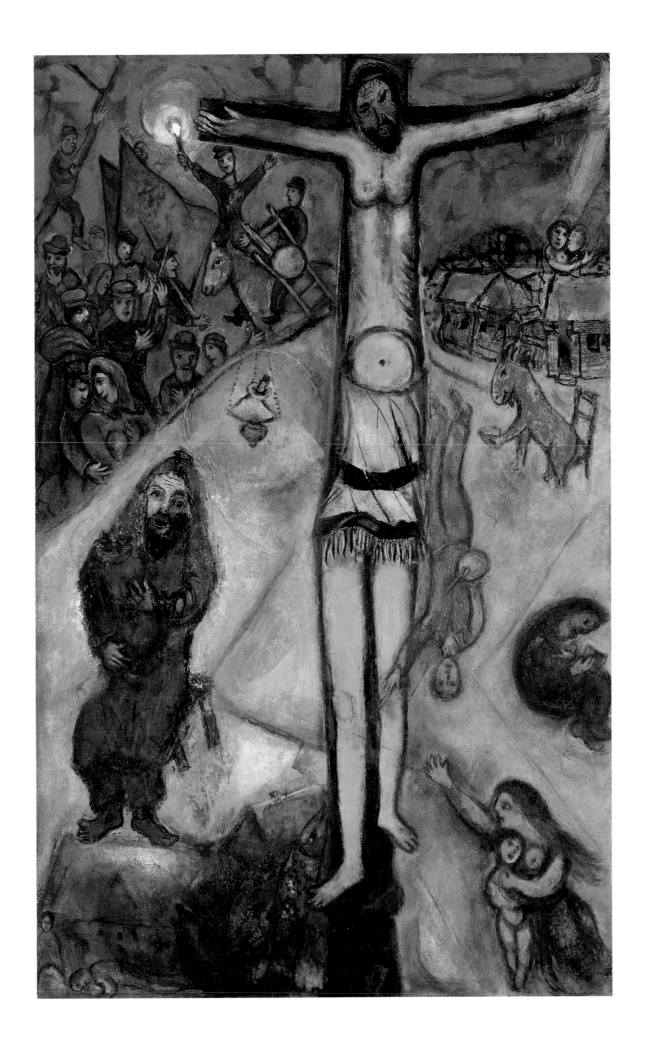

Résurrection, 1937–1948
(*Resurrection*)
Left wing of triptych
Oil on canvas, 168.3 × 107.7 cm
Musée national Message Biblique Marc Chagall, Nice

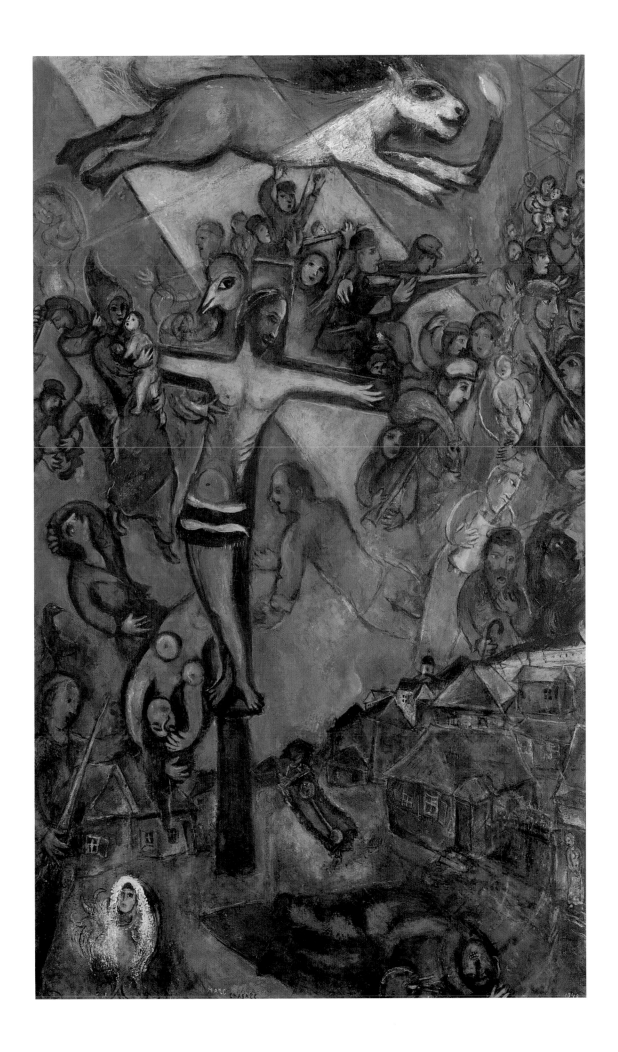

43

Libération, 1937–1952
(*Liberation*)
Central panel of the triptych
Oil on canvas, 168 × 88 cm
Musée national Message Biblique Marc Chagall, Nice

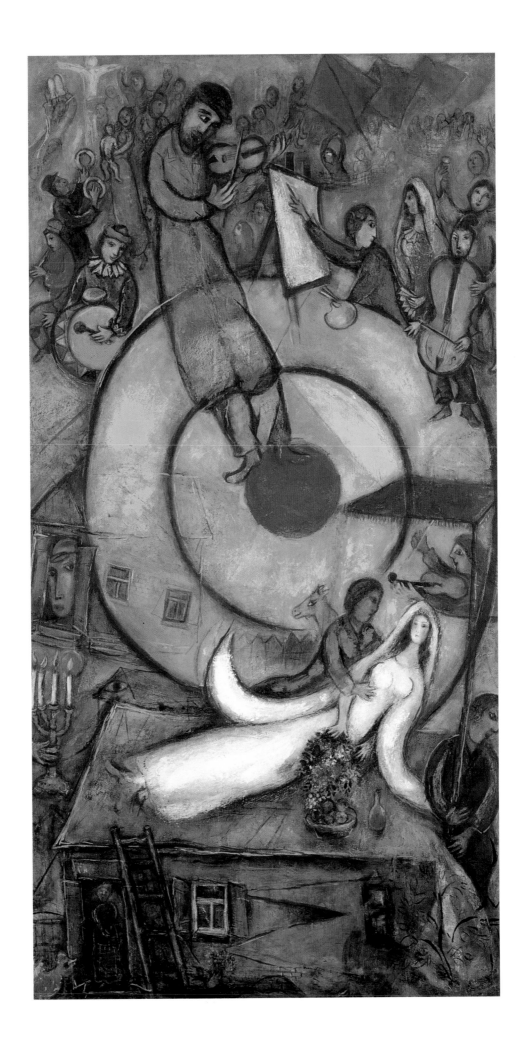

44

Les Deux Têtes, 1949
(*Two Heads*)
Pen-and-wash, gouache and pastel,
49 × 65 cm
Private collection

Return to France and the Mediterranean Years after 1948

By August 1948 Chagall was again in France and had settled down at Orgeval, near St Germain-en-Laye. At Orgeval the painter worked on two pictures he had begun at High Falls, maintaining the muted atmosphere of the *Clock with Blue Wing* (plate 45), a variation on an early motif.

With a flap of its wing, the clock floats above the Russian village. The pendulum has suspended its motion, time has been frozen for the loving couple sketched inside the clock. The whole is suffused in sombre colours. Black, blue and brown make the large blue wing and some vivid splashes of colour – the red of the flowers, the gold of the pendulum and the red ochre of the cock – look even more unreal by contrast. Being in a new setting at Vence, the village itself, the Mediterranean countryside with its lush vegetation and flowers and above all the intensity of the light would generate not only a renewal of form but also a further development of subject matter.

Some of these works still contain early motifs. The gouache *Evening at the Window* (plate 48), painted in 1950, reveals images of Russia associated with Jewish tradition.

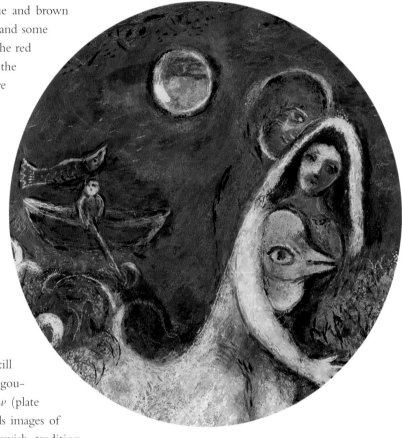

Rives d'amour, 1948–1950
(*Lovers' Banks*), detail

However, the memories of Vitebsk gradually fade to be replaced by more current motifs linked with life at Vence: *Bouquets of Flowers* (plate 62), *Lovers above Vence* (plate 59). Linked with trips to Greece: *Daphnis and Chloe* (plate 63), *Orpheus* (plate 72).

The other transformation to emerge at that time touches on the increasing importance of colour in Chagall's work. Colour gradually began to liberate itself from line and to encroach on the picture plane, generating both pictorial form and space.

"From my youth I've been seeking something which could spread out like a great river discharging itself upon distant and enticing shores."[4] *Green Night* (plate 56), *Large Face: Self-Portrait with Yellow Face* (plate 73).

To allow colour to triumph over line, and background over figures, Chagall sometimes resorted to monochrome: the picture rests on one underlying colour: *Bonjour Paris* (plate 35), *Village with Sombre Sun* (plate 54), *Green Night* (plate 56), *Couple in a Blue Landscape* (plate 74). Or again, he chose a polychrome formula which divides the canvas into

vehemently contrasting bands of colour: *Sunday* (plate 57), *Fiancée with Blue Face* (plate 64), *Shofar* (plate 79).

Chagall also began to opt more frequently for gouache, a more spontaneous and supple technique than oil.

Mauve Nude with Double Head (plate 70) exemplifies this tendency and represents a fresh look at the motif of bicephalism, which had already appeared in 1911: lovers reunited in one person with two dissociated heads which, like other loving couples are a literal expression of Chagall's love for Bella but also, symbolically, the function of his painting.

The year 1952 marks a new stage in Chagall's life: he met Valentina Brodsky. The Russian origins of the woman he would call 'Vava' strengthened his ties to the distant country of his birth. This new love, whom he was soon to marry, revived his powers, giving him a feeling of security which had a positive impact on his creativity: *Portrait of Vava* (plate 68).

King David (plate 55) is the first picture of a biblical cycle. Emblematic of the Old Testament and one of the guiding lights of the Jewish people, this figure appears in a magnificient purple coat. Very tall, he dominates the city of Jerusalem and a Bathsheba of modest dimensions, which are fortunately offset by a long white train. The composition is rendered dynamic by the rhythmic ordering of glowing and dull bands of colour.

Another large cycle, this time with Paris as its theme, also dates from this period (1952–1954). Paris was clearly playing an increasingly important role in Chagall's creative imagination, as if having been so far away from it in the United States had made it even more impossible to live without and had heightened its reality: *The Bastille* (plate 58).

"The only thing that was still alive for him was the Vitebsk he remembered; and sometimes a city outside – Paris – contrasted with this 'inner' city."⁵

The painting *Sunday* (plate 57) is a perfect illustration of this; the geometric stringency of the coloured zones describing Paris, the real city, focuses attention on the light zone, memories of the Russian village under the affectionate gaze of round-faced Chagall and Vava.

The Crucifixion is another recurrent theme. It first emerged in 1909, was present during the late 1930s and resurfaced in a later series of pictures like *Christ in a Blue Sky* (plate 47), *Christ on the Clock* (plate 61), *Before the Picture* (plate 75).

Even if he is no longer expressive of distressing war years, this is still a tragic Christ, attuned to human suffering.

Another religious subject, *The Tomb of Rachel* (plate 67), represents a new interpretation of a Palestinian landscape which had particularly moved Chagall whilst he was travelling in this country in 1931.

A good many of the works of the Mediterranean years are imbued with a calm joy of living and great serenity: *Lovers floating above Venice* (plate 59), *Circus Rider with Doves* (plate 76), *Bride with Horse* (plate 77) and especially the sumptuous *Bouquets of Flowers* (plate 62) around which married couples are orbiting, the donkey, the cock, all the painter's little world of symbols in a light but pulsing rhythm.

Always extremely responsive to all forms of artistic expression such as dance, theatre and literature, Chagall had a particularly sensitive appreciation of music.

The violin, the violinist, music itself are omnipresent in his work. The artist paid his respects to it by designing the scenery and costumes for ballets. *Daphnis and Chloe* (plate 63), to music by Ravel, led him to discover Greece and ancient mythology.. *Memories of the Enchanted forest* (plate 80) can be understood as Chagall paying homage to Mozart.

The 1960s were years rich in work for theatre and music. At the request of André Malraux, Chagall undertook to design and decorate the ceiling of the Opéra Garnier, an extremely demanding project. It took super-human energy to create that stupendous hymn to the dance and music: *Design for ceiling painting, Paris Opera* (plate 66).

He also worked on two mural paintings for the Metropolitan Opera in New York, *The Source of Music* and *The Triumph of Music* (plate 69).

His last works, *The Prodigal Son* (plate 78), *Shofar* (plate 79), *Family* (plate 81) and *Village Festival* (plate 82) still reveal the dualism between line and colour, the real and the surreal, religious and profane which was so characteristic of Marc Chagall, his personal subject matter and universal message.

"With age I see more clearly and justly what is true and what is false along our way and just how ridiculous everything is which one has not obtained with one's blood, with one's very soul, everything that has not been pierced by love ... herein lies true art." [6]

4 Franz Meyer, *Marc Chagall*, Paris, 1995, p. 256
5 Meyer, p. 258
6 Meyer, p. 282

45

La Pendule à l'aile bleue, 1949
(*Clock with Blue Wing*)
Oil on canvas, 92 × 79 cm
Private collection

Rives d'amour, 1948–1950
(*Lovers' Banks*)
Gouache and pencil on paper, 69 × 53 cm
Private collection, Seoul, Korea

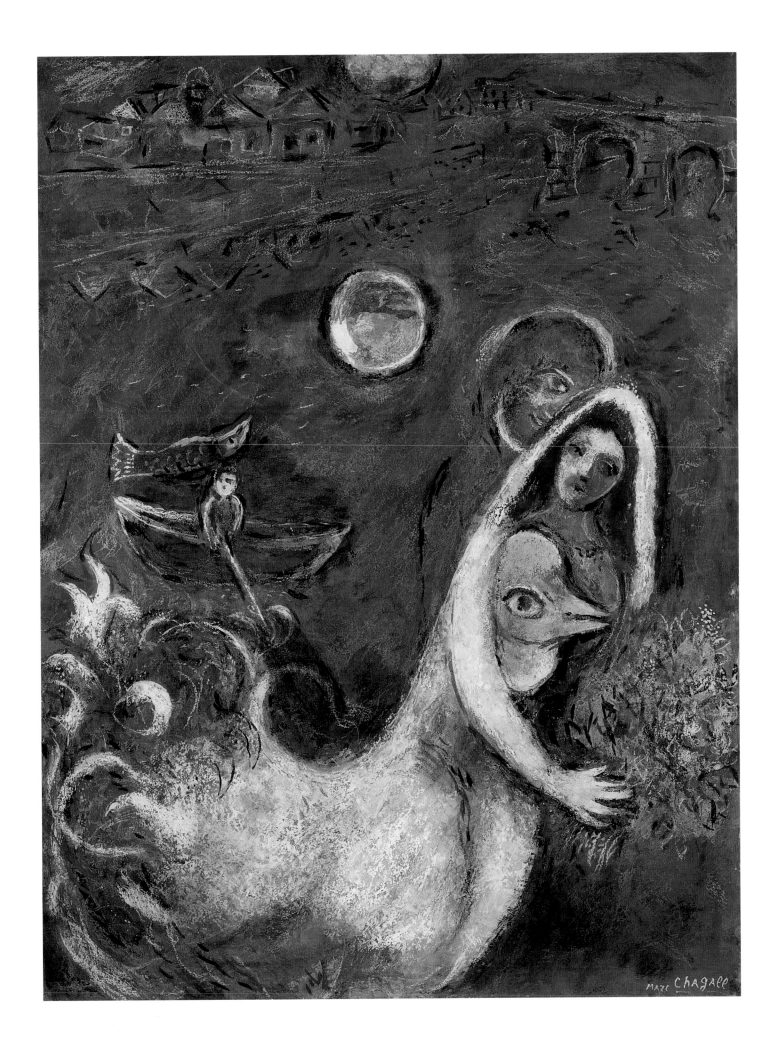

Le Christ au ciel bleu, 1949–1950
(*Christ in a Blue Sky*)
Gouache, 71.2 × 50 cm
Private collection, Switzerland

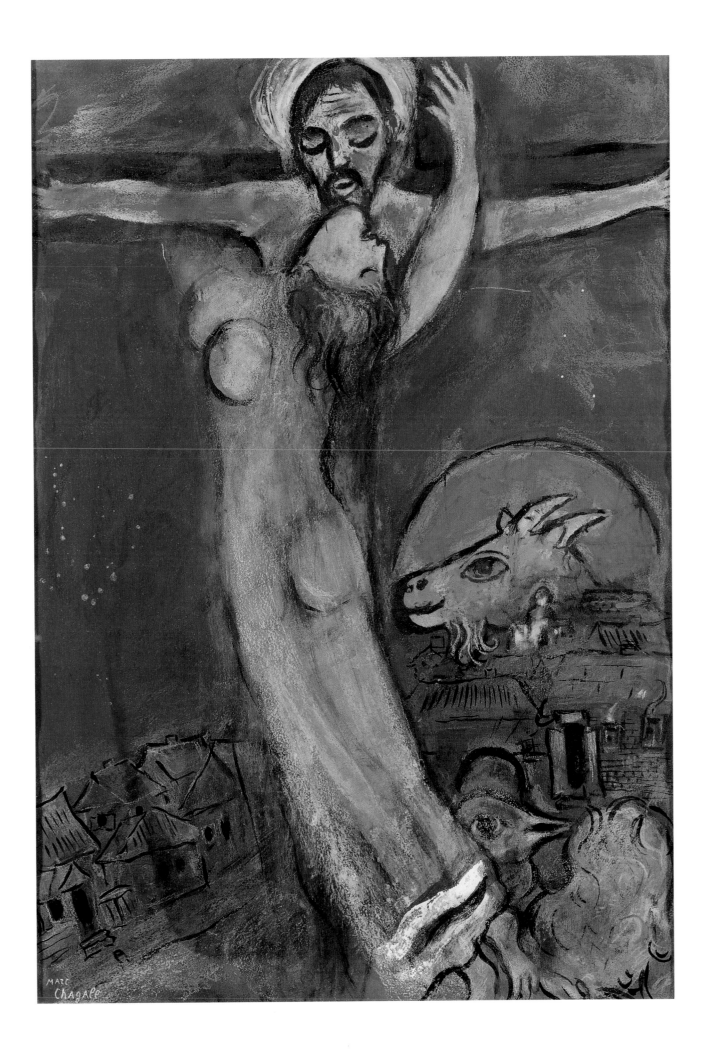

Le Soir à la fenêtre, 1950
(*Evening at the Window*)
Gouache, 65 × 50 cm
Angela Rosengart Collection

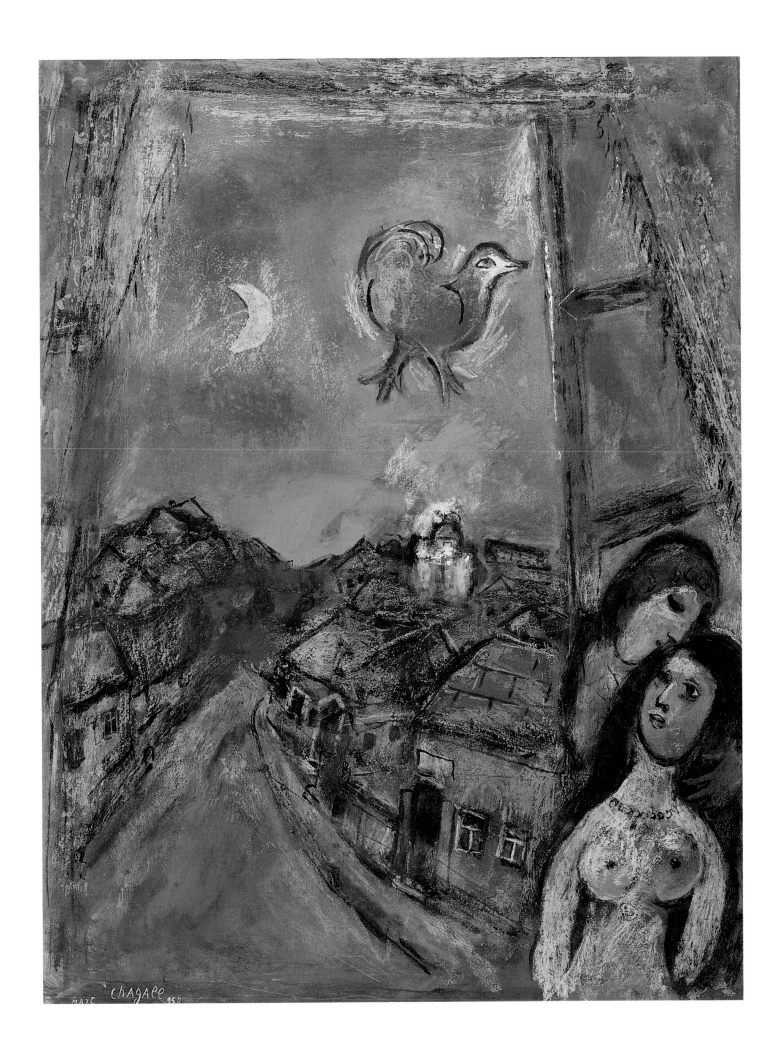

Jeune mariée aux roses, 1950
(*Young Bride with Roses*)
Gouache on paper, 61 × 51 cm
Private collection, Vienna

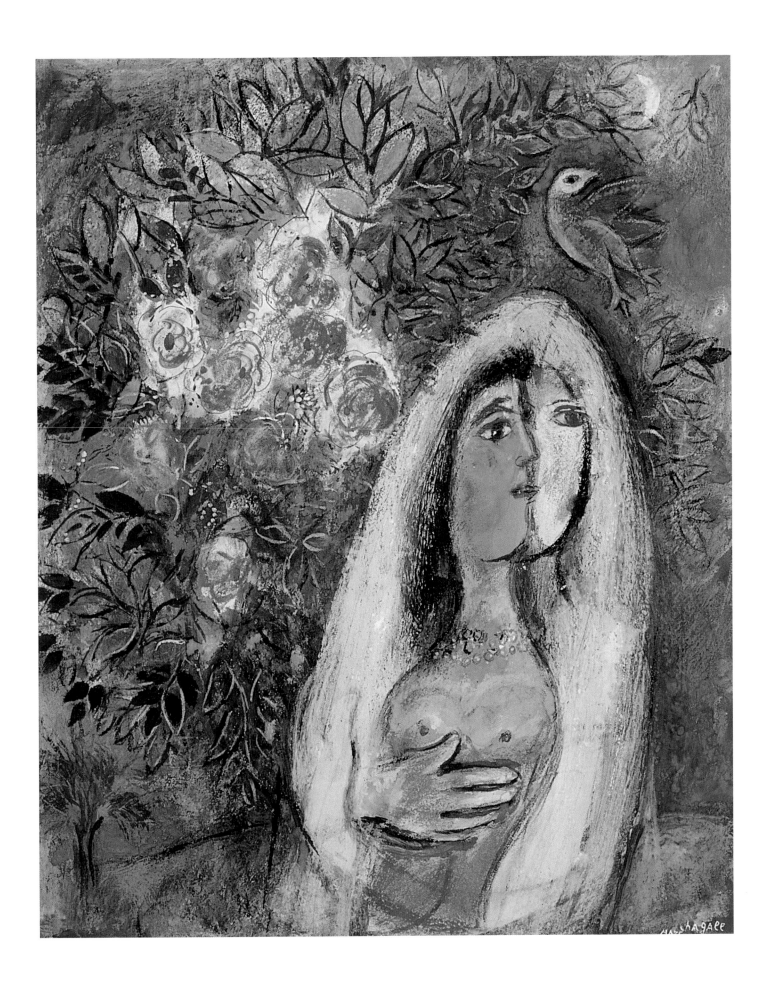

Nu mauve à double tête, 1950
(*Nude with Two Faces*)
Gouache on paper, 56 × 46 cm
Private collection

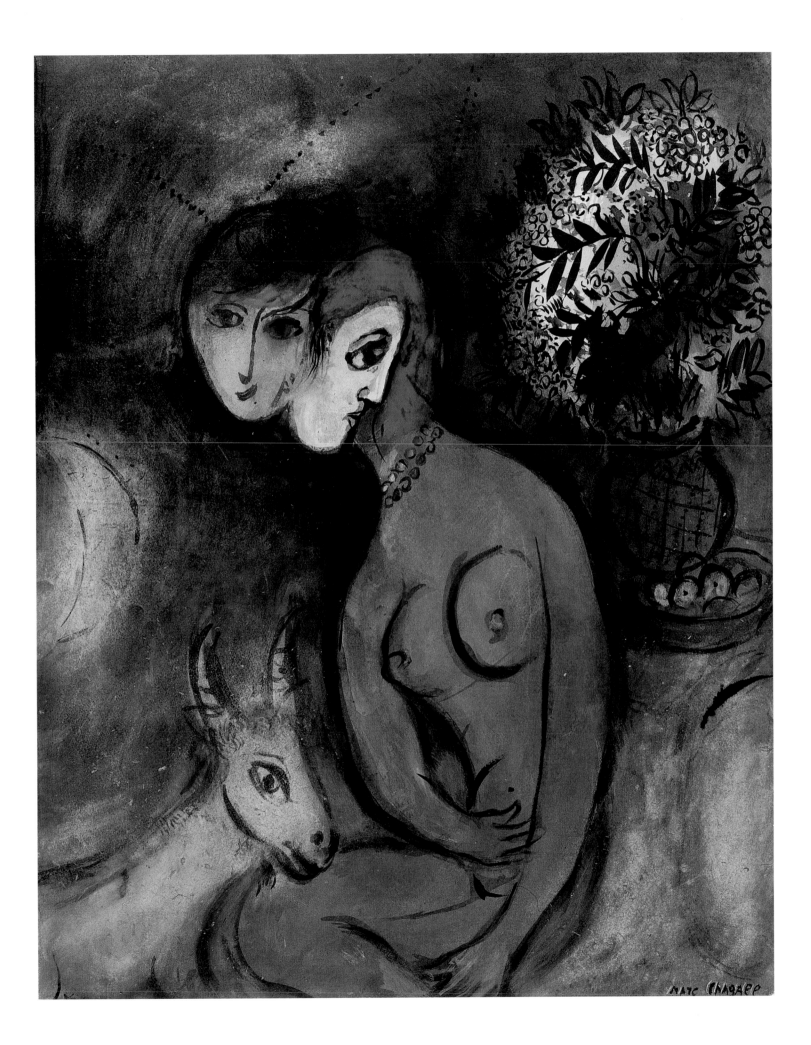

Couple dans le ciel vert, 1950
(*Couple in a Green Sky*)
Gouache and oil on paper, 80 × 58 cm
Courtesy Galerie Brockstedt, Hamburg

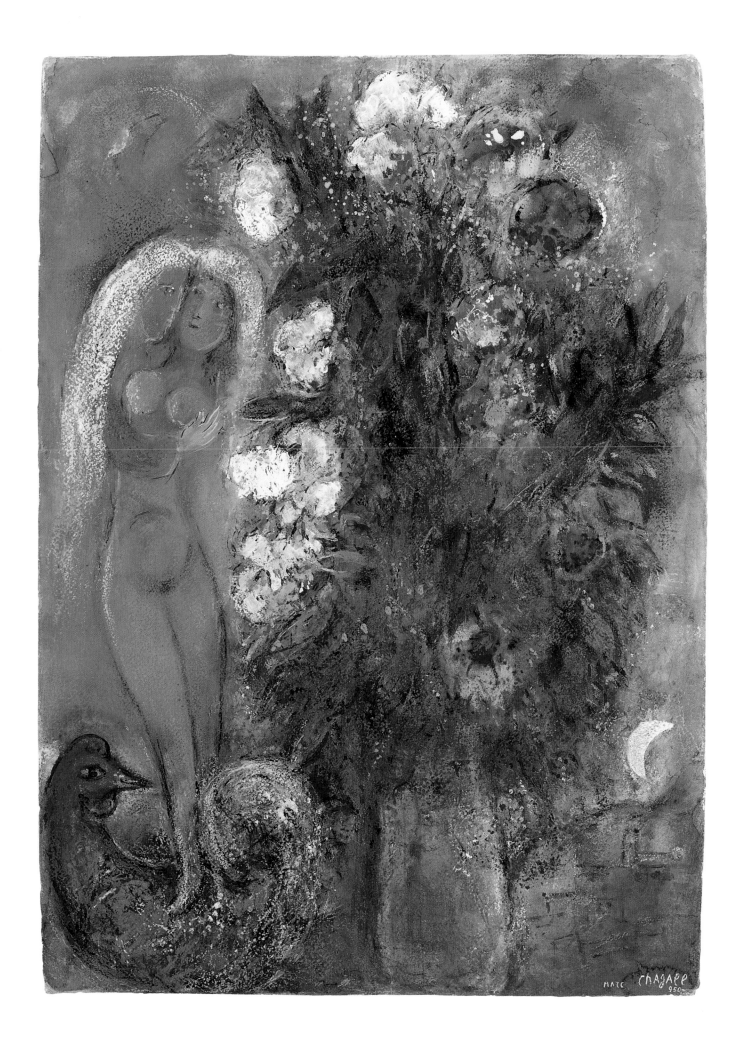

Les Poissons dans la rue, 1950
(*Fish in the Street*)
Pen-and-wash on paper, 75 × 55 cm
Private collection

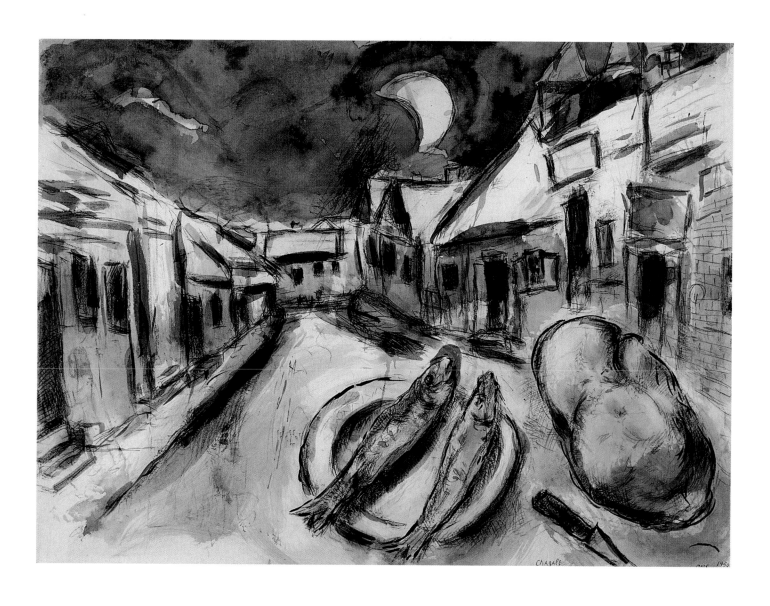

La Danse, 1950
(*The Dance*)
Mixed technique on paper, 32 × 26 cm
Würth Collection, Künzelsau

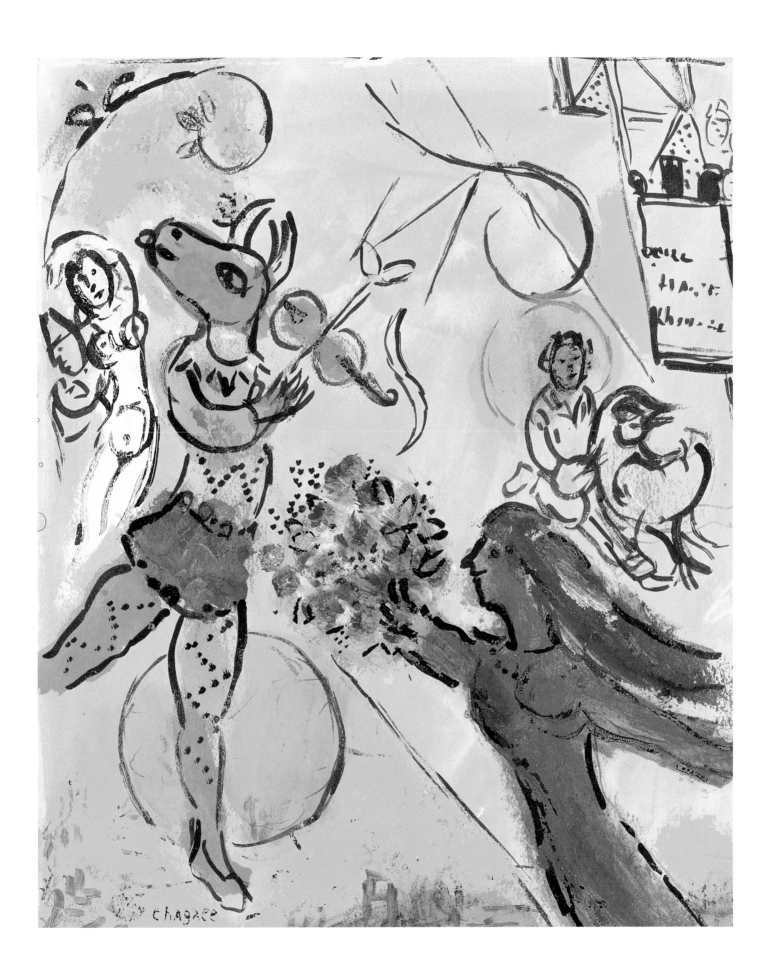

Village au soleil sombre, 1950
(*Village with Dark Sun*)
Oil on canvas, 73.5 × 69.5 cm
Private collection

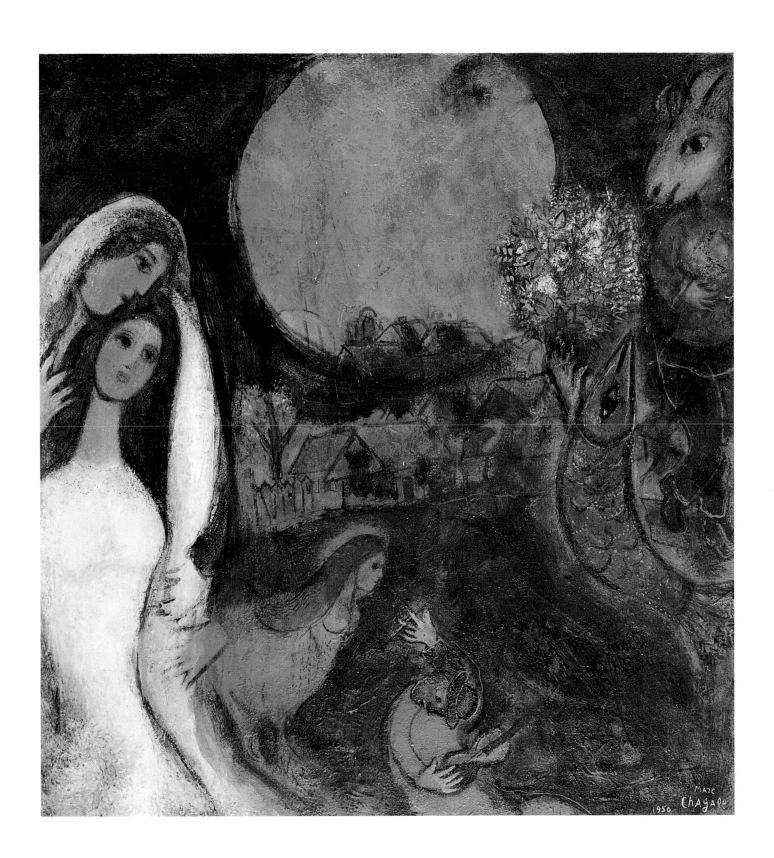

Le Roi David, 1951
(*King David*)
Oil on canvas, 194 × 133 cm
Musée national Message Biblique Marc Chagall, Nice

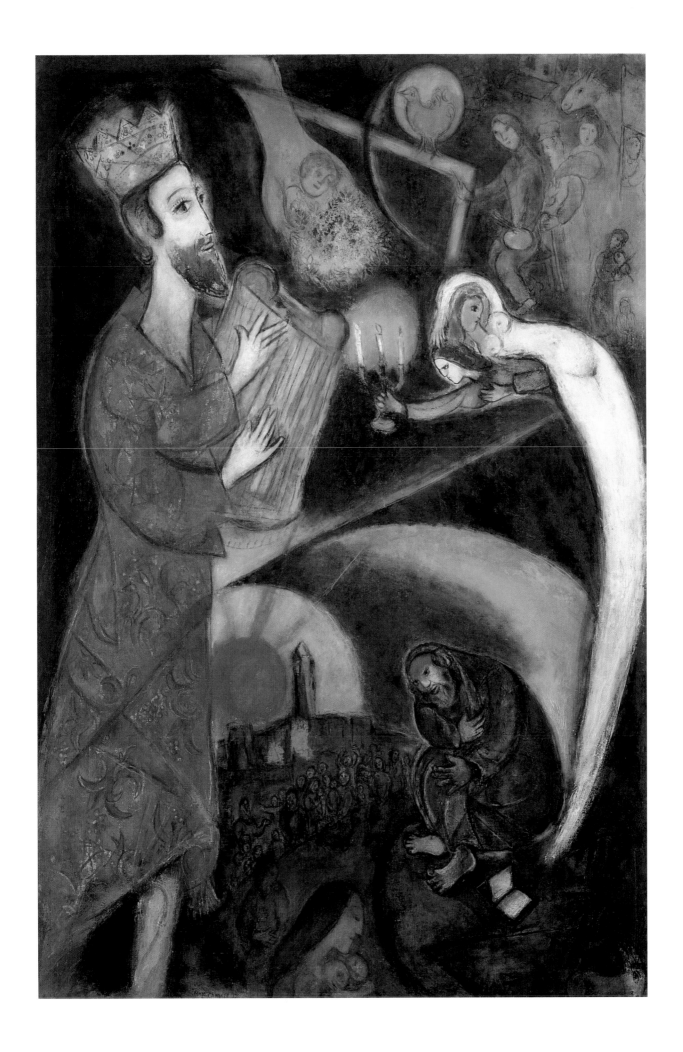

La Nuit verte, 1952
(*Green Night*)
Oil on canvas, 72 × 60 cm
Private collection

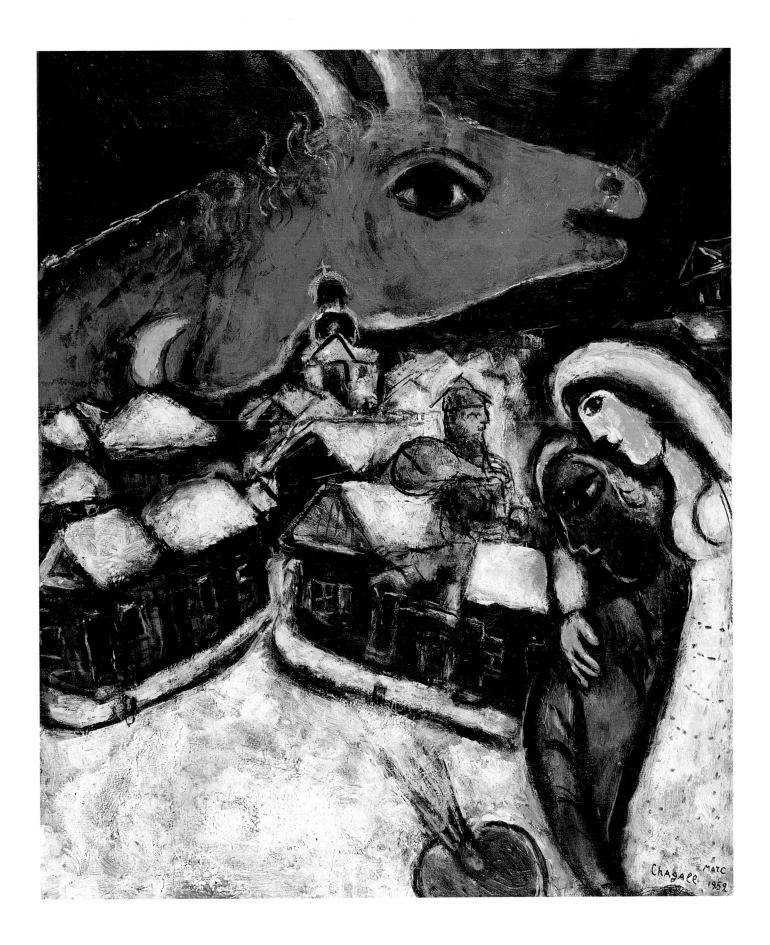

Dimanche, 1952–1954
(*Sunday*)
Oil on canvas, 173 × 149 cm
Musée national d'Art moderne,
Centre Georges Pompidou, Paris

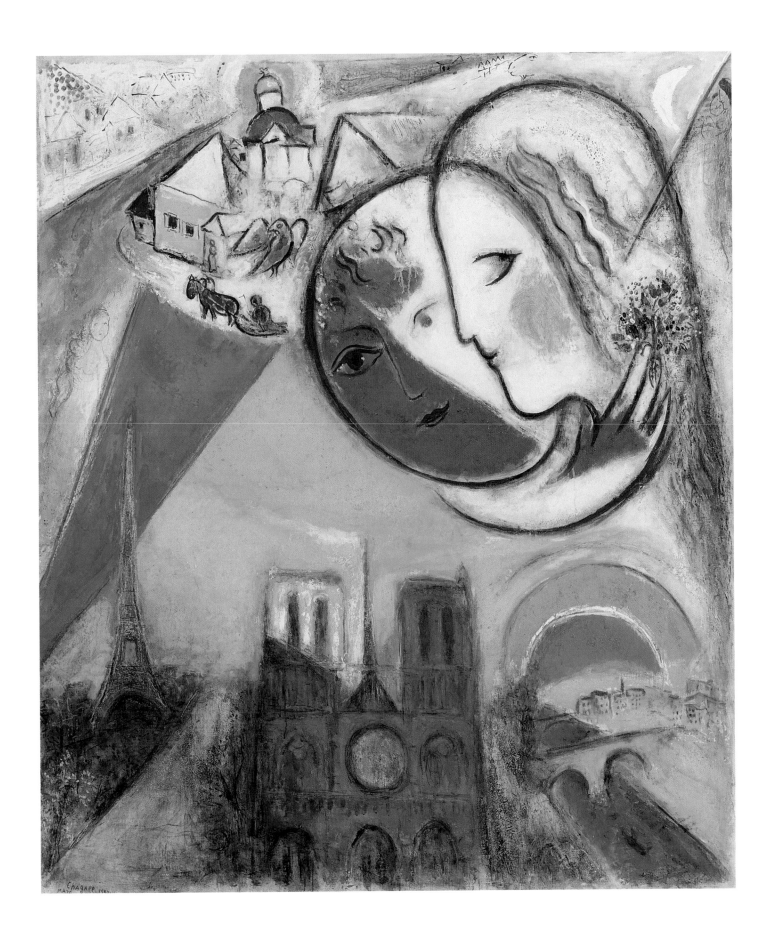

La Bastille, 1953
Oil on canvas, 81 × 100 cm
Private collection

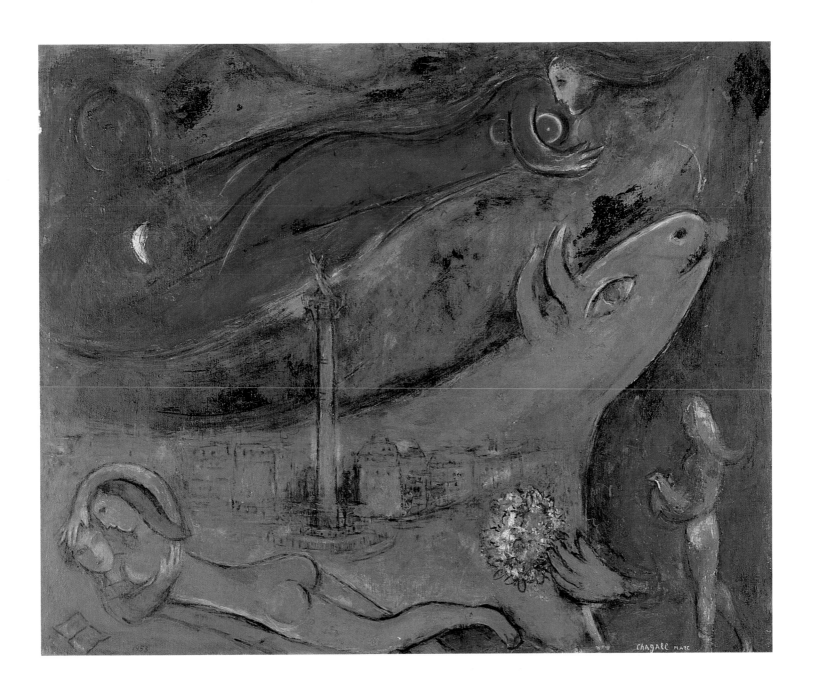

Amoureux au-dessus de Vence, 1953
(*Lovers above Vence*)
Pen-and-wash drawing, 63 × 46 cm
Würth Collection, Künzelsau

Vence 1953
Marc Chagall

Les Tournesols, 1954–55
(*Sunflowers*)
Gouache, ink on paper, 65 × 50 cm
Private collection

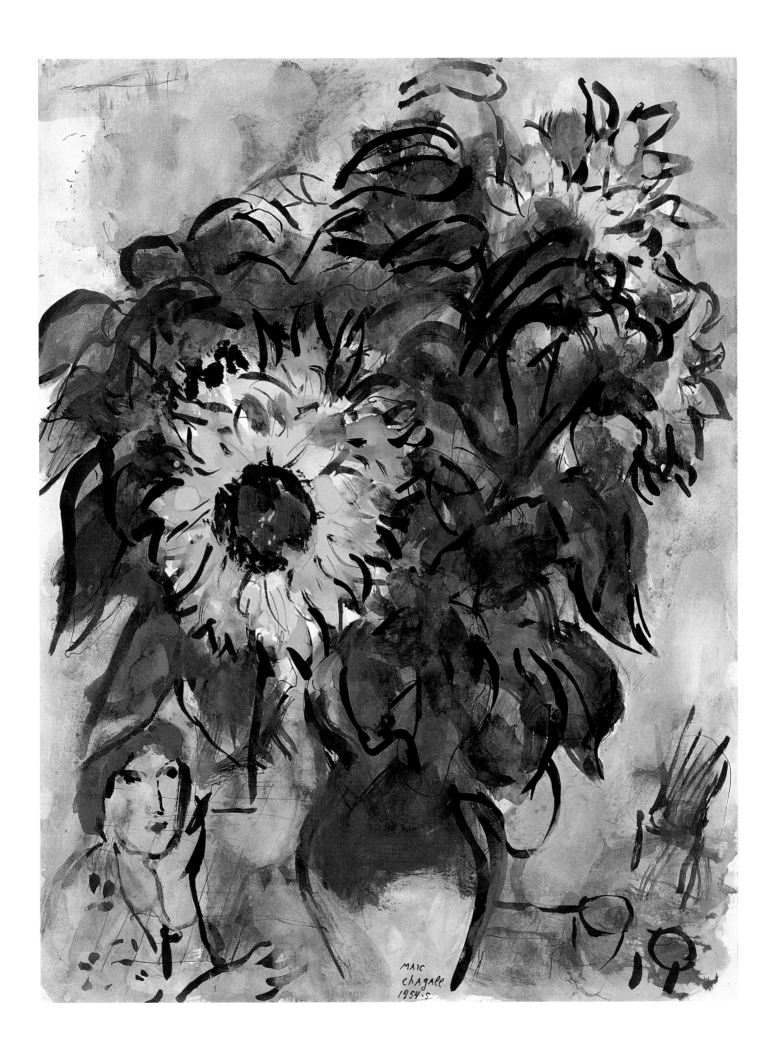

Le Christ à la pendule, 1956
(*Christ with Clock*)
Gouache, 75.8 × 56.2 cm
Angela Rosengart Collection

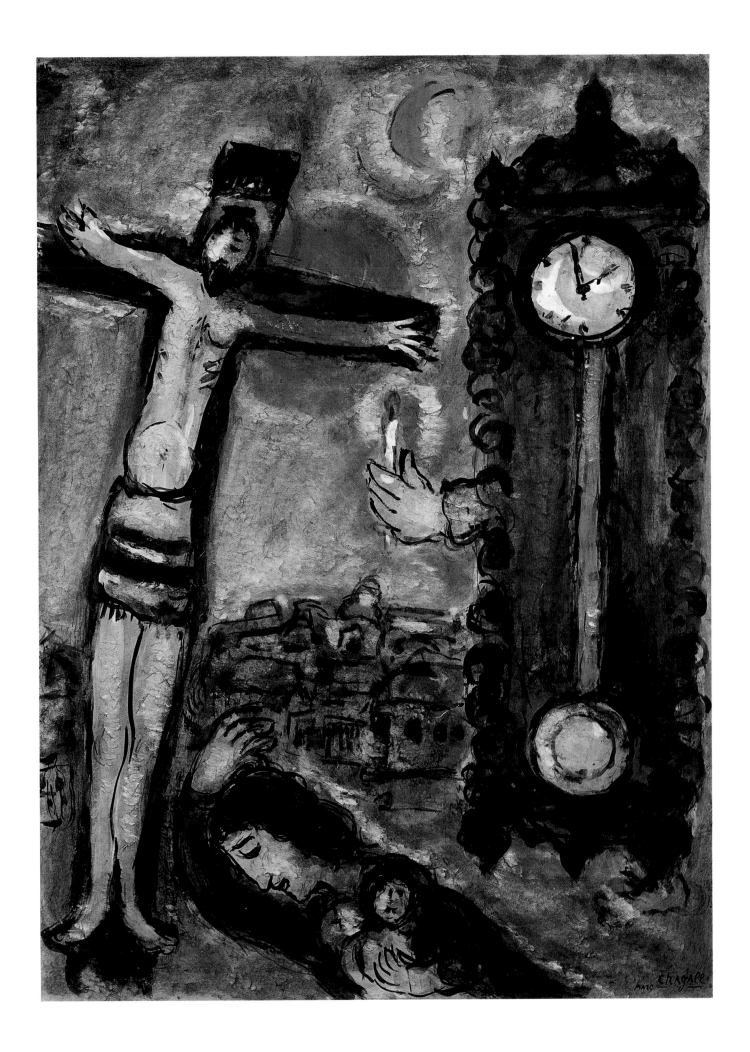

Le Bouquet de fleurs, 1956
(*Bouquet of Flowers*)
Gouache, 76 × 56.6 cm
Courtesy Galerie Rosengart, Lucerne

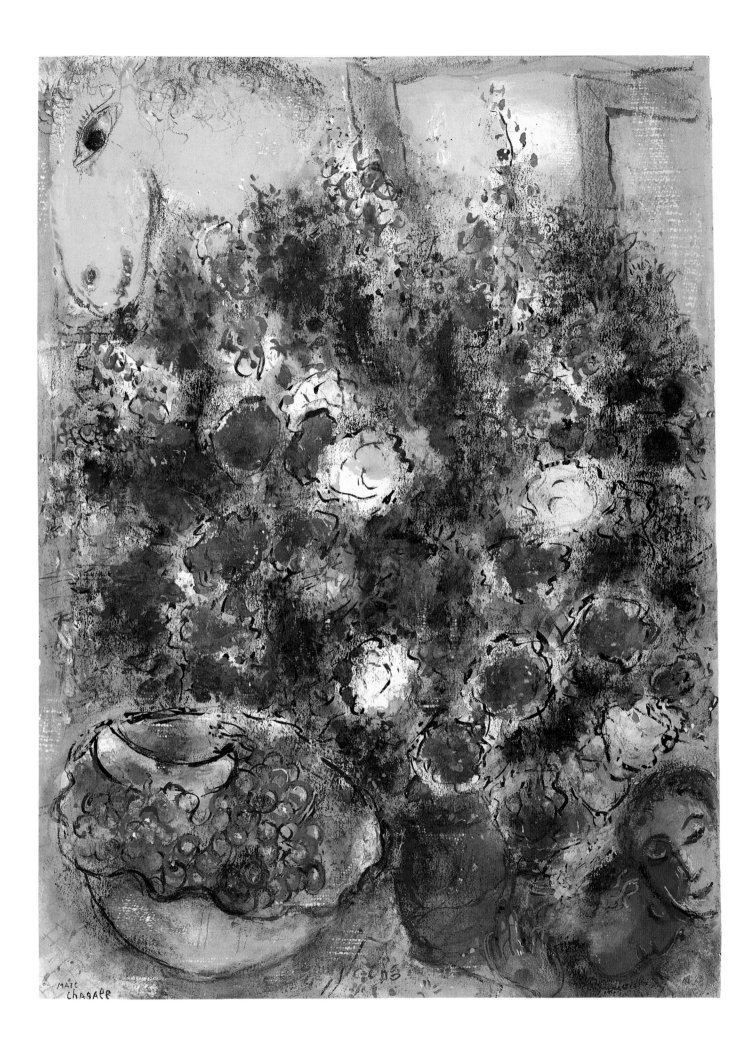

Daphnis et Chloé, 1956
(*Daphnis and Chloe*)
Ink drawing, Roussillon red,
105 × 75 cm
Private collection

La Fiancée au visage bleu, 1932–60
(*Bride with Blue Face*)
Oil on canvas, 100 × 80 cm
Private collection

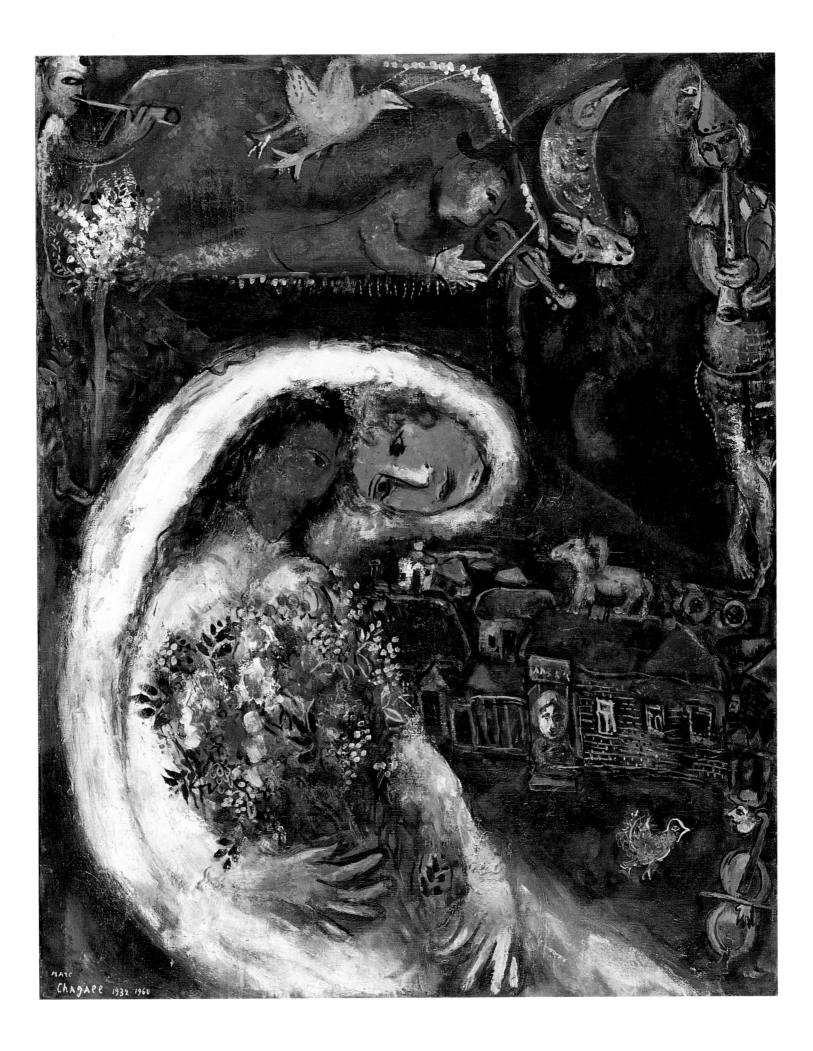

Personnages et animaux, 1960–1965
(*People and Animals*)
Watercolour and gouache, 35 × 26 cm
Private collection, Seoul, Korea

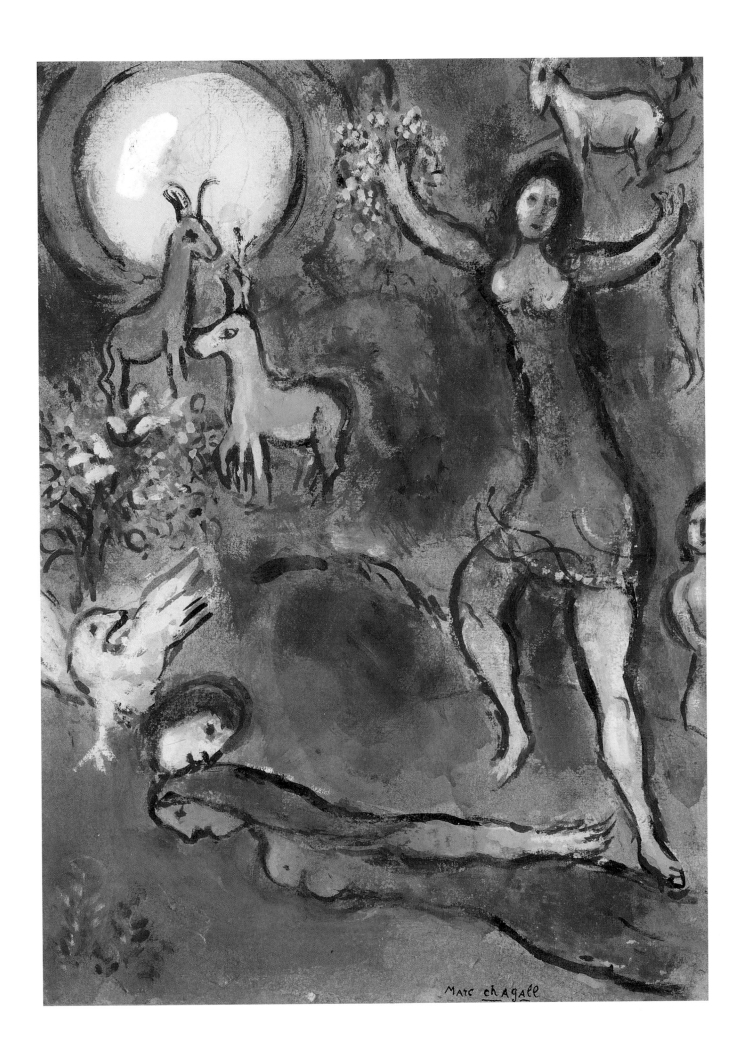

Maquette du plafond de l'Opéra de Paris, 1963
(*Design for ceiling painting, Paris Opera*)
Gouache and watercolour on paper, 140 × 140 cm
Private collection

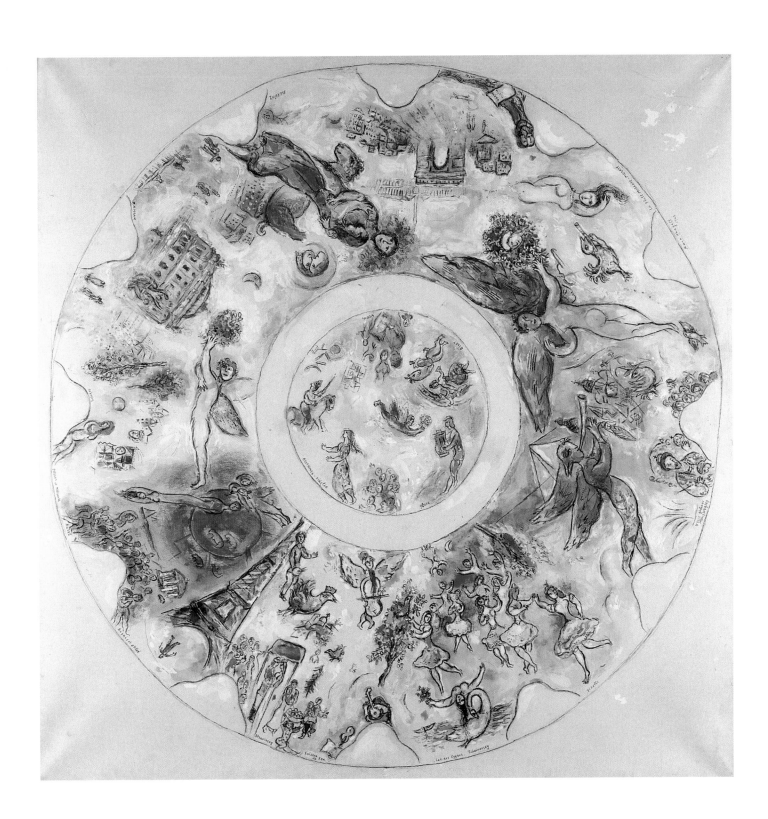

Le Tombeau de Rachel, 1966
(*Rachel's Tomb*)
Oil on canvas, 70 × 70 cm
Private collection

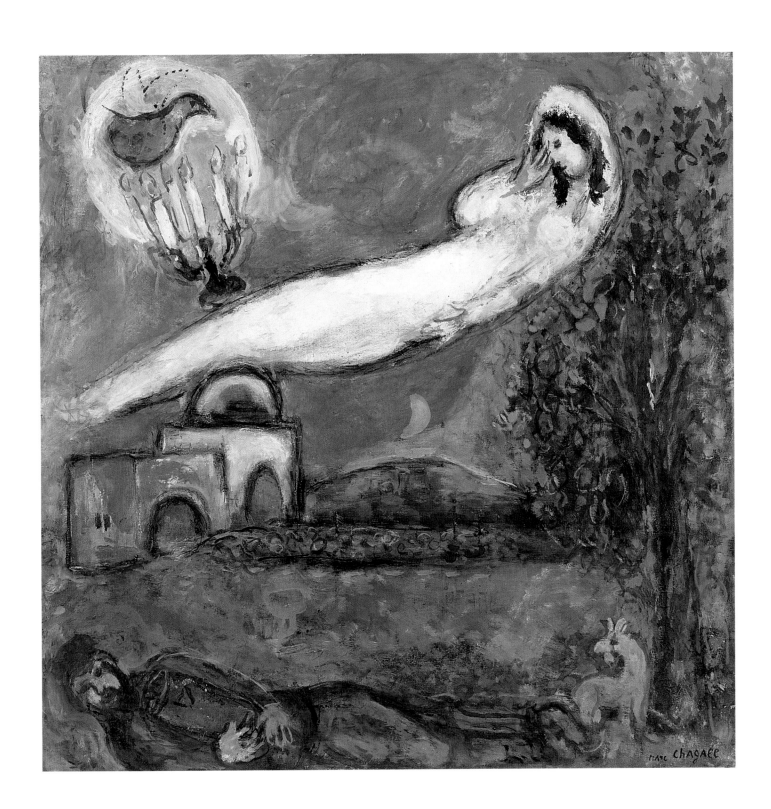

Portrait de Vava, 1966
(*Portrait of Vava*)
Oil on canvas, 92 × 65 cm
Private collection

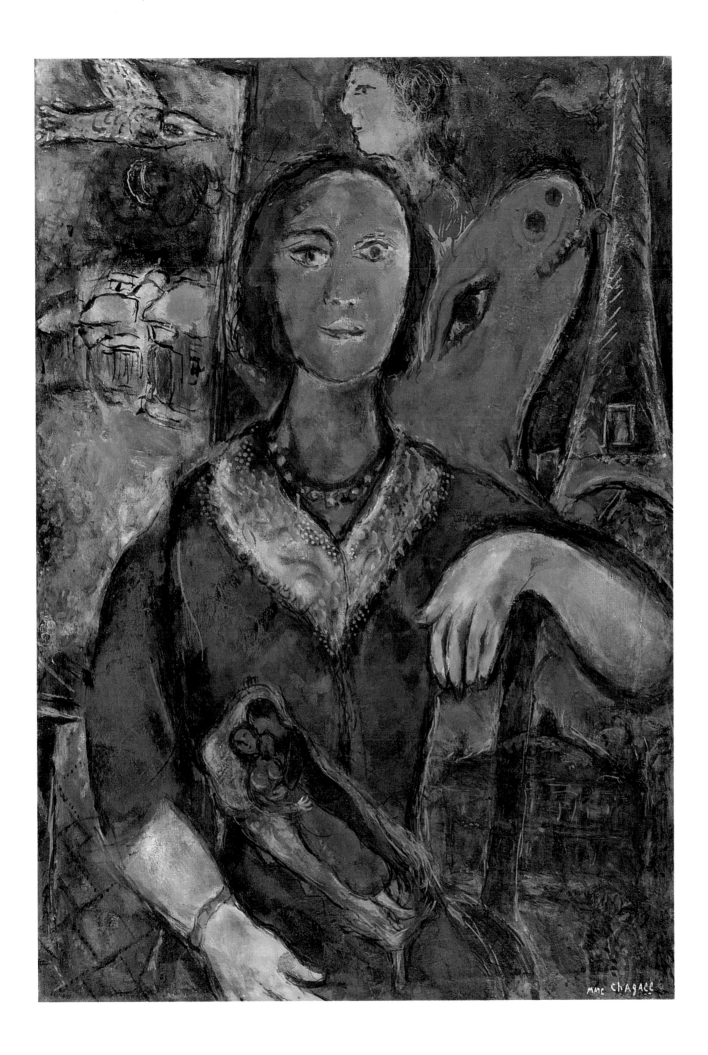

Le Triomphe de la musique, 1966
(*The Triumph of Music*)
Watercolour, gouache and ink, 103 × 91.5 cm
Private collection

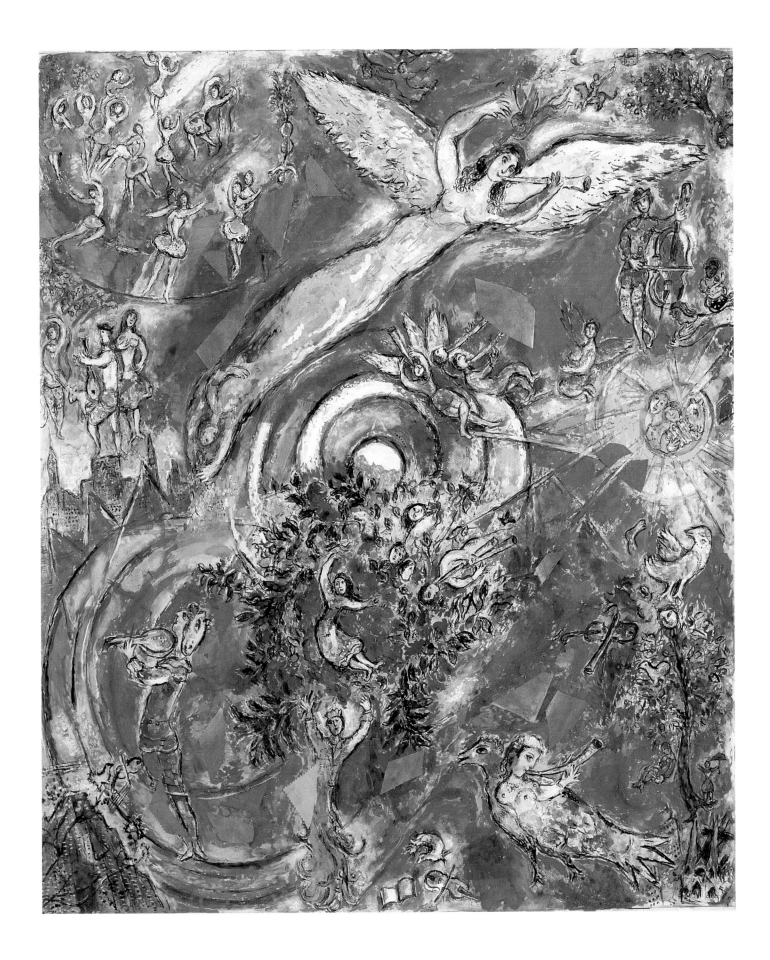

Nu mauve, 1967
(*Mauve Nude*)
Oil on canvas, 70 × 70 cm
Private collection

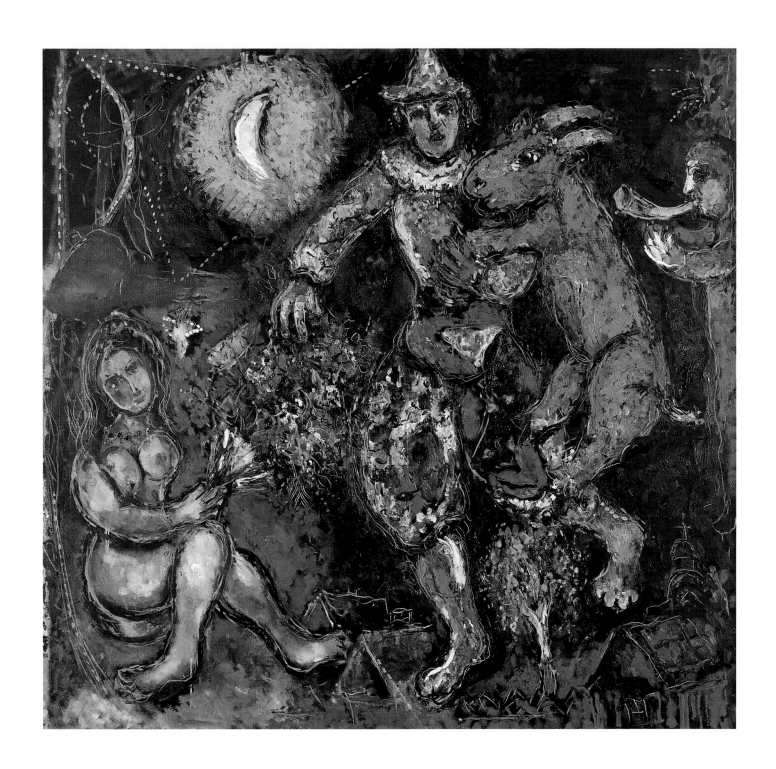

Couple au-dessus de Saint-Paul, 1968
(*Couple above Saint-Paul*)
Oil on canvas, 146 × 130 cm
Private collection

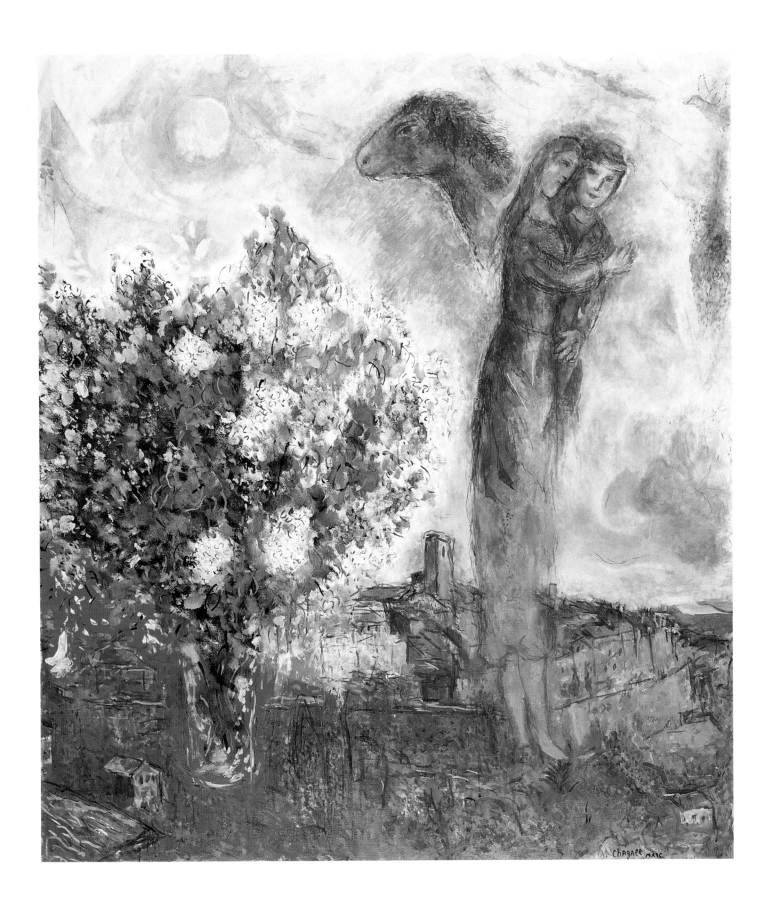

Orphée, 1969
(*Orpheus*)
Gouache and pencil, 74 × 137.5 cm
Private collection

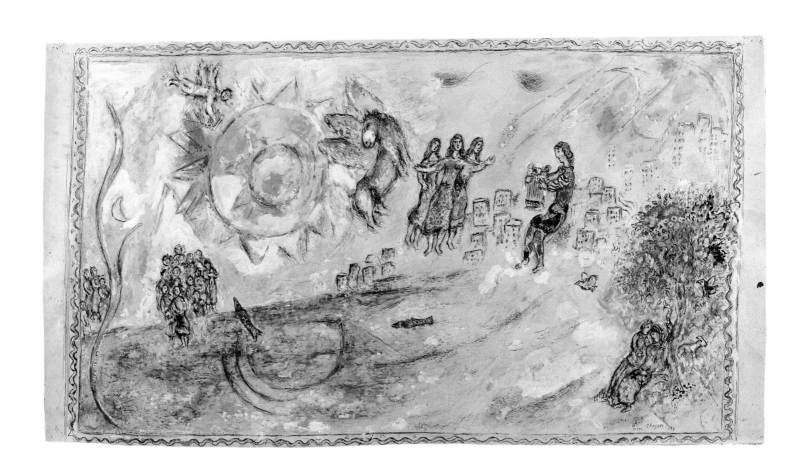

*Le Grand Visage – Autoportrait
au grand visage jaune,* 1969
(*Large Face – Self-Portrait
with Large Yellow Face*)
Gouache, 63 × 54.5 cm
Private collection

Le Couple dans le paysage bleu, 1969–1971
(*Couple in a Blue Landscape*)
Oil on canvas, 112 × 108 cm
Private collection

Devant le tableau, 1969–1971
(*In Front of the Picture*)
Oil on canvas, 116 × 89 cm
Fondation Maeght, Saint-Paul-de-Vence

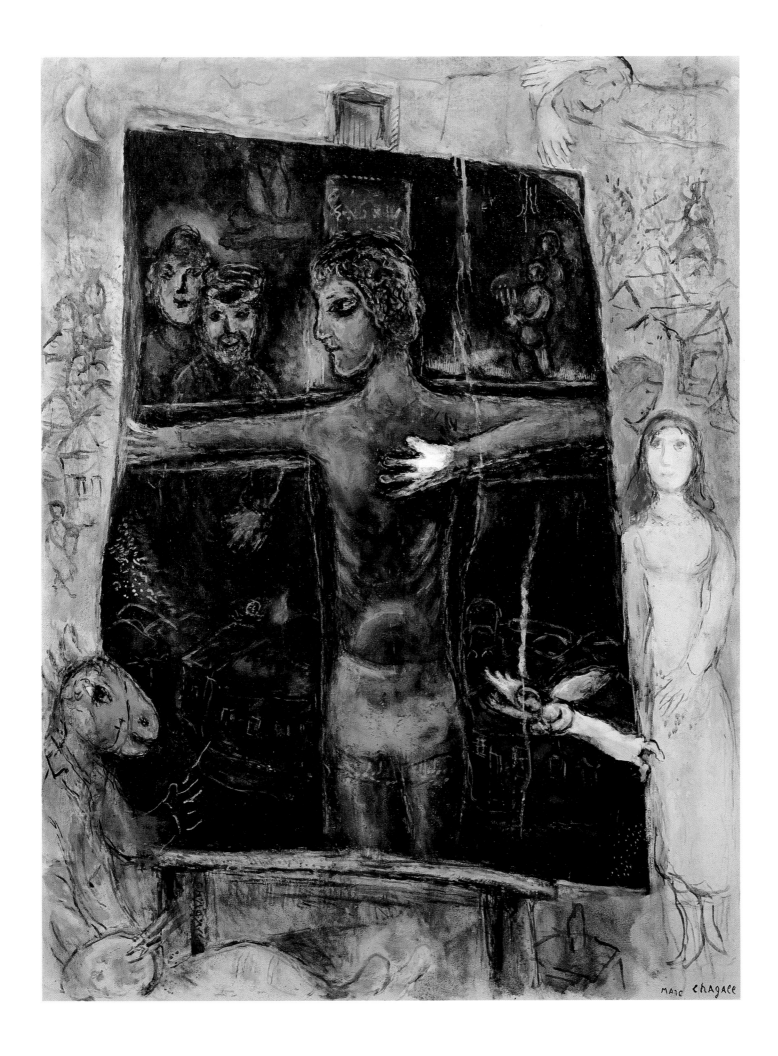

L'Ecuyère aux colombes, 1970
(*Circus Rider with Doves*)
Gouache, 75 × 50 cm
Private collection

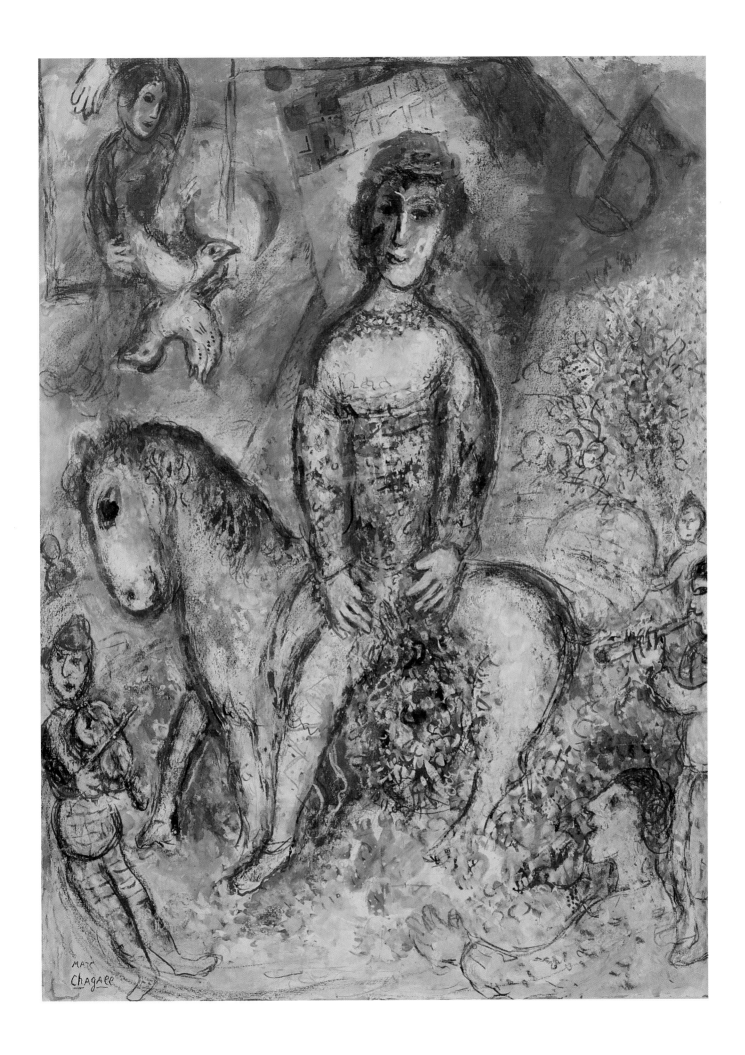

La Mariée au cheval, 1971
(*Bride and Horse*)
Gouache, ink, pencil and chalk
on paper, 82 × 66 cm
Würth Collection, Künzelsau

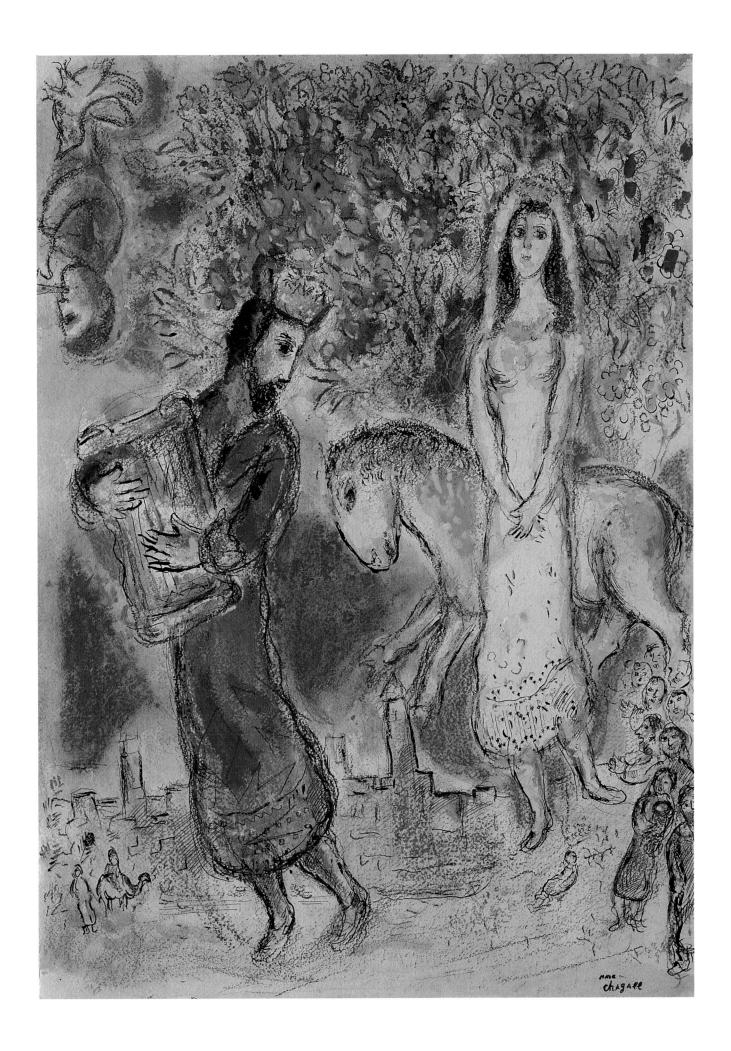

Le Fils prodigue, 1975–1976
(*The Prodigal Son*)
Oil on canvas, 162 × 122 cm
Private collection

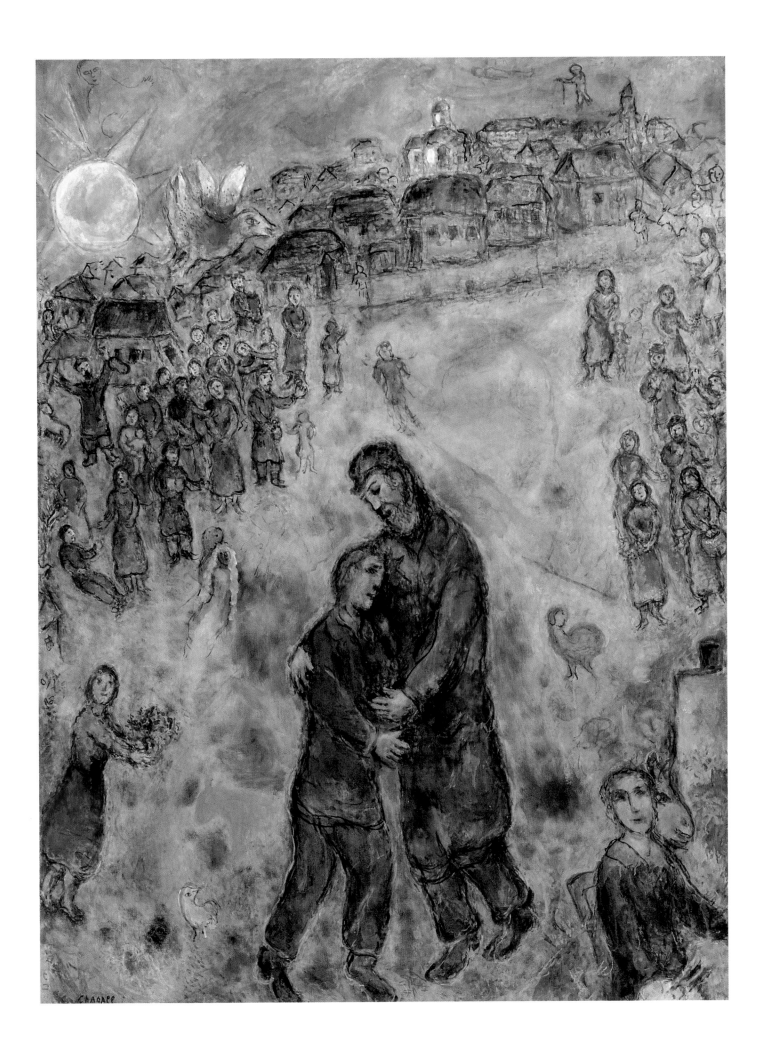

Le Shofar, 1976
(*Shofar*)
Oil on canvas, 146 × 97 cm
Private collection

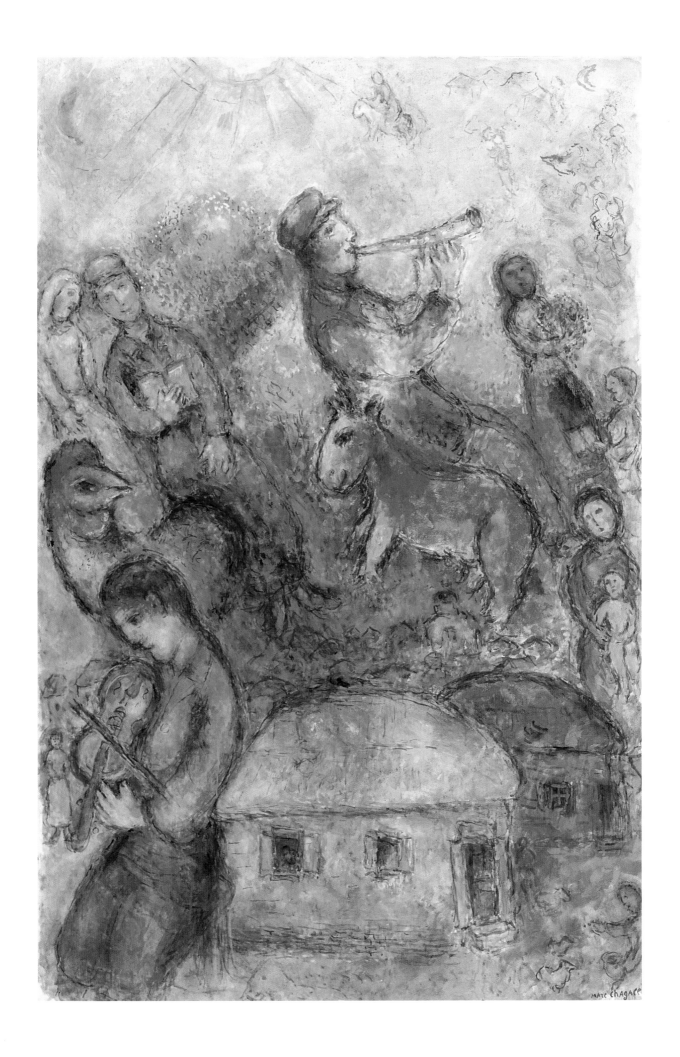

Souvenir de la flûte enchantée, 1976
(*Memories of the Enchanted Flute*)
Oil on canvas, 114 × 195 cm
Private collection

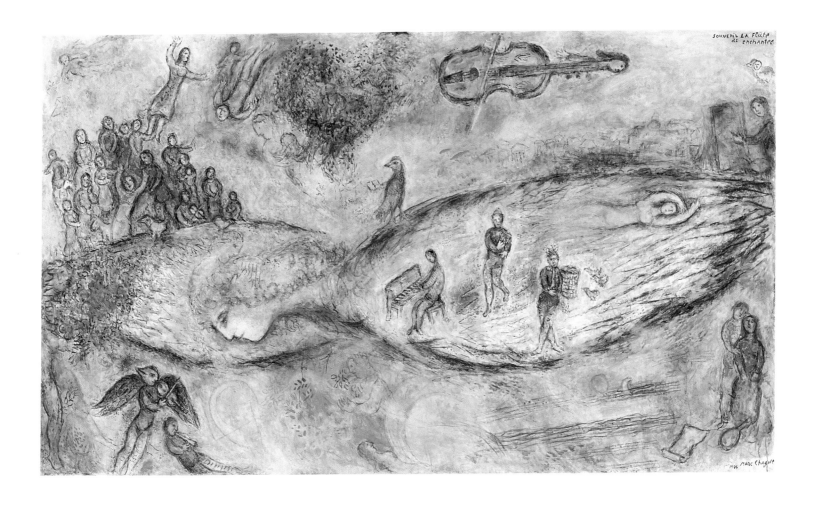

La Famille, 1977
(*Family*)
Oil on canvas, 130 × 97 cm
Private collection

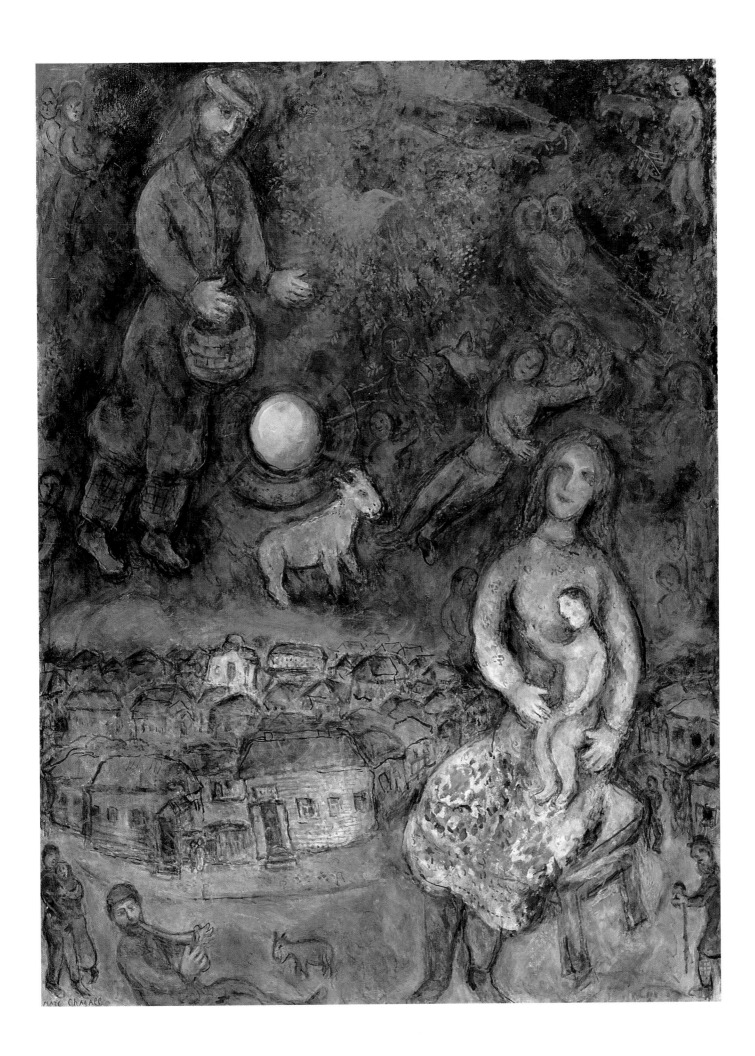

Le Village en fête, 1981
(*Village Festival*)
Oil on canvas, 130.5 × 195 cm
Private collection

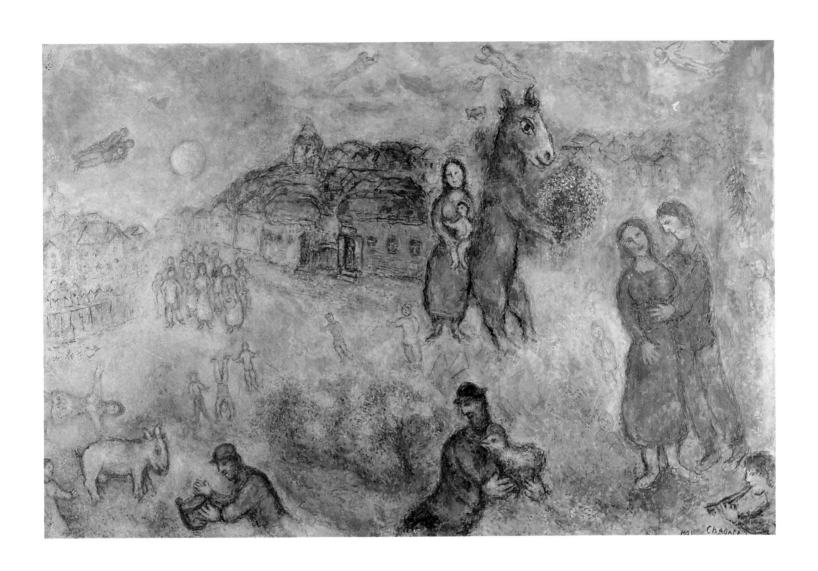

Marc Chagall with his daughter Ida, in front of *At Dusk*, Paris, 1951

Biography

Marc Chagall was born on 7 July 1887 to a Jewish family in Vitebsk, a small town in White Russia situated at the confluence of the Vitsba and the Dvina. In that town, as in others in White Russia, Jews (and they comprised half of a population of 48,000) had the freedom of the city although their professional life was supervised. The house in which Chagall was born was on the outskirts of the town. Marc was the eldest of 9 children, and several years after his birth, his father bought a modest stone house on the right bank of the Dvina for his family as well as three other smaller wooden buildings built round a backyard. The family now lived near the station and the 17th-century wooden Ilinskaya church.

For seven or eight years Chagall regularly attended the heder (Jewish primary school). He took violin and singing lessons and even assisted the cantor at the synagogue before becoming a pupil at the Vitebsk state school where lessons were taught in Russian.

In 1906, after leaving school, Chagall enrolled at a collage run by Jehuda Pen School, a painter of genre scenes and portraits in the manner of the turn-of-the-century Salons. Although the young painter totally immersed himself in realism, he soon emancipated himself from its influence, developing a distinctive style of his own, distinguished by an increasingly bold palette. Within this brief space of two months, Chagall endured a joyless apprenticeship in photographic retouching with the photographer Mieschaninov.

Deep ties of friendship bound Chagall to a fellow pupil of Pen's, Victor Mekler, who came from a rich Jewish family.

During the winter of 1906–1907, they went to St Petersburg together. There life turned out to be extremely hard and the only lodgings they could afford were wretched indeed. In order to gain the right to live there, Jews were obliged to apply for residence permits. These were only granted to members of academies, their employees, artisans and provincial tradesmen. Consequently, Chagall's father was forced to make temporary arrangements with a tradesman. On Pen's recommendation, Chagall again worked as a photo retoucher for a photographer named Jaffe. Then after his residence permit had been renewed, he worked as a sign painter but without being granted permanent residency. Finally, a lawyer named Goldberg, who was a patron of the arts, took charge of Chagall, employing him ostensibly as a servant. Chagall enrolled at the school founded by the Imperial Society for the Promotion of the Fine Arts, headed by the painter Nicolas Roerich, who allowed his pupils complete freedom of expression.

The work done by the young Chagall at this time was noticed and he was paid a small scholarship. Roerich managed to get him a deferment and later an exemption from national military service.

In July 1908 criticism by other teachers prompted Chagall to break off his studies at the Imperial Society. For several months he worked at the private school run by Saidenberg,

Zahar and Feiga-Ita Segal, Marc Chagall's parents

a painter of genre scenes taken from Russian history in the manner of Repin. Influenced by the academic style taught at the school, which was less liberal than the Imperial Society, Chagall produced work that was naturalist in style. However, his admiration for the landscape painter Levitan is reflected in some of his most luminous landscapes – and even in some of his domestic interiors. The young painter met several collectors and patrons of the arts. Among them were Vinaver, a member of the Duma, his brother-in-law Leopold Sev, the critic Serkin and Pozner, the writer. Joint editors of the liberal Jewish magazine *Voshod*, they supported Chagall from the outset.

Sev's recommendation enabled Chagall to approach Leon Bakst, who was a professor at the Svanseva School, which had a liberal tradition and was open to the currents of Modernism. A new chapter had begun in the young artist's life. Now he was confronted with a broad range of diverse artistic movements including Symbolism in literature and Art Nouveau in decoration, encouraged and nurtured by the intellectual independence which was the hallmark of the school. In his teaching, Bakst redefined the palette. According to him, the colours constituted elements of composition as a whole.

Chagall spent two summers with the Goldberg family at Narva, their house on the Gulf of Finland. There, inspired by Gauguin's work, he explored the possibilities of new subject matter. Gauguin had a profound formative influence on Chagall, just as he had on painting internationally in the early

Vitebsk at the turn
of the century

years of the 20th century. Thea Brachmann, a friend of Chagall's from Vitebsk, who was also studying in St Petersburg, was willing to pose for him for nudes and group compositions.

Chagall regularly interrupted his work at St Petersburg to spend quite a bit of time at Vitebsk. In autumn 1909 Thea introduced Chagall to her friend Bella Rosenfeld. The youngest daughter of a prosperous family of jewellers, she was studying in Moscow: 'It's as if she had known me for a long time, as if she knew all about my childhood, my present and my future, as if she were watching over me (...). I felt she would be my wife (...). I have entered a new house and I'm inseparable from it'.¹ Chagall painted *Bella Wearing Black Gloves*. From now on the discovery of his love for her would be reflected by a particular brilliance in his paintings. His assurance as a painter grew out of the passion Bella inspired him to share with her for Italian and 17th-century Dutch painting and for the theatre.

Late in 1909 and during the first half of 1910, Chagall painted several works revealing an entirely new depth. In fact, at this time the young man frequented the St Petersburg museums, where he was particularly struck by the icons, notably those painted by Rublev.

Chagall spent his time between Vitebsk and St Petersburg, where he continued his studies with Bakst. He was also preparing to exhibit at the Salons but this did not come about. The first public showing of Art Nouveau was the exhibition at the Svanseva School, on the premises of the revue *Apollo*. Although it was discreetly staged from 20 April to 9 May 1910 outside the regular art season, the exhibition – in which Chagall had two canvases, one of them *Death* – caused an uproar due to criticism expressed by Repin of the new art movements.

Bakst left St Petersburg for Paris in order to devote himself entirely to working for Diaghilev. Chagall also had a feeling

that it would be best for him to leave. He applied unsuccessfully to work with Bakst as a scene painter. Thanks to a scholarship granted to him for four years by Vinaver, Chagall was able to contemplate going to the French capital.

1910–1911

In August 1910, the painter left Russia for the first time, taking with him all the paintings and drawings he had executed up to that time. At first he lived in the studio owned by the painter Ehrenburg in Impasse du Maine, a cul-de-sac near Montparnasse Station. Because he had so little money, he bought old pictures to use as canvases, painting over them. Among these works are *The Studio* (with *My Betrothed Wearing Black Gloves* hung in the background).

Chagall attended La Palette Academy, where Le Fauconnier and Dunoyer de Segonzac taught, and La Grande Chaumière Academy, where he did drawings of nudes. He haunted the galleries, the Salons and the museums, especially the Louvre. There the work of Manet, Delacroix, Géricault, Courbet, Millet, Rembrandt, Le Nain, Fouquet, Chardin, Watteau and Uccello left a deep impression on him. At the Durand-Ruel

Vitebsk at the turn of the century

Guillaume
Apollinaire, 1912

gallery he discovered Renoir and the Impressionists. At the Bernheim-Jeune he encountered the work of van Gogh, Gauguin and Matisse. However, he was hesitant about approaching the art dealer and publisher Ambroise Vollard.

At the Autumn Salon he became deeply involved in French painting, the 'revolution of the eye, the rotation of colour'[2]. The Paris light and the intensity of the colours there enchanted the young Chagall, inspiring him to translate his impressions into a new pictorial idiom. *The Father* attests to this. A few rare Paris landscapes are caught up in the Fauve spirit. At the same time Chagall was producing a great many gouaches with Russian motifs, harbingers of more rhythmically structured compositions to come.

Late in 1910 he met the Delaunays in Montparnasse. He also got to know Gleizes, de La Fresnaye, Léger, Metzinger, Marcoussis, Lhote and Dunoyer de Segonzac. In addition, he engaged in discussions on Cubism and Futurism in numerous circles of artists.

Paramount among his first great works are *Marriage* (or *Nuptials*) uniting the two 'most important elements of Art Nouveau, the transparent form of Cubism and the translucent colour of Delaunay',[3] all the while becoming 'psychologically transparent'[4]. Chagall orientated his research to this very transparency (see the still lifes, particularly *Cubist Still Life*). According to André Breton, an 'explosion of total lyricism'[5] took place during Chagall's Parisian period, a pictorial expressiveness which was unique at that time. In addition, the animals which were most revealing of his universe like the cow, the bull and the goat appear either in opposition to or in harmony with human beings (*My Village and I, Dedicated to my Betrothed*). Human existence and its development in the face of certain decay are reflected in figures whose heads are detached from their bodies or turned round.

1911–1912

During the winter of 1911–1912 or perhaps the spring of 1912, Chagall moved into a La Ruche studio at 2 Passage de Dantzig. He was to remain there until he left Paris in 1914. This was a building with about 140 individual studios occupied by painters like Laurens, Archipenko, Léger, Modigliani, Kogan and Soutine as well as sculptors, poets and actors. Chagall was very close to the poet Blaise Cendrars. In these surroundings the young painter produced several masterpieces, some of them on scraps of material. They reveal a bias towards geometric form. Cendrars was to give them their titles: *To Russia, Donkeys and Others* as well as *Russian Village* and *From the Moon*. The friendship of poets like Max Jacob

and André Salmon was a formative influence. Guillaume Apollinaire proved a staunch friend indeed. He dedicated *Rodsoge*, according to Breton the 'most liberated poem of the century'[6], to Chagall and drew the attention of the dealer Herwarth Walden to him. In his studio the artist also received his St Petersburg patron, Vinaver, as well as Bakst and the Russian journalist A. V. Lunacharsky, all of whom were pleased with the progress he had made.

1912

Chagall exhibited three canvases at the Salon des indépendants: *Saul, Dedicated to my Betrothed* and *To Russia, Donkeys and Others*. In *Hommage to Apollinaire* the duality of being confronts the unity of volume inherent in the work. During this period Chagall was to paint several portraits of people who were close to him or of people he admired, among them *Mazin the Poet* as well as self-portraits.

Recommended by the sculptor Kogan as well as by Delaunay and Le Fauconnier, Chagall exhibited three canvases at the Autumn Salon, among them the monumental *Golgotha*.

1913–1914

Recognisably Jewish motifs and figures began to well up from his memories of Russia. A Hasidic spirit would henceforth inform his canvases. During the last part of this Parisian period, his inner vision and the external representation of the city of Paris seem to have fused. Chagall exhibited two more times at the Salon des indépendants: in 1913 his large *Birth*, dating from 1911; and in 1914 *The Fiddler, Motherhood* and *Self-Portrait with Seven Fingers*. Sent with part of the Salon exhibition to Amsterdam, they were bought by the collector Regnault. Chagall was invited to take part in the exhibition to be staged under the auspices of the German Autumn

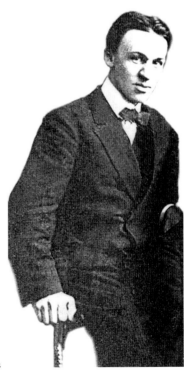

Blaise Cendrars

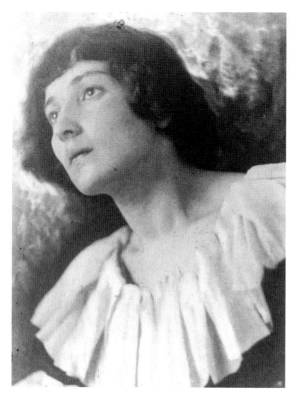

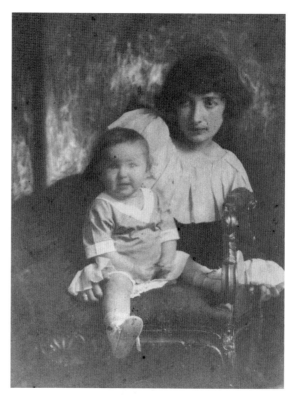

Bella Chagall, 1917

Bella with her daughter Ida, 1917

Salon organized by the affluent art dealer and patron of the arts Herwarth Walden. He went to Berlin, taking with him everything he had painted in Paris.

In April 1914 Herwarth Walden exhibited an important collection of Chagall's work in the Der Sturm gallery. In June and July he mounted the first one-man show of Chagall's work, comprising 40 paintings and 160 works on paper. After the private viewing on 15 June, Chagall took the train to Vitebsk for what he thought would be a short stay there. However, the outbreak of war dashed all hopes of a return to Paris.

1914–1915

After the Paris years of intense creativity, Chagall was once again transplanted to the bleaker reality of his native town. Nevertheless, he gradually came to terms with it. Among the numerous representations of the people around him, his family, the people and countryside familiar from his childhood, remarkable portraits of elderly Jewish people were addded to the series of paintings executed in Paris, related to them in composition. Henceforth, the painter's own portrait would appear frequently on his canvases. For the time being Chagall was expressing himself in drawings whose 'blacks and whites (...) are even denser, richer than (in) his painting'.7 These graphic works were especially appreciated in Russia.

In March 1915 Chagall was invited – on the recommendation of Tugendhold – to exhibit 25 of his paintings at the exhibition *The Year 1915* at the Michailova Salon d'art in Moscow.

What was of greatest importance to Chagall was his reunion with Bella Rosenfeld. Their love gave rise to a poignant

series, 'Lovers.' Their marriage on 25 July 1915 was followed by a stay in the country lasting until September. It inspired lyrical landscapes (*The Poet Reclining*, 1915). Fitting into Russian society again proved very difficult. Chagall tried in vain to return to Paris. Bella's brother, Jacob Rosenfeld, who was a distinguished economist, helped the young couple by putting Chagall in charge of reviewing the press at the war economy office where he worked.

In literary circles Chagall met the art critic Sirkin and some of the greatest Russian poets of the period: Alexander Block, Essenin, Mayakovsky and Pasternak. At the home of the collector Kagan-Chabchai he met Eliachev, a doctor and writer. At his surgery Chagall encountered intellectuals, among them Demian Bedny, a writer of fables and friend of Lenin's, who would help him leave Russia in 1922.

1916–1917

At Petrograd, Chagall exhibited several times at the Dobichina Gallery: in April, 63 works painted at Vitebsk: in November, 4 paintings and 69 drawings – whilst showing 45 pictures at the Jack of Diamonds – and, in 1917, 14 canvases and about 30 drawings at the exhibition entitled *Pictures and Sculpture by Jewish Artists*. Quite a number of Chagall's pictures were bought by distinguished collectors like Kagan-Chabchai, Vissotzky and Moroszov. The critics of the time regarded Chagall as one of the leading artists of his generation.

Ida was born on 18 May 1916.

Chagall was doing his first illustrations, little drawings in ink to illustrate two works of Yiddish literature. Some were for the Peretz novella *The Magician* and others for two verse

narratives by Nister, *With the Cock* and *With the Little Goat*: 'Chagall's pen is at once laconic and limpid (...). Chagall has now made the field of illustration his own'[8], wrote Efross.
On the eve of the Revolution, endeavours were redoubled to create art that was both new and Jewish – this included illustrated works of literature. Work by Jewish artists was exhibited. Moreover, the collector Kagan-Chabchai was planning to establish a museum of Jewish art and acquired some important Chagall canvases for it. The young artist returned to Vitebsk for several weeks during which he painted numerous landscapes.

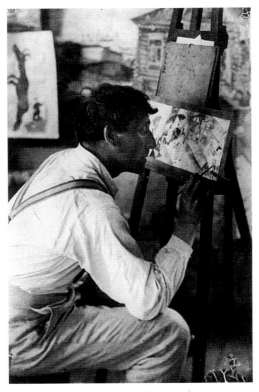

Chagall painting a study for *Introduction to the Jewish Theatre*, 1919–20

The October Revolution at first meant liberation in two senses for Chagall: he was finally able to achieve full citizenship and his friendship with Lunacharsky, President of the Ministry of Culture and the Arts of all Russia bore fruit. The idea of a Ministry of Cultural Affairs was mooted. The poetry section was to be headed by Mayakovsky, theatre by Meyerhold and the Fine Arts section by Chagall. Bella's lack of enthusiasm for this project forced the family to return to Vitebsk, where life was more peaceful. There the couple lived in close proximity to their relatives. The artist painted portraits of Bella and Ida in their new setting.

1917–1918
During the first winter of the Revolution, Chagall celebrated the life of the young couple in large paintings.
1918 saw the publication of the first monograph of his work, written by Efross and Tugendhold.
In August 1918 Lunacharsky approved a project submitted by Chagall for a school of fine art in Vitebsk. Chagall was appointed Commissar. He was authorized, indeed required, to 'organize art academies, museums, exhibitions, conferences and all public presentation of art in the town and region of Vitebsk.'[9]
Chagall mounted a large exhibition of Vitebsk artists and invited his old teachers, Pen, Victor Mekler, among others. On the first anniversary of the Revolution, he assembled all the artists to decorate the town. Hundreds of banners were hung; shop windows and tram lines were decorated; 7 triumphal arches were built and all the streets were hung with garlands and flags. The idea was to bring art down to street level. Enthusiasm was hardly dampened at all by philistine criticism. Chagall threw all his energy into creating an academy of popular art, a communal studio and museum as well as ensuring that drawing was taught at schools. The town offered an old hotel to house the academy and the museum, which was only gradually acquiring a collection. Not until summer 1919 was a series of paintings financed by the official museums fund.

1919
Chagall's chief priority was the academy, which he hoped would attract 'men from the capital to the provinces!'[10] He managed to persuade Dobujinsky, who had been a teacher of his at Svanseva, the painter Ivan Puni and his wife Xenia Boguslavskaya to come to Vitebsk to teach. The school of fine art, by now an academy, was opened on 28 January. During that early period, conferences organized by Alexander Rom and open meetings gave rise to the creation of public studios for 600 art students. Chagall did his best to secure funding. He was in charge of one of the painting studios. The others were entrusted to Ermolaeva and Pen. Lissitzky was Professor of Architecture and Graphic Art. Kozlinskaya was Professor of Applied Art. Jackerson and Lisdokh had two sculpture studios. Kogan taught the preparatory course. Lissitzky

The Committee at the Vitebsk Academy: Marc Chagall in the middle, Jehuda Pen (third from left), Vera Ermolewa and Kasimir Malewitsch (right). Autumn 1919

insisted on Malevich's being appointed to the academy. The Suprematist painter lost no time in becoming openly hostile to Chagall. Chagall was so vehemently opposed to the dogmatism practised by the Suprematist movement which was taking over his academy that he gave up his post and left for Moscow. At the urgent request of his supporters, Chagall returned for a few months. During that time a large free exhibition was mounted, showing the work of Chagall, Malevich, Lissitzky, Pen, Rom, Kandinsky and other Vitebsk artists.

Chagall held the place of honour at the *First Official Exhibition of Revolutionary Art* at the Petrograd Arts Palace. On that occasion the state acquired twelve of his works and the museums at Toula and Smolensk bought two.

In the paintings of that period, the artist returned to geometric form to give rhythm to his composition, which had become freer and more casual (*Cubist Landscape*).

1920–1921

Chagall now left Vitebsk for good, settling in Moscow, where he produced his most important work for the theatre.

The director Nicolas Evreinov, a friend of Meyerhold's, had commissioned Chagall to do the scenery for *To Die Happy in St Petersburg*. The painter had taken an enlargement of his *Saul* of 1911 as his point of departure. Then in 1919, he designed a production of Gogol's *The Gamblers* and *The Marriage* for the Ermitage experimental theatre. A few months later Chagall did the scenery and costumes for Gogol's *The Government Inspector* for the Revolutionary Satirical Theatre. The history of the fledgling Russian theatre begins with Meyerhold's 'Theatre of Style', where the dominant role played by formalist stage settings had been opposed to the 'naturalism' of Stanislavsky since 1905.

After his designs for a production of Synge's *The Playboy of the Western World* had been rejected, Chagall met Alexis Granovsky, the Director of the Kamerny Jewish Theatre in Moscow. This connection allowed Chagall to concentrate on scenery and execute the sets for three plays based on Sholem Aleichem's short stories: *The Agents*, *The Lie* and *Mazeltov*. The leading actor of the company, Michoels, gave these productions a new look stylistically. 'Ah! If you hadn't had such an eye, what a mask might I have invented for you!'[11] said Chagall to Michoels.

Chagall was working for the Kamerny when Vachtangov, a pupil of Stanislavsky's and the director of the Habima Theatre, invited him to collaborate on a production of Ansky's *Dibbuk*. But their ideas were so different that they had to break off their collaboration. For a while Chagall concentrated on painting murals destined for a small Jewish art theatre seating 90, known as 'Chagall's Box'. Ultimately they were transferred to a larger hall in Malaya Bronnaya Street. Exhibited in nine parts during the summer of 1921, these paintings represent a sort of manifest for the powers of the spirit in full play, a theatre of the world: *Introduction to the Jewish Theatre, Music, Dance, Theatre, Literature, The Wedding Banquet, Love on the Stage*, the ceiling and the backcloth.

The financial situation of avant-garde artists holding minor positions suddenly became very straitened, all the more so because Chagall's 'enemies', Kandinsky, Malevich and Rotchenko sat on the committee for the new political economy and were becoming increasingly reactionary. The ministry suggested Chagall seek new employment teaching war orphans at the Malakhovka and 3rd International Schools outside Moscow.

The freer and more original pictorial idiom revealed in the pictures of Chagall's final Russian period must have been due to the disillusion reigning at Malakhovka. There the artist was surrounded by intellectuals like Engel, who had written *Dibbuk*, and the writers Dobruchin, Nister and Hogstein, as well as Markich and Feffer.

1922–1923

In April 1922 the departure of Marc Chagall was announced in the press. Chagall was again living in Moscow. Bella having fallen during a theatre rehearsal, Chagall left Russia alone during the summer of 1922. His wife and his daughter Ida rejoined him some months later in Berlin. Lunacharsky had obtained a passport for him. The art collector Kagan-Chabchai advanced him the money for his trip and the poet Jurgis Baltrusaitis, who was the Lithuanian Ambassador to Moscow, authorized the transport of his work to Kaunas by

Marc and Bella Chagall with their daughter Ida in Berlin, 1923

Marc, Bella and Ida Chagall with Ambroise Vollard (second from left), Paris, ca. 1924

diplomatic bag. Before Chagall left, the Writers' Club quickly set up an exhibition of 65 of his works.

Chagall began to edit *My Life*. After a brief stay at Kaunas, he left for Berlin with all his pictures. Once there, the first thing he did was to see about paintings he had left in the city. Since 1914 Herwarth Walden had been selling some to collectors and, in particular, six large paintings and numerous gouaches to his wife, Nell Walden. Meanwhile, galloping inflation had considerably reduced the value of his earnings from sales, which had been held in escrow by a lawyer all the years he was away. Chagall sued Walden to get the names of the people who had bought his work, if nothing else. A settlement was not reached until 1926, when Nell Walden agreed to return three canvases (*To Russia, Donkeys and Others, My Village and I* and *The Poet*) and ten gouaches.

Reunited in Berlin, the Chagalls moved four times. Chagall did not have the use of a real studio between summer 1922 and autumn 1923, a period interrupted by brief trips to the Black Forest and Bad Blankenburg in Thuringia. The publisher Paul Cassirer was planning to launch an illustrated edition of *My Life*. Chagall had finished twenty copper-plate engravings in Joseph Budko's studio before Hermann Struck managed to supply him with the necessary materials for engraving, enabling Chagall to execute twenty more. The German translation of *My Life* by Walter Feilchenfeldt, the director of the Cassirer Gallery, failed to bring across its poetic language. All that was printed of *My Life* is a portfolio with twenty engravings (the first edition of *My Life* was not to appear until 1931, in Bella's French translation).

'After the war Berlin has become a sort of *caravanserai* where

everyone meets on the way to and from Moscow and the West'.[12] Among Chagall's best friends in Berlin were Dr Eliachev, Pavel Barchan, Moise Kogan, the writer Bialik and Frida Rubiner (who translated Efross and Tugendhold's Russian monograph), the painters George Grosz, Karl Hofer, Jankel Adler, David Schterenberg and his wife Nadeshda, Ludwig Meidner and Alexander Archipenko. In January 1923 the Van Diemen Gallery mounted an exhibition comprising 164 Chagall works dating from 1914 to 1922. Although he had become fairly well known, Chagall did not like Berlin. All he could think of was of returning to Paris.

1923–1925

Chagall received a letter from Blaise Cendrars in Paris with a commission to illustrate books from the art dealer and publisher Ambroise Vollard. In August 1923 Chagall asked for a visa for France. On 1 September the family arrived in Paris. They spent their first months there in a damp room in the Faubourg Saint-Jacques medical building.

From the start, Chagall had been in contact with Ambroise Vollard. He suggested that Chagall illustrate a book by the Countess de Ségur. In turn Vollard agreed to Chagall's proposal that he should illustrate Gogol's *Dead Souls* with 107 plates engraved between 1923 and 1925, work which was proof indeed of Chagall's powers as an illustrator.

Early in 1924, Eugène Zack lent his studio at 110 Avenue d'Orléans to the Chagalls. They stayed there until the end of 1925.

Chagall soon started painting but he needed to draw on his earlier work. Most of it was in Germany and the rest in

Russia. Other more minor works, left behind at La Ruche, had disappeared. In order to get in touch with his past again, the painter executed replicas between 1923 and 1924 (*Jew in Black and White* and *The Birthday*); variants (*Introduction to Jewish Theatre*, *Circus* and *Harlequins*) and new versions (*Double Portrait* and *Bella with Carnation*) of work done in his youth. They were of even more subtle composition than the originals, were freer in form and the colour was more luminous, a celebration of Chagall's reunion with Paris. Chagall met old friends, teachers and patrons there, too, such as Leon Bakst, André Levinson and Max Vinaver. He also made new friends: Gustave Coquiot, Jeanne Bucher, Jacques Guenne, Florent Fels, Ivan and Claire Goll and Marcoussis.

stayed several times during 1925. This village, where he rediscovered flowers, inspired numerous pastoral paintings.

Two exhibitions were mounted: at the Cologne Kunstverein and the Ernst Arnold Gallery in Dresden.

In December 1925 the Chagalls left their flat in Avenue d'Orléans for a house in Boulogne-sur-Seine.

1926–1927

Early in 1926, 100 works were assembled for Chagall's first exhibition in the US, organized by the Reinhardt Gallery in New York.

Chagall spent most of 1926 in the country, mainly at Mourillon near Toulon, a small fishing village on the

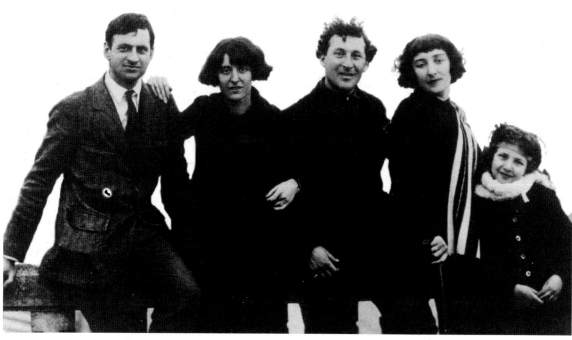

Ivan and Claire Goll, Marc, Bella and Ida Chagall (from left to right), Bois-de-Cise, Normandy, March 1924

After Breton's *First Surrealist Manifesto* had appeared in print, Surrealism was flourishing. Surrealists like Max Ernst and Paul and Gala Eluard invited Chagall to join in. He refused, feeling no affinity with the movement which was based on automatism and obeying the dictates of the subconscious.

Roughly 50 works were exhibited by Le Centaure Gallery in Brussels.

Late in 1924 an exhibition of 122 works was mounted by the Barbazanges-Hodebert Gallery in Paris.

'I want earthy art, not just head art.'[13] This declaration explains Chagall's fascination for nature, light and the French countryside. He experienced this particularly strongly during his frequent trips to l'Isle-Adam on the Oise – where the Delaunays spent the weekends – at Ault in Normandy and on the island of Bréhat in Brittany.

It was the Belgian critic Florent Fels who introduced Chagall to the country between the Seine and the Oise, in particular the little village of Mont-Chauvet, where the Chagall family

Mediterranean. It was not far from Fort-Saint-Louis, where Georges and Marguerite Duthuit-Matisse lived.

The painter went to Nice for the first time. He was enchanted by the light and the vegetation there.

The Chagall family also spent several months at Chambon-sur-Lac in Auvergne, in a house opening on to the village square with a view of the church. While there Chagall was commissioned by Ambroise Vollard to paint about 30 gouache plates for an edition of the La Fontaine *Fables* to be engraved on copper.

Thirty of his works were exhibited by the Katia Granoff Gallery in Paris.

Chagall illustrated his friend Marcel Arland's novel *Motherhood* with five engravings. He illustrated Jean Giraudoux' *Seven Deadly Sins* and texts by Paul Morand, Pierre Mac Orlan, André Salmon, Max Jacob, Jacques de Lacretelle and Joseph Kessel (15 engravings). For Gustave Coquiot's *Suite provinciale* he used some drawings in his Chambon manner.

Right: Marc, Ida and Bella Chagall outside the studio in Boulogne-sur-Seine, 1925

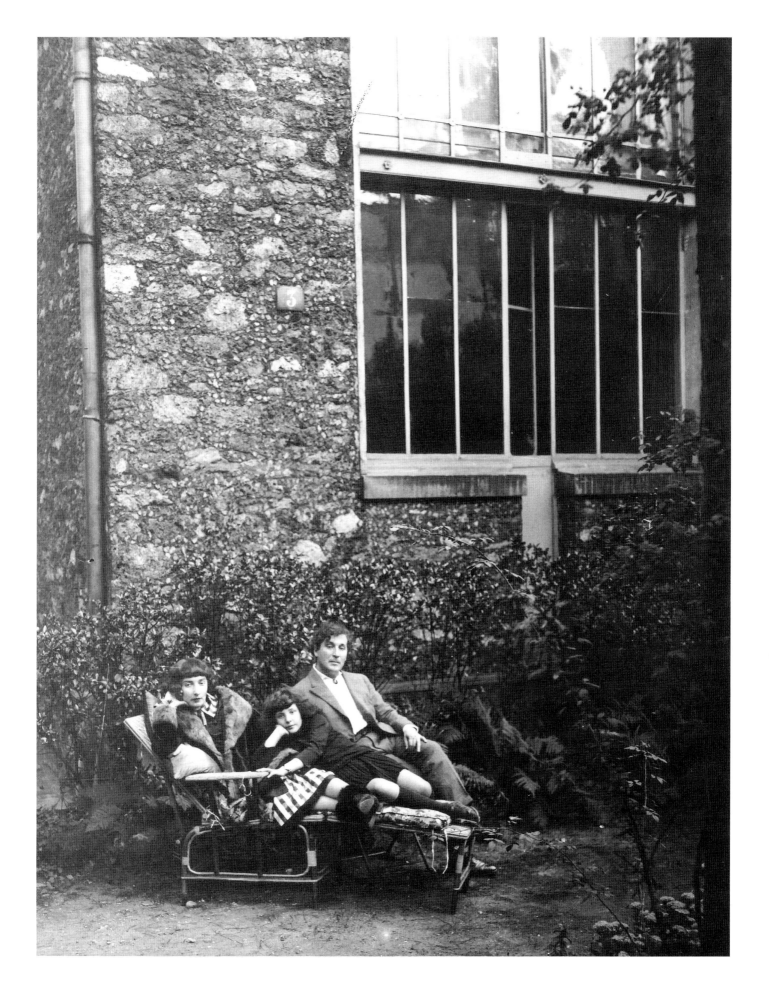

Late in 1926 the Katia Granoff Gallery exhibited his *Summer Work, 1926*.

Whilst Chagall was working on the *Fables*, Vollard was envisaging another illustration project on the circus. The two spent many evenings together at the Circque d'hiver. In 1927 Chagall did 19 gouaches entitled *Circus Vollard*. Vollard introduced Chagall to Rouault, Bonnard, Vlaminck and Maillol. Chagall made friends with Zervos (who introduced him to Picasso), Tériade, Gargallo, and Charreau.

He never broke off corresponding with and meeting Russian friends. Members of his familly even came to Western Europe.

While Granovsky and his company were giving rep performances at the Porte-Saint-Martin theatre, Chagall and Bella spent every evening there. They gave receptions for friends who were in the company as the ties to Michoels had remained very close. Chagall gave 96 engravings for *Dead Souls* to the Tretyakov Gallery in Moscow.

A contract with Bernheim-Jeune guaranteed financial security. Chagall became a founding member of the association of painters and engravers.

From May to September 1927 the Chagalls were at Châtel-Guyon in Auvergne, where Bella and Ida were taking a cure. Chagall met Soutine again there. He and his family were also staying not far from Saint-Jean-de-Luz near Biarritz.

In November Chagall took a 6-days trip by car with Robert Delaunay, going through Montauban and Albi. At Limoux they visited the connoisseur Jean Girou and the writer Joseph Delteil before continuing on to Collioure and Banyuls-sur-Mer and visiting Maillol.

Late in the year Chagall discovered another stretch of beautiful country, the Savoy. At first he was in Chamonix and then in the neighbouring villages of Houches and Des Bossons. The churches in their snowy setting inspired him to some canvases recalling Russia.

1928–1929

The winter of 1927–1928 saw other work on the circus, some of it a remake of *Circus Vollard*. Chagall was still working on the black-and-white engravings for the *Fables*, at first for Louis Fort. The latter had begun printing *Dead Souls* but difficulties arose. The whole series was turned over to Maurice Potin. An exhibition of the *Dead Souls* illustrations as well as the André Salmon monograph on Chagall was organized by the Le Portique Gallery in Paris.

During the summer of 1928, Chagall left on his own for Céret, a small village in the Pyrenees which had attracted him as early as 1911 and, in 1913, Picasso and Braque. At Mas Lloret he concentrated on his engravings for the *Fables* and on still lifes. His compositions of lovers, animals and flowers are poetic, full of the artist's friendship with the poets Supervielle, Eluard and René Schwob. Schwob introduced him to the philosopher Jacques Maritain and his wife Raissa. Every Sunday afternoon a circle of artists and writers met at Meudon at the Maritains' house. For the next ten years the Chagalls were to join them.

André Salmon translated *My Life* into French. His version was too 'Western' in Chagall's opinion and was revised by Bella. With Ludmilla Gaussel and Jean Paulhan, she went through it sentence by sentence.

The Epoque Gallery in Brussels exhibited a series of Chagall's gouaches.

In autumn Chagall was again at Céret, accompanied by Bella. At the close of 1929 he bought villa Montmorency at 15 Rue des Sycomores near Porte d'Auteuil. After moving in, he executed numerous small works, taking lovers, nudes, circus scenes and luminously glowing villages as his subject. The family spent part of the winter in the Savoy Alps, mainly at the Soleil d'Or Hotel in Megève.

The 1929 the Wall Street crash forced Bernheim-Jeune to break off the contract with Chagall. All he now had to ensure a modest income was his work for Vollard.

1930

The *Fables* were exhibited in Paris by Bernheim-Jeune, in Brussels by the Le Centaure Gallery and in Berlin by Flechtheim, where Chagall went to the opening. The painter and his family spent the summer at Nesle-la-Vallée near l'Isle Adam. On Delaunay's advice, he bought property there and painted some gouaches.

During summer and autumn the Chagall family spent some weeks on the Mediterranean and at Peira-Cava in the Maritime Alps. There the artist composed a number of variations on the theme of windows: 'Chagall doesn't descend to his countryside; he contemplates it from afar as if under an enchantment, dreaming of love with open eyes.'[14]

His major works of that period are his Bible illustrations, commissioned by Vollard. The spiritual qualities and poetry of the Bible had been with him since childhood. ('I wasn't seeing the Bible, I was dreaming it'). This commission led him to visit the country of the Bible, Palestine.

An exhibition of oil paintings, gouaches and watercolours was mounted by the Demotte Gallery in New York.

Chagall met Meir Dizengoff, mayor and founder of Tel Aviv.

1931

From February to April Chagall was in Palestine with Bella and Ida for Purim at Dizengoff's invitation. He was present when the cornerstone was laid for the Palestine Museum in Jerusalem. He went to Haifa and Tel Aviv as well as Jerusalem. Earlier the Chagalls had accompanied the poets Chaim Bialik and Edmond Fleg to Alexandria, Cairo and the Pyramids. Stirred by the scenery of Palestine, the artist worked in Tel Aviv, painting interiors of synagogues at Safed and Jerusalem landscapes.

After this enriching experience, Chagall executed some etchings illustrating the Bible on his return to Paris. Once it got going, the project was to keep him busy, with interruptions, for many years. By Vollard's death in 1939 only 66 of the 105 plates planned had been finished. Chagall did not start working on them again until 1952. The work was edited by Tériade in 1956. The beautiful light of Palestine suffused all his work of that period, compositions of flowers and circus motifs.

My Life was published by Stock in Paris.

'Twenty Recent Pictures and Some Unpublished Drawings

from His Youth by Marc Chagall' were exhibited at the Le Portique Gallery in Paris.

Late in the summer Chagall stayed in the La Malsanne Valley in the Dauphiné.

1932

Chagall agreed to design the sets and costumes for a ballet in three parts (French Revolution, Russia, Greece) by Bronislava Nijinskaya to music by Beethoven. The ballet was never finished.

About 55 works were exhibited for the first time in Holland by the Association of Dutch Artists. Chagall took the occasion to go to Holland with Bella. He was awed by the

1934–1938

During the summer of 1934, Chagall and Bella went with other painters and writers, among them Supervielle and Michaux, to Tossa del Mar on the Costa Brava. They then visited Barcelona, Madrid and Toledo, where El Greco's paintings left a deep impression on Chagall.

About 52 of his works were exhibited at the Dra Feigla Gallery in Prague.

After his first London exhibition, at the Leicester, Chagall went to Poland with Bella in August 1935 to be present as the guest of honour at the opening of the Jewish Cultural Centre at Vilna, which mounted a Chagall exhibition of 116 engravings and etchings.

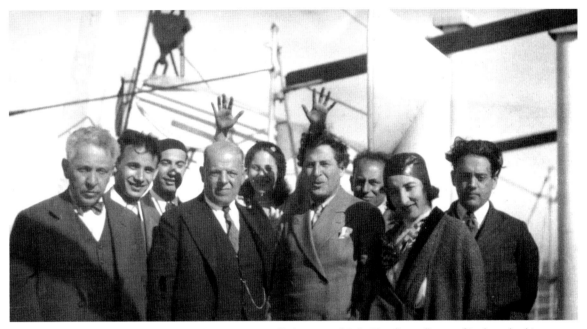

Chaim Bialik, Joseph Boxenbaum, Alexander Fleg, Meir Dizengoff, Ida, Marc and Bella Chagall as well as two friends on the ship 'Champollion', leaving for the Palestine, 1931

masterpieces in the museums there, especially Rembrandt's canvases.

A number of drawings by Chagall were exhibited in Budapest.

Chagall spent the autumn with his family in a little hotel at Cap-Ferret near Bordeaux.

1933

During an exhibition of 'Cultural Bolshevism in Art' at the Mannheim Kunsthalle, Nazis burned work by Chagall.

Chagall was unable to become a French national. His having been Fine Arts Commissar in Vitebsk was the reason advanced for the refusal of his citizenship application. He would not become a French citizen until 1937, when the writer Jean Paulhan intervened on his behalf.

That summer the painter visited Vézelay.

Towards the end of the year he went to the opening of an exhibition of 172 of his works at the Basle Kunsthalle.

Political events were beginning to influence his work.

In 1936 Chagall went to the Café de Flore several times, where he met Picasso, who was working on *Guernica*. Some of Chagall's compositions also reflect the suffering and distress of that period. Nevertheless, his subject matter was highly diverse due to several stays in the French Jura during the summer of 1936 and, during the winter, in Haute Savoy and then in the Vosges.

At the close of 1936, Chagall moved into a new studio at 4 Villa Eugène Manuel near the Trocadéro.

The New Art Circle in New York dedicated an exhibition entirely to Chagall's work.

The painter showed 34 works at the exhibition *Instinctive Painters: The Birth of Expressionism* at the galerie Beaux-Arts in Paris. Political tensions, which had been mounting in France since 1934, induced Chagall to readdress the theme of revolution (*Revolution*), using a new pictorial idiom.

In the spring of 1937, Chagall stayed at Villars-Colmars in the Haute-Provence Alps as well as in the Avignon region before leaving with Bella for Italy. In Florence he executed 15

etchings for the Bible series. The riches of Quattrocento painting there enthralled him.

They went on to Venice, where the painter broadened and deepened his knowledge of Bellini, Titian and Tintoretto.
During the summer of 1937, Chagall showed four works in the exhibition entitled *Origins and Development of International Independent Art*. He also had 17 works in the exhibition *Masters of Independent Art 1895–1937* in the Paris Petit Palais. The Nazi regime had all works by Chagall in German museums confiscated. Three works of his, *Purim, The Treasured One* and *Winter*, featured in Degenerate Art, the notorious Nazi exhibition.

Under the auspices of the international exhibition at the Trocadéro, the Chagalls often lunched with friends. Some of these were close to the Maritains; others were Spanish refugees. They were particularly close to the poet Rafael Alberti and Dr Ichok. This friendship gave Chagall a new zest for life which is reflected in his return to the circus theme.

In 1938 Chagall and Bella spent several months at Villentroy in Indre-et-Loire. Exhibitions of his work were mounted in the Brussels Palais des beaux-arts and the Lilienfeld Gallery

in New York. He had an oil painting in the International Exhibition of Painting at the Carnegie Institute in Pittsburgh but was not awarded a prize.

1939

Chagall returned to Villentroy, where he thought, wrongly, that he was being threatened by a farmer. Soon after war was declared, he moved to Saint-Dyé-sur-Loire. His daughter Ida helped him to transport all the canvases from his Paris studio to Saint-Dyé in a taxi.
The Betrothed took 3rd prize at the Carnegie Institute in Pittsburgh.

1940

In January the painter and his daughter Ida took some oils and gouaches to Paris for an exhibition mounted by Yvonne Zervos to celebrate the opening of the Galerie Mai. At the rear of a hall, the canvas *Revolution*, an anti-war manifesto, was exhibited under the title *Composition*.
During this period Chagall often met Zervos and Picasso. He worked mainly at Saint-Dyé until spring.

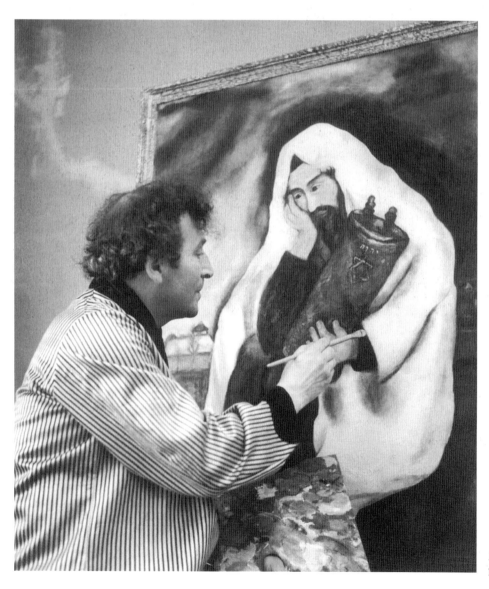

Marc Chagall
painting *Solitude*, 1933–34

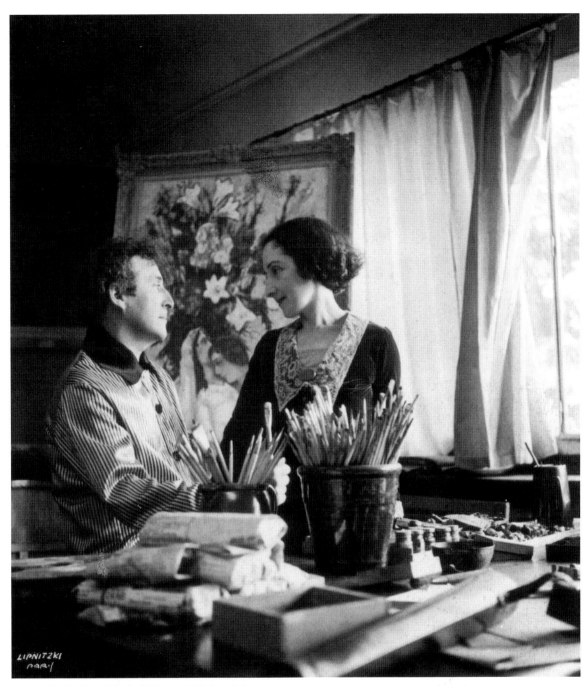

Marc and Bella Chagall. In the backgound *The Betrothed*, 1939

Political events forced Chagall to retreat south of the Loire. André Lhote had told him about the village of Gordes in Lubéron where he went at Easter. On 10 May, as the Germans invaded Belgium and Holland, Chagall bought a former Catholic girls' school at Gordes and set up a studio in it. Early in May Chagall, Bella and Ida took a lorry to retrieve work which had been left at Saint-Dyé. The peaceful atmosphere of Gordes radiates from still lifes, little village scenes and work like *Self-Portrait of the Artist at His Easel*.

1941

During the winter, the director of the Emergency Rescue Committee, Varian Fry, and the Consul General of the Uni-

ted States in Marseille, Harry Bingham, visited Chagall to extend an invitation to him from the Museum of Modern Art in New York to accompany other well known artists like Matisse, Picasso, Dufy, Rouault, Masson and Ernst (all of whom were invited) to America. Chagall did not realize what an opportunity this was because he was entirely unaware of the danger he was in until the day the Nazi anti-Semitic laws were also put into force in France.

In April Chagall and Bella left for Marseille to prepare their departure with the help of their daughter Ida. They were hoping to get a French visa authorizing their immediate return to the country that had become their second home. In Marseille they stayed at a modern hotel where a razzia

Marc and Bella Chagall with Pierre Matisse in his gallery with
Double Portrait with a Glass of Wine, New York, 1941–42

Chagall was commissioned by the New York Ballet Theater
to execute the sets and costumes for the ballet *Aleko*, based
on a Tchaikovsky trio and the Pushkin novella *Gypsies*, and
choreographed by Leonid Massine. The first performance
took place at the Bellas Artes Theatre in Mexico. All prep-
arations were made in New York. Massine conferred with
Chagall daily; the choreography and sets were a joint pro-
duction. In order to do the four sets and supervise the
making of the costumes, Chagall and Bella left for Mexico in
August, one month before the opening night. At first they
lived with Massine outside Mexico City in San Angel, but
moved to the centre of the city because they had to spend all
their time in the theatre.

Chagall and some dancers in front of the backdrop *Aleko and
Zemphire in the Moonlight* for the ballet *Aleko* (scene 1), 1942

took place. Chagall was arrested although soon freed on the
intervention of Fry and Bingham.

On 7 May they left Marseille and, after stopping at Madrid,
arrived in Lisbon on 11 May. There they waited to embark
for America. All his work, packed in trunks and crates
weighing 600 kg, had been sent directly to Lisbon but was
held up for five weeks in Spain until Ida managed to free it
with the aid of French, American and Spanish friends so that
it could be put on the ship with the Chagalls.

'A wall is rising between us / A mountain covered with grass
and graves'[15] Chagall wrote in a poem at that time.

On 23 June, as the Germans invaded Russia, Chagall and
Bella disembarked in New York.

At first they lived in a hotel, then in 57th Street and after that
Hampton House, ending up at The Plaza. They spent some
weeks in New Preston, Connecticut, near the homes of
André Masson and Alexander Calder until in September
they finally found a little flat in New York at 4 East 74th
Street. The Maritains, Lionello Venturi and the Yiddish poet
Joseph Opatochou were regular guests of Chagall and
Bella's.

Chagall was also reunited with Léger, Bernanos, Mondrian
and André Breton in New York. He met Pierre Matisse
(who had mounted an exhibition of Chagall's work
for the Barbazanges-Hodebert in 1924). Matisse became
Chagall's agent, representing a cherished link with France
and French art. Late in November he exhibited 21 Chagalls
in his gallery dating from 1910 to 1941. This exhibition was
followed by others at regular intervals as long as the artist
lived.

New York, which Chagall called Babylon, stunned him
because of its immense scale and throbbing vitality.

The discovery of the tropics and the hot-blooded people
there made the project brought from New York all the more
vibrant. The opening night of *Aleko* on 10 September was a
triumph: 'Bravo Chagall! Viva Chagall! This evening I have
had the pleasure of applauding Chagall as a stage designer
and of celebrating him not only for his splendid stage decor
but also for his magnificent sense of theatre, his humour and
his great humanity'.[16] The triumph was repeated in New
York, when the performance opened at the Metropolitan
Opera House.

Salomon Michaels and Marc Chagall, New York, 1943

1943

The war news and especially the horrors ravaging his native country left Chagall stunned (*War, Obsession, Yellow Crucifixion*). That summer and autumn the artist again encountered Michoels and the poet Itzik Feffer, due to a Soviet government cultural mission to America. Chagall dedicated two canvases to them as well as a letter addressed 'to his Russian friends'. Containing his poems in Yiddish, illustrated by drawings and published in New York, it was taken back to Russia by Michoels and Feffer. Chagall's return in spirit to his native land is also reflected in the snowy landscapes, forests and vast expanses of forest painted at Cranberry Lake, where the Chagalls occasionally stayed.

The circus theme, with trick riders and trapeze artists reappeared in Chagall's work. In the studio belonging to Stanley W. Hayter, where many refugee artists were working, Chagall executed engravings between 1943 and 1944 featuring circus motifs. The imprint of string and cloth made its first appearance in his work.

1944

Marc and Bella spent the summer at Cranberry Lake in upstate New York. The scenery inspired Chagall to numerous scenes of village life and several paintings. There they heard of the occupation of France and, several years later, with deep emotion, of the liberation of Paris. Bella was never to see Paris again.

A few days before they were due to depart for France early in September, she fell ill, struck down by a virus infection accompanied by a high fever. Taken by ambulance to a New York City hospital, Bella died there for lack of care 36 hours later on 2 September. The hospital had been reserved for American military use. Bella's sudden death was an appalling tragedy for Chagall: 'Everything has become shadow'.[17] Prostrated with grief, he was unable to summon the energy to paint again for the next nine months. In his studio the paintings were turned to the wall.

1945

His daughter Ida, who lived at 43 Riverside Drive, gave Chagall the comfort and loving care he needed so that he gradually regained his desire to go on living. The first thing he did was to help Ida with the French translation of the first volume of Bella's memoirs, *Lamps Lit*, written in Yiddish.

That summer Ida hired a young Englishwoman who spoke French, Virginia NcNeil, to take care of her father.

Chagall first worked at Krumville in Ulster, then, accompanied by Ida, he went to a rented house at Sag Harbor, Long Island. There he designed three sets, a curtain and more than 80 costumes for Stravinsky's *Firebird*. Put on by the New York Ballet Theater, it was choreographed by Adoph Bolm, who had once been a dancer in Diaghilev's company, but Chagall disagreed with what he was doing. The costumes were finished at the theatre under Ida's supervision. The opening night of the *Firebird* was a triumph: 'Chagall's sets dominate the performance.'[18] was the verdict in the American press.

1946

During the winter of 1945–1946, Chagall bought a modest clapboard house in the Catskill town of High Falls in the northeast of New York state. He moved there with Virginia, who lived with him for seven years. Their son David was born on 22 June.

The artist occasionally saw his daughter Ida, who, with James Johnson Sweeney, was preparing a retrospective covering forty years of her father's work at the New York Museum of Modern Art. It was shown at the Art Institute of Chicago from September.

After this crowning achievement, Ida returned to Paris to prepare, with the support of Jean Cassou and the director of the Paris Modern Art Museum, an exhibition honouring Chagall to celebrate the reopening of the museum.

Chagall then spent three months in Paris in the company of the collector Louis Stern to get back in touch with Europe and relive the atmosphere and light of Paris. Whilst there, he saw his old friends, both painters and poets. He illustrated Eluard's book of poems *Le Dur Désir de durer* with drawings. In Paris Chagall did some sketches which he would develop into the 'Paris series' in 1954.

That autumn the artist returned to High Falls although his longing for a return to Paris never ceased. He devoted himself to a series of large paintings, concentrating on some magnficent gouaches to illustrate *The Thousand and One Nights* (*The Arabian Nights*). They led to his first colour lithographs, commissioned by the publisher Kurt Wolff.

From the end of the war, many exhibitions of his work were mounted throughout the world, heralding the many exhibitions that were to fill the decades to come.

1947

Chagall left High Falls to attend the opening of a large-scale exhibition of his work at the Paris Museum of Modern Art. Other retrospectives followed: at the Amsterdam Stedelijk Museum, the London Tate Gallery, the Zurich Kunsthaus and the Bern Kunsthalle.

1948

In August Chagall and Virginia sailed for Le Havre on the 'Grasse', accompanied by the philosopher Jean Wahl.

They moved into a house Ida had taken at Orgeval near Saint-Germain-en-Laye with a large overgrown garden. People soon began to gather there. Among their frequent guests were Claude Bourdet, editor-in-chief of *Combat*, Paul Eluard, Jean Paulhan, Maritain, Ivan Goll, Pierre Reverdy, the art dealers Louis Carré and Aimé Maeght – from then on Chagall's French agent – and the publisher Tériade. He had taken over all the engravings for *Dead Souls*, the *Fables* and the *Bible* from Vollard.

In September Chagall went to the Venice Biennale, where an entire room was devoted to his work, and he was awarded the prize for engraving. In the museums, the palaces and churches he marvelled at the frescoes and paintings of the great Italian masters.

He began painting murals for the lobby of the Watergate Theatre in London.

1949

In January Chagall interrupted his stay at Orgeval to visit Tériade at Saint-Jean-Cap-Ferrat. The publisher spent part of the year in a magnificent house surrounded by a lovely flower garden. The painter at first stayed at the *Lou Mas de la Mer* guest house, which had windows overlooking the fishing port. For the first time he did some wash drawings in Chinese ink, on Boccacio's *Decameron*. They were to go to the revue *Verve* in 1950 with a text written by Jacques Prévert. During those months the ties to Tériade grew closer. The latter suggested Chagall should illustrate the masterpiece of Hellenistic literature, the celebrated pastoral tale by Longus, *Daphnis and Chloe*. The stay with Tériade only increased the painter's fascination for the Mediterranean light, which, in his work, emerged as a renewal of form.

Determined to combat a resurgence of racism, Chagall took part in May in a large gathering at the Cirque d'hiver, where he voiced a protest against anti-Semitism. In October he returned to the south of France, staying at Les Chèvres, a villa in Saint-Jeannet, where the Surrealist poet Georges Ribemont-Dessaignes lived. A month later Chagall rented Le Studio at Vence, producing his first pottery in Mme Bonneau's studio. A lovely exhibition of gouaches followed at the Rosengart Gallery in Lucerne.

1950

At the request of her father, Ida returned to the United States to bring all his work back to Europe.

Entranced by the countryside around Vence, Chagall bought La Colline, situated on the Baou des Blancs on the road between Vence and Saint-Jeannet. The property comprised a dwelling and a smaller building housing a studio, both surrounded by magnificent orchards and flower gardens. In spring he moved in.

At Vence, a great many works in progress were finished and others were produced: a series of village scenes flooded with the magical Mediterranean light; oils and gouaches celebrating lovers. Nearly all the works of the years to come were

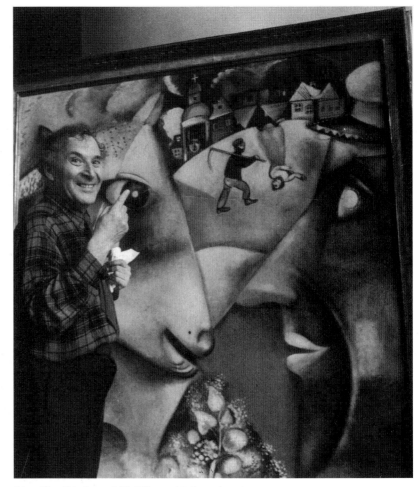

Marc Chagall in front of *The Village and I*, Orgenal, 1948

begun; most importantly, from 1950 onwards, the monumental illustrations for the Bible.

The artist often went to Paris, where he stayed with Ida in the Quai de l'Horloge. Seriously involved with engraving, he was, like so many other painters, sculptors and writers, a regular visitor of the man who had brought lithography back from oblivion, Fernand Mourlot, where he learnt the process. Chagall met Charles Sorlier, who made all the lithographs from his work and was to become one of his closest collaborators. At Mourlot's studios he executed his first lithographic poster for an exhibition at the Maeght Gallery.

The Côte d'Azur had become a centre of art since the end of the war. There Chagall met Matisse and Picasso on a regular basis. The former lived at Cimiez and the latter at Vallauris.

The Haus der Kunst in Munich mounted a retrospective.

The artist was now making pottery, at first painting his pieces in Provençal style, at Serge Ramel's in Vence as well as at L'Hospied Ceramic Studio at Golfe-Juan.

The years between 1950 and 1960 brought Chagall a great variety of commissions, which led him to explore in depth numerous areas of expression and to confront the task of translating his work into a monumental scale. He was asked to illustrate books, to paint monumental pictures, to produce sculpture, glass, mosaics and tapestries.

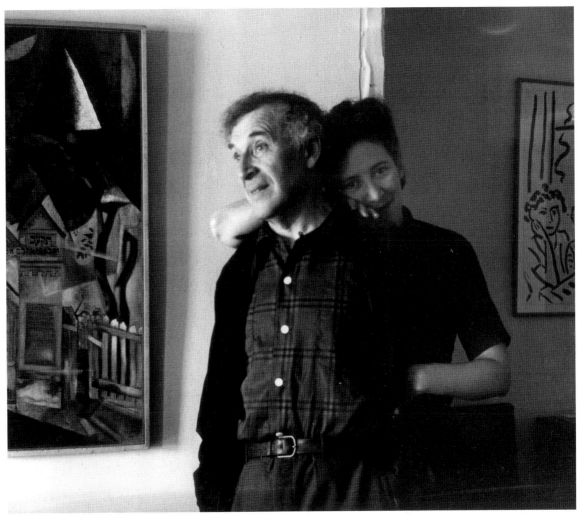

Marc Chagall with his daughter Ida, Paris, 1951. On the left: *The Cemetary Gate*

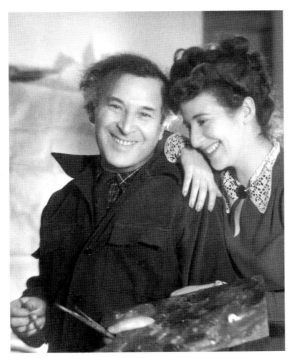

Marc Chagall and Ida, Paris, 1951

1951

Chagall went to Israel, visiting Jerusalem, Haifa and Tel Aviv to be present at the opening of an exhibition of his work.

That summer Chagall spent several weeks at Gordes, where he collaborated with Henri Langlois, the director of the French Cinémathèque, in making a film on his paintings. He also heightened his broad-bordered engravings of the *Fables* with watercolour. After that he spent several weeks at Dramont, a small seaside resort near Saint-Raphael, where he felt inspired to do some gouaches with sea motifs.

Taking her two children with her, Virginia left Chagall to follow the photographer Charles Leirens to Brussels.

1952

In spring the painter met Valentine (Vava) Brodsky, who was born in Russia. He married her on 12 July at Clairefontaine near Rambouillet. Thus began a new chapter of his life. The rapture of this new love led the artist to explore other fields of art. Chagall now devoted himself to ceramic murals and made vases, jugs and plates, changing their shape by moulding them by hand. From then until 1962, he produced pieces at Madoura, the studio owned by Suzanne and Georges Ramié at Vallauris. He also sculpted in marble and

terracotta. During March and April ten of his ceramic murals were shown at the Maeght Gallery. With the approval of Father Couturier, the painter began to work out a project for a monumental ceramic mural which would be placed in the baptistery of Notre-Dame de Toute-Grâce at Assy in 1957. In June he visited the cathedral at Chartres to study the ideas and techniques of medieval glassmaking.

Chagall devoted himself to the theme of Paris, since the city symbolized for him the union of the inner universe and the external world: 'Paris (...) which I have returned to enriched, relived, it's as if I had been forced to be reborn, to shed tears in order to weep again. It took absence, war, suffering to reawaken all that in me, to become the framework for my thoughts and my life (...). Keeping the soil of one's roots or discovering another is truly a miracle'. [19]

In the course of preliminary studies for the *Daphnis and Chloe* illustrations, Chagall and Vava went to Greece, where they visited Delphi and Athens. They also stayed on the island of Poros, which had a profound impact on his art. The *Fables* of La Fontaine were published by Tériade.

Chagall went to Italy, visiting Rome, Naples and Capri.

1953

He visited Turin to open a retrospective of his work in the Palazzo Madama, and executed the preliminary gouaches for *Daphnis and Chloe*. In London for the New Year, he discovered a special 'chemistry' which he translated into colour.

1954

That autumn Chagall and Vava returned to Greece: first to Poros, then to Nauplion for a while before visiting Olympia. Chagall translated the powerful impressions which the country made on him into a great many drawings and gouaches. He also went to Venice, where he was staggered by his renewed acquaintance with Titian and Tintoretto. He did some work in glass at Murano and visited Ravenna and Florence. Chagall painted two large murals for Tériade's house at Saint-Jean-Cap-Ferrat.

The Maeght Gallery exhibited his work.

1955

Whilst making a film at the Cirque d'hiver, the circus once again enthralled the artist, who did some sketches for his 1956 *Grand Cirque*.

He continued to work on his series of murals on the Biblical Message, which would be finished in 1966. He hoped to unite them in one place.

The Kestner Society of Hanover staged a retrospective of his work.

1956

That year saw a prolific production of lithographs. New religious cycles were added to his engravings. The Bible was published by Tériade.

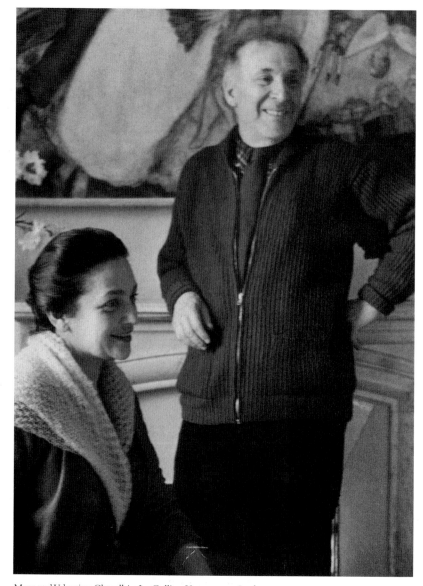

Marc and Valentina Chagall in La Colline, Vence, 1952. In the background: *The Bride and Groom with the Eiffel Tower*, 1938/39

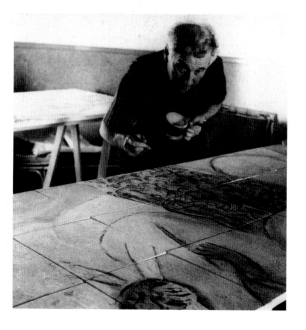

Marc Chagall working on his wall ceramic *Crossing the Red Sea*, 1956, for Notre Dame de Fontes Grâces, Plateau d'Assy

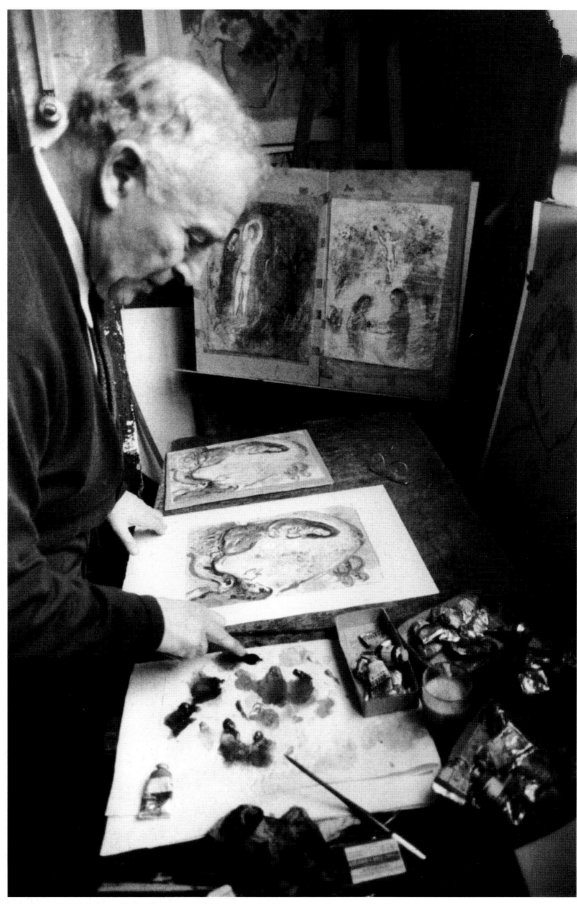

Marc Chagall with his gouaches and prints for the volume of lithographs for *Daphnis and Chloe*, Paris, 1956

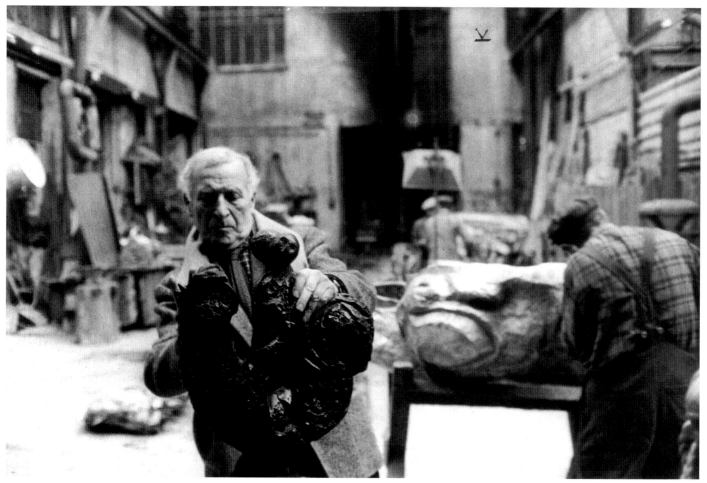

Marc Chagall in front of *The Cock* in the studio of the bronze caster Susse, Paris, 1959

The Basle Kunsthalle, the Bern Kunsthalle and the Brussels Palais des beaux-arts mounted exhibitions of Chagall's work. The artist painted a work in commemoration of Gauguin after a canvas in the Courtauld Institute in London.

1957
Chagall went to Israel for the third time. The Bibliothèque nationale in Paris held a retrospective of his engravings.
Prints from his *Daphnis and Chloe* cycle were now being pulled from the stone at Mourlot's. Chagall painted a cartoon for his first mural mosaic, *Blue Cock*, executed by the Gruppo Mosaicisti de Ravenna in 1958.
His ceramic mural, *Crossing the Red Sea*, was placed in the baptistery of the church at Assy.
In Paris Chagall lived at the Quai Bourbon before buying a flat at 13 Quai d'Anjou on the Île Saint-Louis. There he spent his time, after 1966, doing copper-plate engraving and lithography.

1958–1959
In February 1958 Chagall and Vava went to Chicago. During a conference at the University, he called his work, his life and painting his only means of expression: 'I chose painting, it was as necessary to me as food. It seemed to me like a window through which I could fly away to another world'.[20]

After his *Daphnis and Chloe* illustrations, the Paris Opera asked Chagall to design the sets and costumes for Maurice Ravel's ballet *Daphnis and Chloe*, based on a libretto by Michel Fokine and choreographed by Georges Skibine. It opened at the Brussels Mint during the World Fair.
At Mies on Lake Geneva, the painter delved in his gouaches into the mystery which Gauguin incarnated for him.
Chagall met Charles Marq, a master glassmaker and director of the Simon Studio at Reims. In collaboration with the Saint-Just glassworks, he was to resolve, project by project, numerous problems posed by the richness of colour characteristic of Chagall's stained glass windows.
The sketches for the windows of Metz Cathedral, executed in 1959, already attest to the consummate artistry with which Chagall approached and mastered the challenge of medieval architecture.
The mural *Commedia dell'Arte* was unveiled in the lobby of the Frankfurt city theatre. Chagall worked on his circus theme.
In 1959 Chagall went to Glasgow to receive an honorary doctorate from the University.
He was elected an honorary member of the American Academy of Arts and Letters. Large-scale exhibitions of his work were mounted in the Hamburg Kunsthalle, the Munich Haus der Kunst and the Musée des arts décoratifs in Paris.

Marc Chagall at the window of his flat in the Quai d'Anjou, Paris, 1958–59

1960

Early in the year Chagall did some gouaches in the snowy village of Sils Maria in Switzerland.

He was granted an honorary doctorate by Brandeis University in Massachusetts. He and Oscar Kokoschka were awarded the Erasmus Prize by the European Cultural Foundation.

The painter worked on designs for twelve stained glass windows in the Hadassah Medical Center synagogue in Israel, depicting the twelve tribes of Israel.

His sculpture and windows were exhibited for the first time by the Musée des beaux-arts at Reims.

1961–1962

Daphnis and Chloe was published by Tériade (1960–1961). The twelve stained glass windows for Jerusalem were exhibited at the Musée des arts décoratifs in Paris and at the Museum of Modern Art in New York.

In February 1962 Chagall was present when his windows were inserted in Israel.

The Rath Museum in Geneva honoured Chagall with the exhibition *Chagall and the Bible*.

1963 and 1964

The museums at Tokyo and Kyoto in Japan mounted their first Chagall retrospective.

André Malraux proposed to Chagall that he design a new ceiling for the Paris Opera in the Palais Garnier. The painter did a number of small studies and designs on themes set to music by composers he wanted to honour: Debussy, Ravel, Moussorgsky, Tchaikovsky and Mozart.

He painted two large designs which he presented to General de Gaulle and André Malraux. He executed the one chosen between January and June 1964 in a studio belonging to the Gobelins tapestry factory. Dedicated in September, the new ceiling was a great success.

Marc and Vava Chagall went to New York to the dedication of a stained glass window, *Peace*, at the United Nations Building dedicated to the memory of Dag Hammarskold and his friends. On that occasion Chagall met Rudolf Bing, the Director of the Metropolitan Opera. He commissioned two vast murals and the sets and costumes for Mozart's *Magic Flute*.

On meeting Yvette Cauquil-Prince, Chagall was captivated by her masterly tapestries. From then on she would translate Chagall paintings, works on paper and lithographs into low-warp tapestries.

1965–1967

Chagall received an honorary doctorate from Notre Dame University in America. *The Story of the Exodus*, a cycle of 24

227

original lithographs printed by Mourlot, was published by Leon Amiel in New York in 1966.

Chagall and Vava left Vence for La Colline in Saint-Paul, a house which was designed in its entirety to facilitate the painter's work.

From then on Saint-Paul was to feature in much of Chagall's work. He worked on two murals for the Metropolitan Opera, *The Sources of Music* and *The Triumph of Music*.

The painter executed an ensemble of nine stained glass windows on the prophets dedicated to John D. Rockefeller and Michael C. Rockefeller in the Pocantico Hills Union Church, Tarrytown. From the opening night in February 1967, Mozart's *Enchanted Flute* was an enormous hit at the New York Metropolitan Opera with sets and costumes designed and executed by Chagall. The critics were unanimous: 'No more appropriate scenic designer could be imagined.'[21]

There were two retrospectives in Zurich and Cologne.

The Louvre presented *The Biblical Message* from June to October. It had been donated by Marc and Valentine Chagall to the French state on condition that a place to hold the 17 large paintings and 38 gouaches be built in Nice.

The painter had a press installed in his studio so that he could do copper-plate engravings and

Marc Chagall explaining his stained-glass window, entitled *The Tribe of the Naphtalim* to his three grandchildren Piet, Bella and Meret, shown at the exhibition of windows and sculptures in the Musée des beaux-arts, Reims, 1961

have monotype prints transferred to paper by Jacques Frelaut. *Circus*, illustrated with 38 lithographs accompanied by Chagall's text, was published in Verve in 1967.

At the request of Lady d'Avigdor-Goldsmid, Chagall executed twelve stained glass windows for the church at Tudeley, a small Kentish village, between 1967 and 1978.

1968–1970

In 1968 Chagall and Vava went to Washington D.C.

An exhibition of his work was mounted by the Pierre Matisse Gallery in New York.

At the request of Louis Trotobas, Dean of the law faculty at the University of Nice, Chagall executed a large mosaic, *The Message of Ulysses*. The artisan Lino Melano, whose aid had already been sought with mosaics for the Maeght Foundation (1964–1965) and for La Colline at Saint-Paul, proved an invaluable collaborator.

The windows for the triforium of the north transept of Metz Cathedral were completed. In 1969 the cornerstone was laid for the national museum Message biblique Marc Chagall in Nice.

The artist went to Israel for the inauguration of the new parliament, the Knesset. A Chagall mosaic mural, *The Wailing Wall*, and three large tapestries, *Isaiah's Prophecy*, *The Exodus*, and *The Entry into Jerusalem*, made in the state Gobelins factory in Paris were unveiled.

In 1969, *Letter to Marc Chagall*, with five original etchings in black accompanied by a text written by Jersy Ficowski was brought out by Adrien Maeght, publishers.

A large exhibition, *Hommage à Chagall*, with 474 works was staged in the rooms of the Grand Palais in Paris.

Early in 1970, the Bibliothèque nationale in Paris put on a retrosepctive of Chagall's engravings. He illustrated André Malraux's *Antimémoires* with gouaches.

After years of collaboration with the master glassmaker Charles Marq and his wife Brigitte, Chagall unveiled five stained glass windows, a celebration of *The Prophets, Elijah, Jeremiah and Daniel, The Vision of the Prophet Isaiah, Jacob's Dream, The Tree of Jesse, The Crucifixion* and *The Celestial Jerusalem* for the chancel of the Zurich Frauenmünster in September 1970.

1971–1973

In spring 1971 Chagall again went to Zurich.

The artist made a huge mosaic for the Musée national Message biblique, *Elijah's Chariot*, and began in 1972 to work on a large mosaic commissioned by the First National City Bank of Chicago (*The Four Seasons*). A retrospective of Chagall's work was given in Budapest.

In 1972 *Enchantment and The Kingdom*, a text of Camille Bourniquel's illustrated with 10 Chagall coloured lithographs was published by Éditions Fernand Mourlot.

At the request of Éditions Mourlot, Chagall undertook to illustrate Homer's *Odyssey* in two volumes with 43 coloured lithographs and 39 in-text prints in grey. The first volume was published in 1974, the second in 1975.

At the invitation of Yekaterina Furzeva, Soviet Minister of Culture, Chagall and Vava went to Moscow (he had not been there since he left in 1922). There he signed the panels in the Theatre of Jewish Art, fifty years after he had made them. He visited two of his sisters in Leningrad. The Tretyakov Gallery honoured Chagall with an exhibition. On 7 July 1973, the Musée national Message biblique Marc Chagall, for which the artist had designed three windows on the theme of the Creation to be placed in the concert hall, was inaugurated with André Malraux present.

The Pierre Matisse Gallery in New York exhibited recent work of Chagall's: paintings, gouaches and sculpture.

Chagall in his studio in La Colline, St-Paul, May 1977

1974–1977

On 15 June 1974 three windows were dedicated in the central chancel of the cathedral of Notre-Dame at Reims, *Christ and Abraham*, *The Tree of Jesse* and *The Kings of France*. Each year since the inauguration of the Musée national Message biblique, an exhibition has been held there honouring Chagall on his birthday: in 1974 it was *Marc Chagall, The Monumental Work*. Chagall went to Chicago for the unveiling of his *Four Seasons* mosaic at the First National Plaza, where he was given a raptuous welcome.

In 1975 Chagall painted several large canvases with mythological and biblical subject matter such as *The Fall of Icarus*, *Don Quixote*, *Job* and *The Prodigal Son*. In Geneva Gérald Cramer published Chagall's *Poems*, written between 1930 and 1964. Most of them were translated by Philippe Jacottet and illustrated with 24 wood engravings. In 1976 Chagall finished a window (*Peace* or *The Tree of Life*) for the Cordeliers Chapel at Sarrebourg. In 1978 he was to add four more, celebrating the universal message of nature.

The artist worked on Robert Marteau's book *Chagall's Studios*, illustrated with five original lithographs and two wood engravings. It was published by Mourlot in 1976, as was an edition of Shakespeare's *Tempest*, illustrated with fifty original lithographs in black, published by Sauret.

A mosaic was consecrated in the Sainte-Roseline Chapel at Arcs in the Var.

In September Chagall went to Florence for the presentation of a self-portrait purchased by the Uffizi. In 1976 a travelling exhibition of his paintings circulated in Japan. His engravings were exhibited at the East Berlin Cabinet of Engravings and the Dresden Albertinum. The painter illustrated Louis Aragon's book of poems *Celui qui dit les choses sans rien dire* with 24 original colour lithographs, which was published by Adrien Maeght, as well as André Malraux' *Et sur la terre* with 15 etchings in black, also published by Maeght in 1977.

On 1 January 1978 the artist was decorated with the Great Cross of the Legion of Honour by the President of France.

Two exhibitions honoured his recent work: *Marc Chagall, Recent Biblical Paintings* at the Musée national Message biblique in Nice and *Marc Chagall, Recent Paintings* at the Louvre. Chagall went to Israel to be made an honorary citizen of Jerusalem.

1978–1980

In June Chagall went to Florence to open the exhibition of recent paintings at the Palazzo Pitti.

The first window – of an ensemble of nine to be executed between 1979 and 1985 – was consecrated in the Church of Saint-Etienne at Mayence, as was a window for Chichester Cathedral.

In 1979, on the occasion of the American Bicentennial celebrations, three windows dedicated to the arts were unveiled at the Art Institute of Chicago.

The Pierre Matisse Gallery in New York exhibited paintings from 1975 to 1978.

The Patrick Cramer Gallery in Geneva exhibited *The Psalms of David* (which had been shown at the Musée national

Message biblique at Nice in 1980) and 30 etchings in black on an ochre ground (Éditions Cramer, Geneva, 1979).
In 1980 Chagall decorated a harpsichord which was donated by the American Friends of Chagall Biblical Message.

1981–1983
Chagall finished a number of canvases in large formats distinguished by handling at once masterly and transparent, with biblical, circus and village motifs: *The Vision of King David* and *Village Festival*.
1981 saw several Chagall exhibitions: one of his engravings at the Matignon Gallery in Paris; a second, at the Paris Maeght Gallery, presented the lithographs in large formats printed by

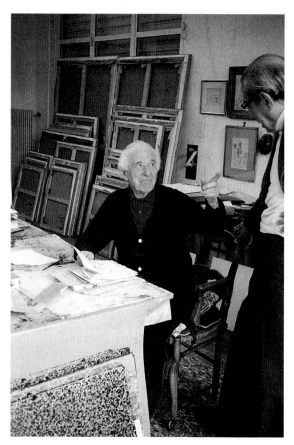

Chagall talking to Siegfried Rosengart in his studio in La Colline, St-Paul, May 1977

Aimé Maeght and the third, at the Zurich Maeght Gallery, showed recent canvases. An ensemble of windows celebrating the *Tree of Life* was consecrated in the Church of Saint-Etienne at Mayence.
Chagall finished the six windows for the parish church of Saillant de Voutezac.
In 1982 two retrospectives were mounted by the Moderna Museet in Stockholm and the Louisiana Museum of Art at Humlebaek. That same year the Pierre Matisse Gallery in

New York again dedicated an exhibition to recent paintings and the Patrick Cramer Gallery in Geneva exhibited books illustrated by Chagall.
The artist was now concentrating on work in small formats for engravings and lithographs.

1984
The Musée national d'Art moderne in Paris honoured Chagall with *Works on Paper*, a large-scale exhibition which then went to the Kestner Society in Hanover, the Zurich Kunsthaus and the Capitoline Museum in Rome.
Chagall was present at the opening of a retrospective of his paintings mounted by the Maeght Foundation at Saint-Paul-de-Vence as well as at the exhibition of his windows and sculpture at the Musée national Message biblique in Nice.

1985
A comprehensive retrospective of Chagall's paintings was being prepared by the Royal Academy in London (to be shown also at the Philadelphia Museum of Art), when the artist's health began to fail. Yet he kept on working every day, especially on his lithographs. On the evening of 28 March, after a day spent in his studio, Marc Chagall died peacefully. His funeral was held on 1 April. The artist's grave is in the cemetery at Saint-Paul.

1 Chagall, *My Life*, Paris, p. 13.
2 Marc Chagall, 'Some Impressions of French Painting' (lecture held in Pontigny, Franco-American, at Mt. Holyoke College, August 1943), Renaissance, abstract from Vols. I and II, New York, 1945, p. 46.
3 Georg Schmidt, *Zehn Farblichtdrucke nach Gouachen von Marc Chagall*, Basle, 1954, p. 8.
4 loc. cit., p. 7
5 André Breton, *Le Surréalisme et la Peinture*, Paris, 1946, p. 89
6 ibid.
7 Efross and Tugendhold, *Die Kunst Marc Chagalls*, Potsdam, 1921, p. 74
8 loc. cit., p. 76
9 Vitebsky Listok, 20 September 1918
10 From 'Lettre de Vitebsk', *L'Art de la communauté*, No. 3, 22 December 1918.
11 Pavel Novitzky, "Michoels", *Obras akteron*, 1941, p. 135.
12 Edouard Roditi, 'Entretien avec Marc Chagall', *Preuves*, No. 84, February 1958, p. 27.
13 Florent Fels, *Propos d'artiste*, Paris, 1925, p. 33.
14 Lionello Venturi, *Chagall, Etude biographique et critique*, Geneva, Skira, 1956, p. 67.
15 Marc Chagall, 'Départ', *Poèmes*, Geneva, Cramer, 1975, p. 109.
16 Tiempo, Mexico, 18 September 1942.
17 Preface in: *Lumière allumées et Première Rencontre*, trans. by Ida Chagall, Paris, 1973.
18 John Martin, New York Times, quoted in Dance Index, New York, IV, No. 11, November 1945, p. 188.
19 Jacques Lassaigne, *Chagall*, Paris, Maeght, 1957, p. 35.
20 Talk by Marc Chagall, Chicago, February 1958.
21 Winthrop Saregant, 'Musical Events', *The New Yorker*, New York, 7 March 1967.

Selected Bibliography

Alexander, Sidney, *Marc Chagall. A Biography*,
New York, 1989

Berger, Roland/Dietmar Winkler, *Zirkusbilder*, Alten-
burg 1983

Cassou, Jean, *Chagall*, Paris 1982

Chagall, Marc, *Ma vie*, Paris 1995

Compton, Susan, *Marc Chagall. My Life – My Dream.
Berlin and Paris 1922–1940*, Munich 1990

Crespelle, Jean-Paul, *Chagall, L'amour, le rêve et la vie*,
Paris 1969

Forestier, Sylvie/Meret Meyer, *Chagall y la ceramica*,
Milan 1990

German, Michail, *Marc Chagall. Le pays qui se trouve
en mon âme: La Russie*, Bornemouth 1995

Güse, Ernst-Gerhard (Ed.), *Marc Chagall. Druckgraphik*,
Stuttgart 1994

Haftmann, Werner, *Marc Chagall: Gouachen, Zeichnungen,
Aquarelle*, Cologne 1975

Kamenski, Alexander, *Chagall, période russe et soviétique
1907–1922*, Paris 1988

Kekkö, Marika, *Marc Chagall im Kunsthaus Zurich*,
Zurich 1980

Kuthy, Sandor/Meret Meyer, *Marc Chagall 1907–1917*,
Bern 1996

Le Target, François, *Marc Chagall*, Barcelona 1985

Longos, *Daphnis and Chloe*, with lithographs by
Marc Chagall, Munich 1994

Makarius, Michel, *Chagall*, Paris 1987

Marchesseau, Daniel, *Chagall, ivre d'images*,
Paris 1995

Meyer, Franz, *Marc Chagall, Leben und Werk*,
Cologne 1961

Meyer, Franz, *Marc Chagall*, Paris 1995

Schmalenbach, Walter/Charles Sorlier, *Marc Chagall*,
Paris and Frankfurt a. M. 1979

Schneider, Pierre, *Chagall à travers le siècle*, Paris 1995

Sorlier, Charles, *Marc Chagall et Ambroise Vollard*,
Paris 1981

Souverbie, Marie-Thérèse, *Chagall*, New York 1975

Venturi, Lionello, *Chagall*, Paris 1966

Vitali, Christoph (Ed.), *Marc Chagall.
Die Russischen Jahre 1906–1922*, Bern 1991

Walther, Ingo F./Rainer Metzger, *Marc Chagall
1887–1985. Malerei als Poesie*, Cologne 1993

Werner, Alfred, *Chagall Watercolors and Gouaches*,
New York 1970 (1977)

Photographic Credits

© Archive Ida Chagall, Paris: plates 1, 2, 5,
6, 10–14, 16, 18–22, 26, 30, 31, 34–36,
38–40, 44, 45, 50, 52, 54, 56, 58, 60, 63,
64, 66–72, 74, 78–82, pages 53, 207, 208,
210–213, 215, 217, 220, 221, 226, 228 and
frontispiece
Galerie Brockstedt, Hamburg: plate 51
Fondation Maeght, Claude Germain: plate 75
Photo Gaspari, Paris: plates 18, 19
J. Hyde, Paris: plate 26
© Izis: pages 206, 226
© Lotte Jacobi, New York: page 223 bottom
Walter Klein, Düsseldorf: plate 9
© LIFE Photo: page 227
© Lipnitzki, Paris: pages 218, 219
Photo M. Bockiau, MAMAC, Liège: plate 25
Photo Philippe Migeat, Centre Georges
Pompidou, Paris: plates 41, 42, 43, 55
MRBA, Speltdoorn, Brussels: plates 7, 29
Musée national d'Art moderne, Service
Documentation photographique:
plates 23, 37, 57
© André Ostier: pages 222, 225
Photopia Professional Lab: plate 40
Galerie Rosengart, Lucerne: plates 32, 48,
61, 62, pages 229, 230
Philipp Schönborn, Munich:
plates 53, 77
© Michel SIMA/Selon: page 224
Soyka Photo Studios, Vienna:
plates 27, 49